LIVERPOOL SEEN

LIVERPOOL SEEN

Post-war artists
on Merseyside

PETER DAVIES

REDCLIFFE

First published in 1992 by
Redcliffe Press Ltd
49 Park Street, Bristol

© Peter Davies

ISBN 1 872971 27 X

British Library Cataloguing-in-
Publication Data.
A catalogue record for this book is
available from the British Library.

To Pat

Sponsored by
KPMG Management Consulting

KPMG Management Consulting
recognises the importance of
helping to promote Britain's
position as an international centre
for the arts and businesses.

Our sponsorship of this book,
Liverpool Seen, enables us to
demonstrate our commitment to the
future of visual arts in Britain as
exemplified by the rich vein of
talented Liverpool artists.

Typeset by Mayhew Typesetting,
Rhayader, Powys
Printed by the Longdunn Press Ltd,
Bristol

Contents

Preface

When its author, Peter Davies, asked me to contribute a preface to this book I instantly agreed. This was not so much because I had read and admired his previous survey of those visual artists centred around Manchester (*A Northern School*), nor even that I was automatically in favour of any critic prepared to devote time and energy to British artists outside the metropolis and the Cork Street-Bond Street axis. The real reason I didn't hesitate was because this time his subject was Liverpool, and those painters and sculptors associated with that city.

If this seems an insufficient reason I would stress that Liverpool, and I write this as a Liverpudlian, is the most chauvinist city in the world. You may know someone from, say, Birmingham for years and never learn, except by chance, that they were born there, but within five minutes of meeting a Liverpudlian you'll be made aware of it, and when two Scousers run across each other wherever it may be, they are instantly transplanted, engaged in intoning street-names, back in that obsessive city which, to quote Alun Owen, never lets its children go.

As to those who might wonder why Mr Davies has found it necessary to write separate books about the artistic life of two cities only forty miles apart, I would explain that it could as well be four hundred for all the attitudes they share in common. Manchester is a Lancashire town, Liverpool, whilst in Lancashire, is an Irish city with a large Welsh minority. It is in consequence nearer in spirit to Dublin and Cardiff than to Manchester and furthermore, as a port, albeit a derelict one, feels itself closer to New York or Hamburg than London. Manchester is jealous of London, in competition with it ('What Manchester thinks today London thinks tomorrow'); Liverpool ignores the capital, despises it even. Those who leave Liverpool, the Beatles are the most obvious example, take a long time to live down this act of betrayal. When I returned to jazz singing in the early seventies and gave a concert at the Liverpool Playhouse, the poster was headed "Come Back George. All is forgiven!" It was only partially a joke. Peter Davies is well aware of this frequently self-defeating attitude. Many fine artists are unknown south of the Mersey because of their intransigence. In an article by John Windsor in the *Independent* a London dealer is quoted as grumbling that ". . . Liverpool artists are totally uncommercial" but later complains that, when they do show in London ". . . they sometimes double their Liverpool prices."

The article also points out that many Merseyside artists are from elsewhere. Davies bears this out, and yet it isn't as important as you might imagine. The point is that whereas those who immigrate are almost instantly accepted and in many cases (the late Sam Walsh, for example, was a Dubliner) become plus scouse que les scourcers.

This book is the first to deal with art in Liverpool since John Willett's excellent *Art in a City* in 1967, but it has a very different viewpoint. Willett, while devoting a perceptive chapter to (then) contemporary artists, is mostly interested as to why the great, if somewhat stifling interest in the 19th century had largely evaporated, in the social application, in town-planning, in visual education and so on. He is especially concerned in tracing the histories of the (now defunct) Liverpool Academy, the Sandon Studios Society and the Walker Art Gallery (the Tate in the North was still in the distant future) and in the largely resentful local attitude to the national eclecticism of the John Moores bi-annual. Davies, in contrast, while far from ignoring the structure of Liverpool's art world, concentrates in the main on the individual artists at work between the end of the last war and the present day. The foreground of Willett's book is Davies' background. He is right, though, in failing to detect a school or schools. This was possible in his previous book on the Manchester-centred artists, but the Liverpudlians are too anarchic (their strength and weakness) to cohere and furthermore there hasn't been (as yet) a Lowry to impose on the world at large a strong visual or conceptual image of Liverpool. Here the writers have been far more successful. From Alun Owen through to Russell and Bleasdale a sense of that hard-edged humour, cynicism, and self-parody through which Liverpool keeps despair at bay and preserves its identity, has impressed itself on the country at large. Films (*Letter to Breshnev*) and the soap opera *Brookside* have helped keep the Scouse pot constantly on the boil. The British public has a fairly precise idea of Liverpool but only the vaguest concept of life in, say, Sheffield or Newcastle, but there is no painterly equivalent of Lowry's factories or Hockney's California.

Davies' survey therefore is of unique interest. He has no axe to grind, respects each artist's intentions, and yet doesn't hesitate to pass considered judgement as to the quality of the work on its own terms. In my view his conclusions, and the emphasis he places on the influence and achievement of individuals, are remarkably perceptive.

There is no point in pre-empting what follows in Davies' text, but there are some general points he raises which confirm my unformulated suspicions. For example, although quite a number of art students were accepted by the Royal College of Art, South Kensington (Peter Blake found them a tough lot), they all came back. This exemplifies the Liverpudlian view of London as there only to be raided and pillaged — the attitude of local football supporters down for the cup. He also reiterates the credo that,

during the pop era, Liverpool pop artists maintained that they were closer to American pop art than anyone in London; a typical example of Scouse arrogance but arguably true.

Other revelations: that the Catholic church has been the most adventurous patron of modern sculpture in the city and that the only serious collectors of Liverpudlian art are local tycoons. A less original view is that Stuart Sutcliffe's early death robbed Liverpool of an artist who showed every sign of becoming an artist of international stature, but Davies also maintains, quite rightly in my view, that Sam Walsh, if only he had lived long enough to find his own path, showed great potential, while his friend, Adrian Henri, is given credit as a much more important artist than is usually the case — an injustice that is in part the price he has paid for his diversity. Maurice Cockrill on the other hand is now widely recognised but significantly, as Davies points out, he has moved to London; a step advised, strangely enough, by that arch-Scouse patriot, Arthur Ballard.

In relation to Ballard, Davies should be honoured for rectifying a grave injustice. That ex-boxing intransigent was, vis a vis Liverpool, an inspired teacher and a serious, if uneven, painter. It was he who first recognised Sutcliffe's potential and the originality (although not as a painter) of his troublesome friend, John Lennon. Ballard was, for many years, the eminence gris ('rouge' would be a more accurate colouration) of the Liverpool art scene. Davies is right to insist that this was the case.

All in all, 'Liverpool Seen' is a lively, well researched and well written book, of interest not only to Liverpudlians (although it will no doubt be noisily debated in 'The Cracke', Liverpool 8's artists' pub) but to anyone interested in regionalism and the effect of modern art in those distanced from its centres of origin.

But it is also, obliquely yet in sharp focus, a portrait of a city which, despite turning the Beatles into a tacky cottage industry, despite its deplorable record over many years in destroying or ruining its rich architectural inheritance, despite its transforming the abandoned docks into a boutique-riddled theme park, remains unique in spirit and, for all its faults, indomitable.

GEORGE MELLY

Introduction

This study of post-war Merseyside artists grew directly out of my previous book about Lancashire painters, *A Northern School*, published by Redcliffe in 1989. That book, referred to by some as 'the Manchester book', paid insufficient attention to a post-war art scene in Liverpool which gathered momentum during the 1950s and revealed greater willingness to deal with contemporary developments than was generally displayed by the more tradition-bound Manchester artists. Liverpool was also traditionally the more substantial art centre, and even today the numerous museums on Merseyside enjoy the best aggregate attendances of anywhere outside London. Liverpool is also a city of renowned spirit and character, and behind the more familiar persona of its football clubs and the Beatles, lies a considerable tradition of artistic excellence, one that has gained insufficient recognition. This is only the second book on Liverpool art, and the first since John Willett's pioneering study published twenty-five years ago.

I did not therefore have to start this study from scratch. The Liverpool section in *A Northern School* was a beginning. *Liverpool Seen* developed gradually and depended on the goodwill of all the artists who proudly associate themselves with a partisan, though open, Liverpool art scene. I am grateful for a co-operation that was so great, it felt at times that I had become one of them, (which I now have).

I owe thanks to four artists who helped me above all others. George Jardine extended regular hospitality during my researches, drove me to interview many artists, and showed me around Merseyside, Wirral and North Wales. He spoke at great length about the many obscure people, the mostly forgotten patrons, old Sandon members and so on who all went to make up the rich fabric of art in a city. Arthur Ballard, retired in North Wales, was visited and he generously lent me a most valuable archive — the scrapbook of letters and cuttings covering his entire career. His daughter Rachel lent me her student thesis on Liverpool artists of the 1950–70 period. Carol Ballard provided me with the Arthur Ballard photographic material. Nicholas Horsfield, as ever, was a great help, providing clarity and objectivity, the fruits of hindsight. Maurice Cockrill also patiently answered many questions and gave generously of his time, talking not only about the developments of his own work but also about his colleagues from old Liverpool days of the late 1960s and 1970s, before his move to London.

Many of the artists covered in this book are still alive to tell the tale. One I narrowly missed was Tom Rathmell, who lived in the same South Wales village where I grew up. My letter to him about this book apparently interested him, but sadly he died before I was able to visit him. His widow Lilian provided me with the necessary information, and I wish to thank Millicent Ayrton for putting me in touch and also for answering questions about herself. Retired artists living on the Wirral like George Kennerley, Mavis Blackburn and Harry Hoodless were also very helpful. Other artists who gave informal interviews and discussed the times when they were teaching or practising art in Liverpool include Anthony Butler, Ray Fields, Clifford and Pat Fishwick, Ian Grant, Frank Green, Philip Hartas, Mike Kenny, Mike Knowles, Josh Kirby and Robin Rae. Most of these have since moved away but they all gave distinct impressions of how important Liverpool had been at a particular time in their own creative lives.

Arthur Dooley and Sean Rice, two practising sculptors in metal, were generous with their time and each showed me his working studios in the city. George MacPherson died in 1984, but his widow Hilda gave me the information about how he built up the sculpture department on Hope Street. In MacPherson's department there was Neville Bertram, and I am grateful to him and to his wife Danae Tyson Smith for information going back to early days. David Hillhouse and Colin Simpson of the Williamson Museum in Birkenhead provided me with photographs, while Julian Trehertz and David Morris of the Walker helped me gain access to the Walker archives on leading local moderns. Brian Biggs and Chris Kennedy of the Bluecoat Gallery, and Janine Pinion of the Acorn Gallery were helpful as was my 'pal' Stephen Forshaw of the Atkinson Museum in Southport. I am also grateful to the staff of the Witt Library, Courtauld Institute and Sothebys for supplying photographic material. John Entwistle, the eminent Liverpool solicitor, trustee of the Walker, and art patron, gave me encouragement. For photographs on early John Moores shows I also wish to thank Sheila Lanyon and Adrian Heath.

Ros McAlastair provided the Sam Walsh photographs, including the excellent transparency for the front cover. Pauline Sutcliffe, sister of Stuart, was helpful over many meetings and provided photographs relating to Stuart. Bill Harry, Alan Wood (over from Canada on a visit), Mike McCartney and Adrian Henri gave vivid recollections of the life and soul of the Liverpool art scene in the late '50s and early '60s. Adrian Henri was always elucidating and I am grateful for his many insights and for the illustrations he provided. George Melly, the one and only 'Scouse Mouse', proved he has 'never got over' his Liverpudlian origins by writing a characteristically elegant and perceptive foreword. Liverpool art owes much to Henri and Melly, intellectually powerful spokesmen and loyal supporters of the cause. It has been a fortunate convergence of interests that this study

has helped Pauline Sutcliffe in her long-term project of promoting the work and perpetuating the memory of her late brother, the Hamburg Beatle.

Julia Carter Preston, John Heritage, the ever-talkative June Furlong, Max Blond, Barbara Davies, Graham Dean, Clement McAleer and Mark Skinner each responded enthusiastically to this project. Richard Young was also very helpful. Andrea Longsbottom provided information about the late John Edkins. Paul Cousins, George Drought, Ulrich West were responsive. My longstanding, and long-suffering, friends Alex Simpson, Ambrose Shere and Pat Evans helped see me through the project with their reliable and varied support. My friend Bob Simm, of KPMG Management Consulting, and Bernard Jacobson are to be specially thanked for their financial support and sponsorship of colour plates. I also wish to thank my friend John Windsor of the *Independent* for his constant hospitality, enthusiasm for my projects and his article on Liverpool artists, 'Eccentric, esoteric and expensive', published in his newspaper in August 1991. Finally I am grateful to Martin Ainscough of the Merkmal Gallery, Liverpool, Joyce Graham and Bob Simm of the Graham Gallery, Tunbridge Wells, and Bill Scobie of Arbiter, New Brighton for their role in promoting and retailing this book.

Early post-war artists

Any serious study of art after the Second World War has to take into account the prevailing attitudes of the two inter-war decades. The artists who matured during the 1950s had themselves been students in the 1930s, and had been trained — whether in Liverpool, London or elsewhere — in the conventional, academic atmosphere of that time. Nevertheless, the winds of modernist change had at least begun to blow down the corridors of most art schools before the war. In Liverpool, traditional values were evident at the Sandon Studios Society, but what the painter Nicholas Horsfield later described as the "congenial, well informed discussion with serious professional artists" on offer at the middle-class Sandon did not preclude modernist possibilities. Indeed, what gave the 1930s student generation such authenticity after the war was the way, having reached legible standards with academic form, they confidently introduced stylistic 'novelties'. If not exactly hot out of the pot, these novelties at least reflected the post-cubist and expressionist legacy of the early twentieth century.

The painter Roderick Bisson became a member of the Sandon in 1931. His book *The Sandon Studios Society and the Arts*, published by Parry in 1965, gives the fullest possible account of the wide assortment of members, both artists and laymen. It also portrays an art culture well integrated into Liverpool's middle-class life. Bisson was largely self-taught, making up for lack of art school background by working as an architect's draughtsman. This gave him a strong feeling for design, enabling him to present complex figurative detail without cluttering the picture plane. As a result his often surrealistic compositions have an abstract significance as well as a poetic spark that is the product of putting disparate maritime, organic or architectural objects together in the same work. Indeed, Nicholas Horsfield, writing for the artist's 1987 retrospective exhibition at the Walker (sadly, it became a memorial show, for the artist died during the exhibition), described how Bisson's *Herculaneum oil tanks and foreshore dingle* "show his patient development from observed experience to variations of abstraction".

As we shall shortly see in the case of Arthur Ballard, war service in the Middle East was not without significance for British artists and Bisson was no exception. He was a cartographer, and even more significantly, he made many studies of both organic desert forms and ancient architectural objects which later gave his work that strange blend of softer naturalism on the one hand and hard-edged, linear design on the other. After the war Bisson

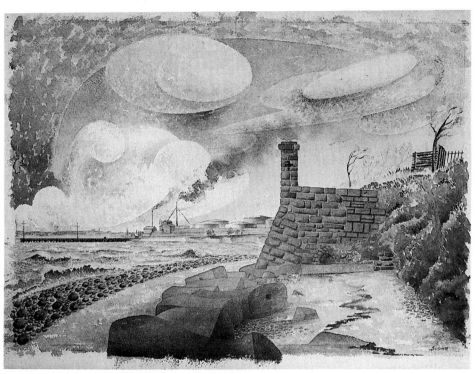

Roderick Bisson Herculaneum oil tanks and foreshore dingle. *Watercolour. Coll: Walker Gallery, Liverpool.*

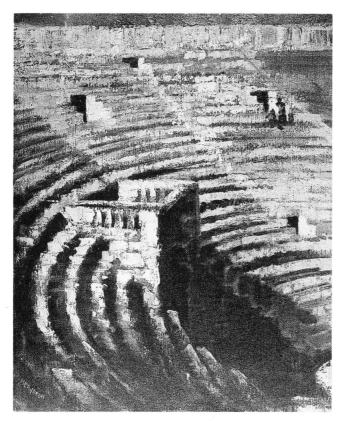

Millicent Ayrton
Amphitheatre, Verona,
*1958. Oil. Coll: Graham
Gallery (Tunbridge Wells).*

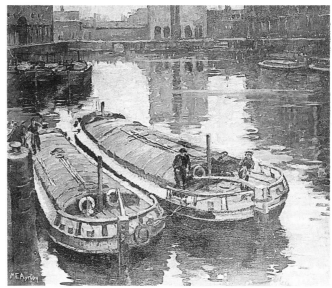

Millicent Ayrton Liverpool
Dock, *1949. Oil.*

conducted his life as a painter with a modesty that prevented his work gaining the local, let alone the national, respect that it deserved. In comparison with, say, John Tunnard, Bisson has to be seen as a second-rater. Yet his own more restrained mix of design and surrealism warrants a recognised place in early post-war British modernism. Another reason why Bisson never imposed his presence as well as he might was that he was not part of the art school scene. Instead, he worked as a designer for Lewis's, and more importantly, was an art critic for the *Liverpool Post*, reviewing local exhibitions during a 25-year stint. Horsfield described his numerous reviews — some of which are used in the course of this book — as being "fair, scholarly and distinguished for their wit and subtlety of interpretation." Bisson's modesty and critical integrity was such that he often concealed the authorship of his writings; many of his reviews are cryptically signed 'Z', undoubtedly a phonetic joke on the middle letters of his name.

Among the pre-war generation of Liverpool art students, Hoylake-born Millicent Ayrton (born Pollock) showed how a middle-class painter could break out of the academic atmosphere of the 1930s. By the 1950s she was painting in the avant garde styles prevalent on the Merseyside art scene at that time. She had reached middle age and was a widow. Her involvement with the avant garde tenor of the Liverpool Academy fulfilled her teacher Will Penn's prediction that Millicent (known locally as 'Mit') would be the only female Wirral student able to survive as a painter after getting married. Perhaps her ability to stay the course has something to do with the fact that her mother, Gladys Pollock, was a talented watercolourist who had herself been to the college in the early years of the century and had also become a member of the Liverpool Academy.

At the college Ayrton was one of a talented crop of early '30s students which included Martin Bell, Bill Stevenson, Stanley Reed, Tom Rathmell (her lifelong friend) and, of course, Arthur Ballard. The regime, in which Penn, Wiffen and Tankard were dominant, was strict and followed academic guidelines that meant regular life drawing only after orderly graduation from the antique room. In later post-war years Martin Bell, in pursuing the ideal of Cézanne, smashed up the plaster casts and advocated life studies. For all his strict control, Penn was a tolerant teacher who never imposed his way of painting on his students, and this no doubt later enabled the aforementioned students to evolve freer, more expressive styles in response to the international painting climate of the late 1950s. A number of Ayrton's contemporaries went on to the Royal College, but although she was offered a place her marriage in 1937 to a barrister prevented her following suit. She lived with her husband in London until the outbreak of war, when she returned north to live with her mother. The war prevented much painting, and Ayrton worked in her native Hoylake as a regional representative for the Treasury. Soon after the war she started painting again, took

private pupils at home, and became an exhibiting member of the Liverpool Academy in the early 1950s.

The style and professional methods that emerged in Ayrton's work during the 1950s were the outcome of pre-war influences. In particular her mother was important for instilling in her the *alla prima* principles of watercolour painting; as a child Mit was taken down to Teignmouth where she was taught watercolour by W.E. Egginson, one of her mother's former teachers. Ayrton's watercolour style had all the firm control and tonal clarity of the professional but became a medium pursued on the side. Oil paintings had become the artist's chief concern by the 1950s and she gradually took on board experiments with paint handling. By the later part of that decade her figurative, topographical style — best seen in the excellent oil study of barges in the enclosed waters of the Albert Docks (now part of the Tate Gallery complex) — had loosened into a packed, palette-knifed impasto of structural units that were well down the road to full abstraction. She never took the final jump, harking back in the 1960s and beyond to a more coherent, impressionist figuration based on annual trips to the Mediterranean. The series of Italian amphitheatre scenes, including *Amphitheatre Verona* (exhibited at the Liverpool Academy in the late 1950s) were the high water marks of her involvement in the contemporary de Stael-influenced manner that engaged most of her Liverpool contemporaries such as Anthony Butler, Austen Davies, Arthur Ballard, John Hart and Nicholas Horsfield.

Ayrton never fell under the kind of spell that a major painter like Ben Nicholson exerted over a contemporary painter such as Shearer Armstrong in St Ives. Instead she drifted into the orbit of a group manner that suited her inclination as she put it to "mentally abstract the subject so that subject could be seen as a pattern". The writings of Clive Bell were important to Ayrton because they stipulated the need for looking at a subject aesthetically (formally) and not just realistically. Her involvement in the local art scene led to her founding the Deeside Art Group in 1948 (she retired as Chairman in 1988) which had Wiffen as President in the 1960s. A lively annual exhibition (held for a week in July) was put on first at Hoylake then later at West Kirby. Highly respected artists who participated included Theresa Copnall, Wiffen, Mavis Blackburn and Joshua Armitage, a student contemporary whose studies in illustration under Wiffen led to his designs for *Punch* and P.G. Wodehouse books. The exhibitions were popular. Ayrton's natural need for social interaction led her to throw Liverpool Academy parties at her Hoylake house throughout the 1960s and 1970s. Frequent visitors included locals like Edna Rose, sculptor of bronze and ceramic animals, George MacPherson, Nicholas Horsfield and Mavis Blackburn. As well as showing annually at the Liverpool Academy Ayrton also exhibited several times at the Royal Academy.

Ayrton's contemporary Mavis Blackburn was a part of a select circle of

talented painters who remained in the West Kirby area of the Wirral. But Tom Rathmell (1912–1990) and his wife Lilian Jones, who were Millicent Ayrton's fellow students at Liverpool Art College in the early 1930s, were to spend most of their careers in South Wales. Rathmell built up the art school in Newport. He became a very talented figurative painter whose gifts were nurtured under Will Penn at Liverpool during his student days. He was born in Wallasey and after studying at Liverpool won a scholarship to the Royal College. This was gained largely on the strength of an impressive picture Rathmell painted in 1932 of a dole queue outside the Liverpool Labour Exchange. Influenced in general by the tendency of the time to move away from romantic or mythical subjects and embrace realist themes of everyday life, the picture harmonises the many figures in a controlled piece of lyrical painting. The work of Brangwyn, Lamb, Sickert and even Yeats is recalled in Rathmell's confident and surprisingly mature picture. Rubens exerted an influence at the time. He liked the old master's rich, fluid handling, and produced a number of lighthearted mythological versions with nymphs and other creatures. Lilian Rathmell later remembered that the staff at Liverpool were unapproachable and little mingling occured between tutors and students. But Penn thought highly of Rathmell and the staff helped him obtain an award, based on his performance in Liverpool, that allowed him a spell in Rome before going on to the Royal College. During his student years in Liverpool, Rathmell lived at home in Wallasey. He married in 1933.

The time at the Royal College was not as valuable, though he developed his drawing skills and benefited from staff members such as Will Rothenstein and Gilbert Spencer. Never endowed with the kind of family resources that Mit Ayrton enjoyed, Rathmell took odd jobs in London before joining the Admiralty Camouflage Department in 1940. He spent the war years in Leamington, where he had two children. After the war he applied for teaching jobs and in 1949 he began at Newport. He built up the college until his retirement in 1972. His daughter Elizabeth, another talented painter, began her studies at Newport before going on to the Royal College where she was taught by Carel Weight and Peter Blake. Weight was invited down to Newport by Rathmell, where he assessed students' work. During his Newport years Rathmell, ever a modest man content to let the world come to him, mostly exhibited in South Wales. About his early Newport work it was written that "the figure drawing very skilfully reconciles realism with the demands for strong overall pattern . . . the colour bold . . . the aim monumental." The same commentator later pinpointed Rathmell's concern for "sunshine, privacy, rest, the comedy and seduction of the body." This assessment accurately describes the artist's pronounced feeling for the life figure, which is relayed in fluent drawing and strength of composition. In the best sense of the word Rathmell is a

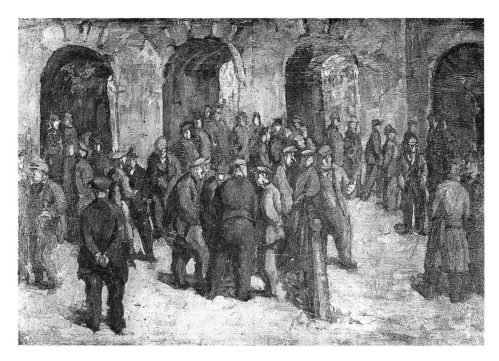

Thomas Rathmell Liverpool
dole queue at Unemploy-
ment Exchange, *1932. Oil.*

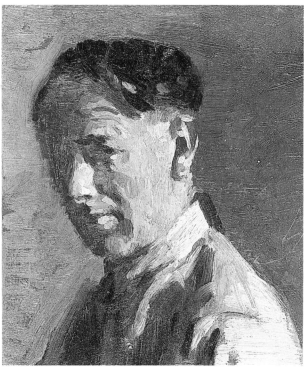

Thomas Rathmell Self
Portrait.

18

modern classical painter whose academic standards never prevent an authentic portrayal of contemporary reality.

Ian Grant is usually associated with Manchester, but he began his career in the north-west at Southport and exhibited in early years with the Liverpool Academy and indeed in the Southport Spring Show. Grant's earliest contribution to the Academy came in 1930, but the leading light in Southport, Percy Lancaster, vented his prejudice against the Liverpool art scene by advising Grant to go for the Manchester Academy in preference to that of Liverpool. Grant's involvement with the Liverpool Academy came about through Will Penn and Henry Huggill. Indeed Grant entered the art school in Southport while the topographical engraver and etcher was Principal, though Huggill was about to move on to the head position in Liverpool. Huggill was the type of personality who gained widespread respect. Both colleges thrived under his leadership. A letter from Penn and Huggill asked Grant to join the Liverpool Academy for the purpose of instilling new blood — and a youthful spirit recently exposed to the vibrant Parisian scene of the 1920s — into a very academic institution. Grant formed a cheerful coffee-drinking camaraderie with Grainger Smith, Wiffen and the other artists who then had studios in the Sandon.

During his years in the Liverpool area, Grant abandoned the use of tempera painting he had learned from George Balthus, a visiting teacher to Glasgow Art School during Grant's student days. Tempera painting was not uncommon at the time and had the advantage of being a permanent medium suitable for flat, decorative painting of the kind practised locally by J. Coburn Witherop, the painter who also did much restoration work for the Walker Art Gallery. Balthus had taught Grant about using tempera not with an egg base, but with a casein medium. Casein, an extract of milk, later became hard to obtain. While having problems with the egg-based medium, Witherop was taught the uses of casein by Grant, much to the benefit of Witherop's art.

Grant enjoyed the timeless quality of Liverpool's life. Liverpool's wealth in the 1930s was based on old money derived from the great shipping boom in the nineteenth century. Manchester's was more a processing economy, using cotton and other products brought into the country via Liverpool. Fortunes were made and lost faster in Manchester and to this day the city has a more hard-headed attitude to business and life in general. The fact that Grant soon moved over to Manchester was more a matter of circumstance than strict choice.

Although a little older than the group of painters who modernised painting on Merseyside after the war, Grant belonged as much to their orbit as he did in the inter-war school. He never abstracted in any convincing way, though his talent for orchestrating the browns, greens, pinks and autumn rusts of woodlands led to a series of entirely non-representational, palette-

knifed compositions during the later 1950s. For all the refinement of hand-
ling and subtle colour harmonies such works were a shade pretty and lacked
the authentic rigour and toughness of the kind achieved by Ballard or by
Grant's good friend Horsfield. In some respects Grant's style — particularly
with portraiture — became a tighter and more refined version of Penn's
post-impressionism. By finding Penn "a little bit slick"[1] Grant was no
doubt alluding to the easy virtuosity of Munnings or John. But one instance
where they did overlap was when Penn painted a portrait of the wife of
Gordon Hemm, the prominent Southport architect, while Grant painted a
fine academic version of Hemm himself.

In 1937, after seven years in Southport, Grant moved to Manchester and
began teaching at the art college. After the war the professional stance of
the Liverpool Academy gave way to an inefficient administration which lost
paintings and allowed the entry of amateurs. During the 1940s the exhibi-
tions were moved out of the Walker across to the Bluecoat and Grant
remembers them as scrappy, makeshift affairs. Perhaps memories of the
grander institutional attention given to the fine arts in Glasgow and Edin-
burgh made him feel like this. Grant resigned from the Academy before the
significant post-war revival took place under the influence of Ballard,
Horsfield, Davies, Mayer-Marton and others.

Another artist whose mature career took place away from a formative
Merseyside background was Accrington-born Clifford Fishwick, who moved
to Ellesmere Port as a young boy and attended Chester Grammar School.
Fishwick entered Liverpool College of Art in 1940, where he studied for a
drawing certificate under Wiffen, Tankard and Timmis. Wiffen was an
excellent book illustrator and sympathetic, practical teacher though he
argued with Fishwick on the merits of Cézanne. Fishwick had found a book
on the father of modern art at Chester Art School and was excited by what
he found, an enthusiasm that was not shared by his older and more conser-
vative tutors. Timmis taught still life painting, a natural outcome of his
tutoring antique classes, and his more impressionistic use of paint probably
meant more to Fishwick's generation than the rigorous style of the
topographical artists. But once again Penn was the chief inspiration, and
was described by Fishwick as "tough, autocratic" but a "very clever
painter". Fishwick even went out to the old man's Birkenhead home for
informal drawing sessions. Among his student contemporaries, Arthur
Goodwin was a particularly close friend; indeed the Ormskirk student later
taught under Fishwick at Exeter Art School, and as students they lived
together on Croxteth Road. Ted Atkinson, Josh Kirby and Pat Fishwick,
later to become Cliff's wife, were other contemporaries.

Fishwick's art studies on Mount Street were interrupted by the war. He
was often late into college if night-time bombing had obstructed the journey
from the Wirral. He sometimes stayed at the college in his capacity as a

voluntary fire watcher. In 1942 war service took him to the Americas and the Far East. He resumed studies in Liverpool for a year upon his return and in 1947 left the college with teaching qualifications. The final year after war duties was enjoyable. A Bohemian society was emerging in Liverpool 8 and Fishwick used to drink in the Cracke, where inevitably he knew Arthur Ballard. Fishwick straightaway obtained a teaching post at Exeter's then small art school (based in the old Gandy Street building with only five staff members), where he was to remain throughout his professional life. Among the staff was a former student of Geoffrey Wedgwood in Liverpool, George Adamson, who taught etching and became a cartoonist for *Punch*. One of Fishwick's first students was Jack Pender, the talented Cornish painter of Mousehole harbour. They shared a flat near the college until Fishwick married. Fishwick, who always loved climbing and hiking, was introduced to Cornwall by Pender. He subsequently produced pictures in a painterly neo-romantic style with seashore and beach settings. He made contact with most of the key Cornish artists of the period and began sending in work to Penwith and Newlyn exhibitions. He also befriended Alexander MacKenzie, another Liverpool student who became a Cornish painter of the Nicholson school. Fishwick invited Peter Lanyon to do some part-time teaching in Exeter. Links with Liverpool were maintained despite this period of absorption into the West Country art scene. Alan Wood was sent down by Ballard to seek introductions from Fishwick to the key Cornish artists. Subsequent to this Wood became a part of the St Ives colony.

Fishwick exhibited twice with the John Moores exhibition, in 1959 and 1961. The first contribution was a Zennor landscape, in a broadly Lanyonesque style. *Porthmoine*, as the picture was called, referred to Fishwick's rock climbing adventures. Pat Fishwick also exhibited, her snow scene of Exeter in a tightly composed, linear structure impressing Mark Rothko for its quality of metaphysical stillness. But other contacts with the north were kept up with regular visits to Holyhead where Pat Fishwick's family lived. Fishwick's long series of neo-romantic beach scenes in a style that had much in common with Keith Vaughan was based on the beach on Anglesey at Holyhead. A monumental, if spiky, sailor figure that anchored the horizontal bands of sand, sea and sky to the picture plane was based on the strong figure of a local sailor, Jack Sharp. The interest in stylised, linear figures was originally suggested by Devon farm workers hedging and ditching in the early 1950s. The Anglesey period of the mid-1950s was followed by a more abstract style towards the decade's end, in concert with the widespread abstracting tendency of that period.

Mavis Blackburn was another art student on Hope Street during and after the war. She was born at Wallasey in 1923 and lived from the mid-1930s onwards in a quiet road at nearby West Kirby. Among the staff encountered at the art college only Martin Bell made reference to modern

movements such as surrealism and cubism. Blackburn spent a year under Bell having been guided for her first year by Will Penn, with whom she developed a lasting rapport. Penn, whom she described as "a very forceful personality", was a Londoner who had been taught an easy virtuosity by Sargent. Penn's frequent use of wide brushes to make fluent, pronounced markings in a bright, naturalistic palette made his work appealing to a younger generation even if it fell short of a modernist formalism. Penn's painting of Hope Street seen from the staff room of the art college is not only a document of the street before the erection of modern buildings such as the Catholic Cathedral, but is also a clear example of Penn's style. It resembles the late work of Henry Lamb or more particularly that of the Newlyn painter Stanhope Forbes who later on concentrated on street views of Penzance. The picture is owned by Mavis Blackburn, and is a testament to a friendship that developed out of an early pupil-teacher relationship. She saw the tragedy that later blighted Penn's life: the painter's wife suffered from mental illness and his daughter Dora, a talented musician, committed suicide.

Whereas Penn emphasised light in his generously handled pictures, Martin Bell aimed for pronounced pattern. This tendency reached its climax in a 1958 picture now in the Walker called *Seaside Fair Ground*. It is a rectilinear composition of soft-focus forms simplified from a partially recognisable motif. It shows Bell in a compelling contemporary mood, emulating the rhythmic tonal style of Parisian abstract artists like de Stael or Viera da Silva. Bell was another of Blackburn's teachers with whom she built a friendship long after student days. He lived not far away at Upton-on-the-Wirral. Having missed the opportunity to marry, Bell lived with his mother and sister and built a studio in his garden. The 1960s were difficult times for him. That generation of French-inspired painters were eclipsed by the more strident transatlanticism of Pop Art, personified in local Academy shows by Sam Walsh and Adrian Henri, among others. Bell was also struggling to recover from a stroke that effectively ended his demanding teaching career. Alfred Wiffen was Blackburn's other principal teacher whom she described as "extremely conscientious", a quality that compensated for a certain rigidity. Pessimistic, even depressive by nature, Wiffen sold his work cheaply, a possible symptom of low self-esteem. Yet he had a sensitive, exquisite hand for drawing, which he taught expertly, and in his wartime *Jet of Iada* (Walker Art Gallery) he uses sophisticated drawing skills to integrate the difficult composite image of a large dog and soldier searching among bomb wreckage for survivors of a blitz.

Geoffrey Wedgwood's presence was significant at the art college because he maintained the high graphic standards of the past. Blackburn never doubted his talents, feeling he was "waylaid" by staying in Liverpool. It had not always been so because after war service and studies at Liverpool

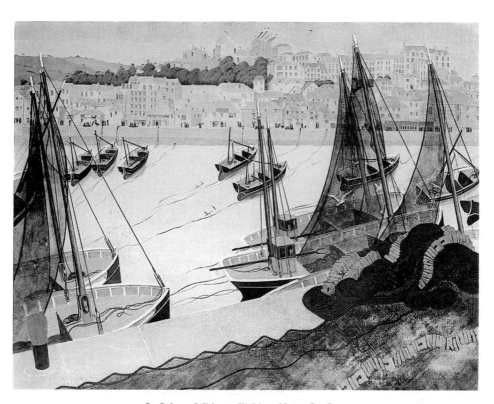

J. Coburn Witherop Fishing Nets, St. Ives.

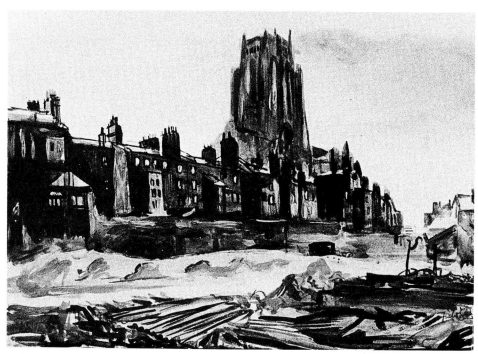

Clifford Fishwick Liverpool
Cathedral, *1947.*

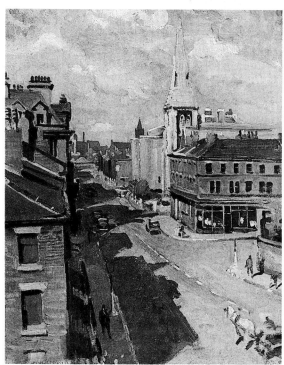

Will Penn View of Hope Street
from Art College staff room.
Oil. Coll: Mavis Blackburn.

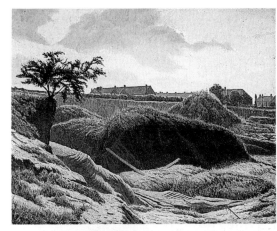

Eric Gill Prenton Clay Pits.
*Oil. Coll: Walker Gallery,
Liverpool.*

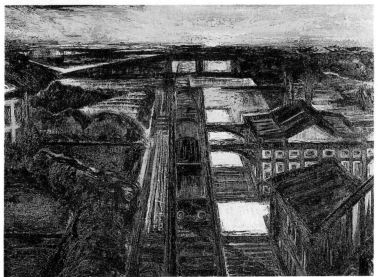

John Keates Derelict station, *oil.*

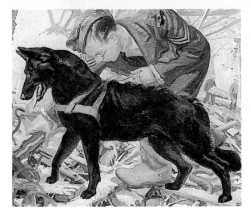

Alfred Wiffen Jet of Iada, *oil.
Coll: Walker Gallery, Liverpool.*

25

College of Art in the early 1920s, Wedgwood went on to the Royal College. He studied engraving under Frank Short and Job Nixon. Wedgwood continued his studies at the British School in Rome, where he enjoyed the company of a number of Liverpool painters and architects (among them Herbert Thearle). Influenced by Piranesi, Wedgwood's engraved work in Italy concentrated solidly on architecture which he relayed with an immaculate and precise linear style. From the mid-1930s until his retirement in 1960 Wedgwood taught at Liverpool College of Art. He thus became an early example of a gathering number of students who went on to teach at their former college. Wedgwood produced not only grand architectural studies of classical Italian buildings, but also etchings, drypoints and engravings of Liverpool architectural and topographical subjects. He contributed to the post-war 'Recording Merseyside' exhibition series.

After Wedgwood, Ballard is the most significant example of the students at Liverpool who graduated onto the staff, but there are others like Ballard's friend and colleague Eric Peter Gill, who was born in Birkenhead in 1914. As students, Gill and Ballard took camping and sketching trips together. Gill's period of study lasted from 1932 to 1936, under the inevitable trio of Wiffen, Penn and Timmis. After graduating, Gill taught at a leading Birkenhead school before finally joining the staff of the junior wing of the art college. These early successes led to his painting *Prenton Claypits* (1940) being acquired for ten guineas by the Walker collection in October 1940, with Ballard acting as legal witness for the transaction. Gill was living in the Prenton area of Birkenhead at this time and he was attracted to some brick workings near his home. The artist produced a fine watercolour study on the spot as was his habit, which was subsequently used to work up an oil. Gill wrote that he was "much attracted to impressionist painting and effect of light . . . the idea of warmth in light and cool in the shadows."[2] The work reflects this well and is a *contre jour* view of clay workings, uneven terrain with undulating banks of grass and some terraced rooftops silhouetted on the horizon against a gold dusk sky. The mood of the subject is one of mundane realism and the picture gains a dramatic quality from the naturalistic flow of vivid evening light across dark foreground recesses. The new realism had gradually come to replace more fanciful genre subjects during the 1930s, and but for a neo-romantic interlude, continued to do so into the 1950s.

Gill joined the R.A.F. and married in 1941. After the war he painted Victorian houses on the Blundellsands seafront, where he lived for two years before taking up a position as head of St Helens art school in 1950. He also painted derelict areas in Bootle, and was drawn to docklands, quarries and interesting parts of the Wirral which were "areas and places which attracted for their romantic associations."[3] He participated in the 'Recording Merseyside' exhibitions after the war, a series that unleashed a phase of

watercolour works which as the artist later wrote "were influenced in some degree by the works of the Romantic School of English painters."[4] The identification with the broad romantic tradition is clear in the other picture acquired by the Walker, *Walton Village* (1946), an elaborate ink and watercolour study of a terraced street seen from a churchyard. The work conveys the tombs and trees of the foreground and the street beyond with a pronounced linear pattern. If not quite neo-romantic the work recalls the heightened formal animation but empty atmosphere of Nash and Ravilious. At St Helens, Gill taught painting and ceramics. He was commissioned to produce ceramics for schools in St Helens, Liverpool and Salford. He retired in 1974 and in 1991 celebrated his golden wedding anniversary.

John Keates was also born in Birkenhead but a year after Eric Gill. His studies at Liverpool overlapped with Gill's own, though Keates graduated a year later, in 1937, and did not join the staff of his former college until 1948. *Derelict Station* was acquired by the Walker from a Liverpool Academy exhibition in 1956. The picture represented the old Birkdale Palace railway station just before it was demolished. The choice of this derelict site continued the interest that Gill and others had displayed in the 'Recording Merseyside' phase of the late 1940s. Keates composed the painting using small sketches made from a bridge over the railway line. The artist later admitted to painting "over a transparent ochre or red ochre ground in order to give a greater richness."[5] Richness certainly resulted for the scenario of railway industrial architecture was painted with a generous helping of pigment over a strongly delineated composition. The picture resembles the work of Alan Lowndes, whose painterly expressions of the urban environment around his native Stockport also embraced similar subjects as was the case with his painting of Tiviot Dale railway station. Lowndes also painted a view of an industrial street in his *Great Howard Street, Liverpool*.

In contrast with artists like Keates, Gill and Ballard, Mavis Blackburn never returned to teach at the art college in which she had trained. Instead, in 1948, having recently graduated, she taught art in a convent for two years and then, encouraged by a number of commissions, became a full-time painter. She visited Portugal then Paris, and a number of high quality pictures resulted. Specialising in portraits, flower pieces and landscapes she also tackled a large mural in casein tempera for a new church in Bootle. Theresa Copnall, her neighbour in Hoylake, may have inspired the floral still life paintings. Copnall's habit of setting up flower arrangements on window ledges and painting them from inside the house looking straight into the outside source of light may well have stimulated Blackburn's own interest in *contre jour* effects that she had first been encouraged to explore by Penn in life classes. The adventure of painting full-time was, alas, a short-lived one as the Wirral peninsular was not the most promising place to

27

pursue a cosmopolitan reputation; also, a comfortable middle-class background needed to be maintained. She returned to teaching in an Upton school, taught in adult education, and became a founder member of the Deeside Art Group and a member of the Liverpool Academy. She exhibited landscape or still life paintings most years. She painted a series of large composite views, based on memory, of holiday-makers on the beach at Rhyl, and these are among the best achievements of her career, integrating academic realism with a convincing subjectivity and even naïveté.

In the 1960s and beyond Blackburn experimented either using photographs as aids to paint snow scenes and other inaccessible winter views, or more significantly painting abstracts that convincingly employed transparent, superimposed planes of colour placed or stacked in rhythmic sequences. Having taught art history she was by now well aware of the modern movement, and in 1968 visited the Venice Biennale, where she saw the work of Bridget Riley. She preferred Vasareley for the more intricate role of colour. The Byzantine mosaics of St Marks were another inspiration, with their use of square abstract patterns. In her own abstract work Blackburn imposed a clear, linear design and she never quite lost representational sources.

NOTES

1. Conversation with the author. Stockport, February 1991.
2. Letter in archives at the Walker Art Gallery.
3. Ditto.
4. Ditto.
5. Ditto.

Arthur Ballard

Arthur Ballard takes a central, even pivotal place in the story of post-war art on Merseyside. Considered by many the best of a generation of painters who matured during the second half of the 1950s, Ballard exerted an influence well beyond that important period. His influence on younger painters was considerable, his infectious, at times abrasive, personality instilling tough artistic principles into students beginning with Don McKinlay, Alan Wood and Stuart Sutcliffe in the 1950s through to 'followers' like Maurice Cockrill in the 1960s and beyond. He lived in Paris during a vital period in the later 1950s, and introduced to Liverpool the lessons of contemporary avant garde French painting. Ballard's eventual retirement from teaching at Liverpool College of Art came in 1980 — the year that his one-time student John Lennon was assassinated — and marked the end of an era on Hope Street, coinciding with Cockrill's decision to leave for London. Ballard was certainly an anchor man, yet dwelling too long on his charisma as a teacher and local personality can obscure the facts of his own professional career as a painter, which promised so much in its early and middle phases, but delivered so comparatively little after 1960. Exactly what went wrong can best explain itself through a biographical account of his career.

This most gifted of Liverpool-born painters retained a more or less lifelong association with his local city, and had not painting remained a marginalised activity in the provincial reality of British culture as a whole, he would certainly have become a widely known and popular figure. Many local newspaper articles celebrated the not infrequent occasions when Ballard or his Merseyside colleagues showed work in prestigious London exhibitions. But many a journalistic focus on this genuinely home-grown painter was characterised by a tongue-in-cheek humour, suggesting that to be a painter was a slightly cranky, offbeat activity. On one occasion, when a Ballard was mistakenly hung upside down in a prominent Liverpool exhibition, the media suggested that abstract painting did not need to be 'correctly' hung. Perhaps it was an affection for eccentricity that led to the establishment of Liverpool's humour cult, allowing a whole generation of 'Scouse' comedians to gain the kind of national recognition denied to their more serious, more high-brow contemporaries in the art scene.

Ballard was born in 1915, the son of a local furniture dealer who encouraged his interest in art. After attending St Margaret's School, the

young Ballard won a scholarship to Liverpool College of Art, entering the junior school in 1930. Will Penn was the chief figure on the staff who exerted considerable influence and Ballard later deemed him "the only sympathetic character." Ballard won a travelling scholarship and went on the first of two extended visits to Paris in 1935. He lived in a quiet quarter away from the art scene. He did not fraternise with any of the famous Parisian artists, though with a student companion did manage to see many exhibitions. Upon his return to Liverpool he taught at a school in Needham Road. This job took him to the outbreak of war, when he was sent to North Africa as a signals soldier in the 8th Army. From here he transferred to the camouflage corps, spending the whole of the war in the Middle East.

In 1943 Ballard exhibited his work, with other servicemen, at the British Institute in Cairo. He had taken part in the Battle of Eritrea, and scenes of that momentous battle were exhibited alongside his watercolour studies of Nile sunsets, trees (the rarity of which focussed aesthetic attention), Tel Aviv beaches and finally Abyssinian women. Writing in a services newspaper Joyce Colam was able to refer to "a complete lack of inhibition about his work and a startlingly bold treatment of the subject matter." In early 1944 a United Nations art exhibition followed in Cairo, where Ballard's fellow exhibitors included the Scottish abstract painter William Gear, Charles Messent (who later exhibited with the Midday Studios in Manchester), and Norman Blamey, today a successful Royal Academy figurative painter. Gear, who was one of the first British artists to paint in the abstract style of post-war French and Dutch art, retained the interest in vivid Byzantine design which the Middle East had given him. Ballard's successes were reported back home in the Liverpool press and further appreciation of his efforts came in April 1946 at the Bluecoat Gallery's exhibition 'Liverpool Artists in the Fields of War'. A Major Bristow wrote that the U.N. exhibition was of "work by people who are not observing — because they are in it up to the neck. They are not looking for subjects to illustrate, glamorize or dramatise the miserable pride of war." Indeed, an air of solace and beauty surely motivated Ballard's several studies of Arab women, rendered with a particularly fluent use of watercolour over powerfully drawn heads.

These paintings of Abyssinian women's heads were a success at the Bluecoat exhibition. Wartime work and its subsequent exhibition clearly encouraged Ballard. He was invited by Henry Huggill to join the painting staff at Liverpool, and he began teaching all the plastic disciplines at the junior school until he was transferred to the senior school in 1950. Huggill, who died in 1957, was principal of the art college between 1930 and 1951, the very period that saw Ballard rise from junior art school entrant to full-time teacher in Foundation Studies. Writing Huggill's obituary Bill

Stevenson referred to the "patience, acuteness and determination of the organiser." The college under Huggill saw a regime of hard work and discipline which "did not preclude gaiety", lessons that were not lost on Ballard.

The fruits of Ballard's labours at this time were put on display in 1950 at Salford Art Gallery in an exhibition of thirteen Liverpool artists associated with the Sandon Studios Society. Writing for the *Guardian*, Charles Sewter found that even in worked-up oils Ballard still seemed conditioned by the severe rationing of colours that had imposed itself on his black wash wartime studies. Sewter found Ballard's colour (or lack of it) "the least attractive aspect of his work at present." He found Ballard's colleague, Austin Davies, the "most interesting" while at the same time acknowledging that Davies's linear style of picture construction ran "dangerously near to mannerism". For all this the exhibition represented a healthy sortie of Liverpudlian art in rival Mancunian territory.

Speculating on the differing complexions that these two contrasting cities etched on the canvas surface, the *Guardian*'s John Willett wrote that the "difference between the Manchester Group and Liverpool's Sandon Studios Society is that whereas the former's pictures are characteristically Lancashire the latter's are not . . . the standard is reasonably high, yet because there is no very distinctive flavour one considers the whole more as an offshoot of London than as an indigenous affair."[1] Willett makes an important observation here. The 'Lowry school' in Manchester looked to the Lancashire mill towns, the foothills of the Pennines or the splendid Derbyshire peak country beyond Manchester. In Liverpool, though, there was greater tendency to draw from the landscape of North Wales which one is conscious of beckoning beyond Liverpool's southern outskirts. Certainly for Ballard, but also for an entirely different kind of Liverpool painter like George Jardine, the inspiration came from the Welsh hills rather than from the Lancastrian mill belt. Yet in his suspicions that Liverpool art might then be seen as an "offshoot of London" Willett was also alluding to Liverpool's greater degree of experiment in modernism.

Nevertheless some hint of Ballard's social awareness, in particular his clear left-wing sympathies, enters the work in such instances as the contributions he made to the 'Recording Merseyside' exhibitions which were held after the war at the Bluecoat. These shows were rare instances of a concerted effort by the artistic community in Liverpool to dwell, in Lowry-like ways, on the changing architectural, industrial and even social features of the city. This kind of exhibition stimulated an awareness of Liverpool's fine Victorian past with its rich architectural legacy. The artists who most came to the fore now were a sedentary group of pre-war artists like Wedgwood, Grosvenor, Tankard and Sharpe, who worked with the

precise linear style and printmaking techniques of topographical art. Ballard contributed a slum scene called *Relaxing* to the exhibition.

By 1954 Charles Sewter was able to write favourably on Arthur Ballard's development now evident in his contributions to the 1954 Liverpool Academy exhibition. "Arthur Ballard has made considerable advances recently," Sewter wrote, "simplifying, broadening and softening his style, without losing the sombre mood of realism which previously emerged from his subject matter rather than from his treatment." Ballard was now using Welsh subjects more and more, extracting not the pretty and colourful aspects of purple heather, grass or smoky blue hills (such as formed a backdrop for George Jardine's pictorial fantasies), but focussing instead on bleak, slate-strewn features of a pagan Celtic landscape. Throughout the 1950s Ballard made frequent use of a cottage he had purchased called 'Waerwar', high in the hills above Caernarvon. The Walker Gallery's picture *Farm* came from this period. In 1955 his picture of sheep shelters on the slopes of Snowdonia caused a stir at the Academy, not because of its bleak setting, but because a semi-abstraction enabled the predatory press to chuckle that its accidental upside down hanging at the Walker Gallery made no difference to what was in any case an incorrigible and incoherent representational image. Ballard was forced to explain that he was "trying to depict the quality of the pureness and mood of stone sheep shelters."

Perhaps this rural picture was the closest Ballard came to depicting north country settings. He figured nevertheless in a number of promotional exhibitions during the second half of the decade that aimed at presenting a school of northern artists. One, at the Manchester City Art Gallery in October 1955, was called 'Artists with North Country associations', and Ballard exhibited *Stone Shelters*, though this time the correct way up. This exhibition showed the rich contribution made by northern-born artists to British art as a whole, yet also revealed the dispersal of those talents to other, more favourable or supportive centres like London and St Ives. Ballard, considering the magnitude of his talent, never succumbed to the allure of the south. The pugnacious side of his character was sometimes evident in his antagonistic pronouncements about the soft, corrupt south. In 1960 Ballard spent a number of months in St Ives, where artists like Lanyon, Hilton and Wynter were working in a similarly 'advanced' contemporary style.

Alan Bowness had first suggested that Ballard find comradeship in the Cornish art colony, advice he took to his advantage because it destroyed his prejudices about a group of middle-class artists he thought "a gang of pansies".[2] Before the war Ballard had fought in the northern boxing championships. He had been knocked out by the middleweight champion of northern counties, but not before Ballard had floored him in the second round. Much to his surprise Ballard found similarly robust characters

among the artists of the south-west, and discovered that his use of Welsh landscape themes echoed Lanyon's search for the rugged features of the Celtic landscape of his native Cornwall.

At the beginning of 1956, Ballard displayed all his best Welsh pictures to date at an exhibition entitled 'Four Wirral Painters', with Harry Hoodless, Anthony Butler and Kenneth Jameson. Once again *Sheep Shelters* was put on view, along with *Welsh Shepherds*, lent by Leslie Blond, *Farm*, lent by the Walker, and a series of Anglesey cliff subjects. Charles Sewter, ever mindful of Ballard's development, declared the work to be "simplified almost to the point of abstraction, and his pictures rely for their expressive quality upon the purely visual effect of muted tones, soft and misty, even mysterious transitions from one shape to the next. The formal structure, however, is always uncommonly well considered, the balance of mass and space, surface and recession exceptionally secure and satisfying." This formal analysis of the purely pictorial qualities of Ballard's work suggests its contemporary relevance as modernist currency. Yet the almost local subject matter (North Wales), together with a continuing loyalty to the culture of his native city, made him resist any opportunistic migration south. He was still an apt candidate for the kind of group exhibitions, circulated around the north-west during these years, that argued strongly for the identity of a putative northern school.

The extended sabbatical visit to Paris during 1958 had a decisive effect on Ballard's career. Exposure to post-war 'Ecole de Paris' painting caused Ballard's position to shift into an uncompromised form of abstraction. The paintings were given monotonous titles, such as 'Non-Figurative No.1', though nothing was lost in terms of formal strength. For a few years before the Paris visit, Ballard had been showing his work with the prestigious London gallery, Roland, Browse and Delbanco. Correspondence with Henry Roland is informative. It reflects on the relationship between artist and gallery, and provides us with insights into Ballard's thinking at this high point in his career. The association with the gallery, which started late in 1954, put Ballard on the map, and there is no doubt that had he continued showing there into the 1960s and moved down to London to paint full time Arthur Ballard would be a much better-known artist that he is today. Committed to family (he had three young children) and to teaching, there were limits to his ambition as a public artist. Nonetheless, thanks to regular opportunities to show his work in a leading West End gallery, Ballard had opened up a 'second front' in a modest bid for artistic success.

The man who brought Roland, Browse and Delbanco's attention to Arthur Ballard's work was Patrick Cohen, an architect who lived in Oxton. He had seen Ballard's paintings in a local exhibition and impressed upon his friend Delbanco how good the pictures were. Delbanco wrote to Ballard

towards the end of November 1954, requesting some photographs of the work. The artist replied promptly, and as early as the first week of December Ballard had been made a tentative offer of a group show at the gallery. By the end of 1956 Ballard featured in an exhibition 'Colour, Pure and Atmospheric' and Lillian Browse wrote to Ballard asking that five paintings be sent down for a group show by six artists in early 1957. Several of Ballard's works sold, including *Fishing Nets Drying*, *Beach and Pile*, and *Canal*, which was bought by J.B. Priestley. Delbanco lent *Meols Harbour* to a ten-month touring exhibition, 'Pictures with an Impact', which took in half a dozen provincial public art galleries. The contemporary British artists who were favoured by Roland, Browse and Delbanco and with whom Ballard often exhibited included Bernard Key, Norman Adams, Donald Hamilton Fraser, Ceri Richards and Philip Sutton, a mixed but suitable bunch who were clearly on the ascendant.

Initial correspondence between gallery and artist had been handled by Delbanco, though by 1957 Henry Roland had become Ballard's chief champion and adviser, and it is from their correspondence that a number of events and situations become clear. In a letter written in May 1957 Roland gives a clue to a creeping dissatisfaction he felt with the contemporary vogue for non-figurative painting. Referring in his letter to Ballard's Liverpool colleague John Hart, Roland wrote, "I am so glad that Hart found Zwemmers to show him . . . they will make more of a success with them than we would have done with our hearts not in it."[3] Hart was painting with rectangular slabs of colour in the classic post-de Stael manner. The style was not of course limited to Nicolas de Stael and his French contemporaries for in England William Scott, and indeed Nicholas Horsfield, were painting in this way. Whether Roland's dislike of the Tachiste and abstract styles was down to personal taste or was mediated by commercial considerations is unclear, though obviously the rough surfaces, subject-less themes and physical painterliness of the work were much more shocking to average taste then than they are now.

At the end of the summer term of 1957 Ballard was preparing to go to Paris on a grant from Liverpool Council of Education. A list of chores to get the house ready for letting during the Ballard family's absence is pencilled in on the back of one of Roland's letters. The latter were becoming increasingly avuncular, with advice on projects ranging from the high cost of living in Paris on a Liverpool Council grant, to the direction that Ballard's paintings should take. Nowhere is the protective, advisory tone of Roland's relationship with Ballard in greater evidence than in letters the dealer wrote to the exiled artist. It is clear that Ballard was immediately exhilarated by the artistic atmosphere of Paris. He never got to meet the legendary de Stael (1914–55), who had committed suicide before Ballard's visit. But the English artist was to meet Giacometti, Soulages and later

Poliakoff. Roland wrote with trepidation that "some names hold a terrific aura for you."[4] Exposure to a dynamic Parisian milieu left Ballard torn between his English roots and the sophistication of avant garde French painting. "I can well imagine how torn you are," Roland wrote, "for the English are nearer nature than the French are, and further away from Rationalising and therefore Abstracting. But if I may be honest: exactly what has held me back a little from your pictures, what I missed in them, was the fact that there was too much nature, and too little abstraction in them."[5]

The sophistication of contemporary Parisian painting soon had the desired effect of lending Ballard's own pictures a greater degree of plasticity. At the same time as welcoming the 'Parisian effect', Roland emphasised to his young artist the pitfalls of trying to take on artificially the garb of received style and mannerism. He felt that the painting culture of Paris could become a liability if Ballard were completely to lose sight of his own artistic roots. The dealer advised him to ignore the irrelevant issues of contemporary versus anachronistic. Apologising for any paternalistic tone the letter may have conveyed, Roland concluded that his advice was "only meant to allay your worries, lest one of the French artists might think you do not belong to '1957'." Roland also revised his opinion of Karel Appel's work for the better, but warned Ballard that "I do not think it is 'your' art, Arthur. You are a teacher, a man who is used to looking behind things, to connect cause and effect. I think if you tried to go Tachiste you would belie your very own usual approach. I do not think that Singier, and particularly Bazaine, can be of more help to you. I would look at the classical period of Corot as much as at Manessier." This Ballard undoubtedly did, if we are to judge by his later silver tonalities and general approach to colour, form and rural subject matter.

The Tachiste intricacies of these contemporary French artists never rubbed off on Ballard the way they had originally done on William Gear, Ballard's co-exhibitor in the armed services exhibitions in wartime Cairo. Gear had been one of the first British artists to absorb continental abstraction. Gear's fellow Scot Alan Davie had also been on hand, and together with William Scott became the first to paint in a genuinely abstract expressionist style. This left Ballard, in the second half of the '50s, at some remove from the roots of this development, and in any case Ballard's only real 'influence' had come from the recently deceased de Stael whose partial abstraction of figurative or landscape themes led to a distinctive composition made from slabs of viscous primary colour. De Stael exerted the kind of widespread influence that Whistler had on Edwardian painting. In his post-Paris work Ballard brought to this convention of textural surface, designed composition and sensual handling his own northern austerity of colour.

By the end of Ballard's Paris sojourn, Roland seemed sure enough of the

progress his artist had made, for by the middle of October he was requesting five new pictures for a mixed show of British painting planned for the following January. Roland's lingering doubts by now focussed on whether Paris had allowed Ballard judicious insight into choice of theme. "What to say, what to express," Roland opined, "one does not necessarily see or learn in Paris. One can find oneself in the loneliness of a Liverpool suburb perhaps easier than in the babel of a capital. It is in the capital that one learns the sophistication of language but not what one wants to say." Before leaving Paris Ballard had an exhibition at the Galerie René Bâteau, showing the kind of non-figurative pictures exemplified by the Walker's 'Non-Figurative Painting' (produced in Paris during 1957).

The resemblance of Ballard's style to de Stael's had been noted even before he alighted in Paris. In 1957, for instance, Ballard told the *Birkenhead News* that "the critics said my paintings had been influenced by a French painter called de Stael. Curiously enough, I had never heard of him, and it was some time later that I saw his pictures for the first time." Earlier that year, a *Times* reporter had noted that at a Roland, Browse and Delbanco group exhibition of six contemporary British artists Ballard had drawn "heavily but with a touch of personal poetry on the credit of de Stael."[6] There was nothing new in this, for two years previously when Ballard showed for the first time at Roland's gallery, the *Art News and Review* reporter had written that Ballard's "broadly conceived near abstract landscapes possess considerable depth of feeling and pictorial originality. *The Cliff-Wales* is easily the best, there is a distinction in its massive composition and economy of statement almost akin to de Stael."[7]

In the summer of 1958 Arthur Ballard, firmly back in the saddle of a familiar Liverpool routine, was preparing for an exhibition that would include some of the Paris abstracts, at the New Shakespeare Theatre in the city. The artist had asked Roland to write a catalogue note for the show, which he declined saying, "I feel unable to repeat or even underline the many arguments which are in favour of the kind of picture you are doing now, and I also feel unable to argue theoretically in favour of it with any sense of conviction."[8] Seldom can Roland's apprehension about the contemporary fashion for non-figurative painting have been made clearer. He followed this with thinly veiled disparagement when he wrote to Ballard shortly afterwards about the visit to his gallery of the Paris dealer Claude Bernard, who "stood in front of your pictures and did them not only no justice, but gave them not as much as one look. Perhaps he deems only the Tachistes in his own gallery worth consideration."

In spite of Roland's misgivings about Ballard's new degree of abstraction the Shakespeare exhibition went on successfully in September 1958. Ballard found an alternative for the catalogue note in the shape of *Guardian* reporter Charles Sewter, who wrote a precise and succinct introduction. He

Arthur Ballard Children playing. *Oil. Coll: Walker Gallery, Liverpool.*

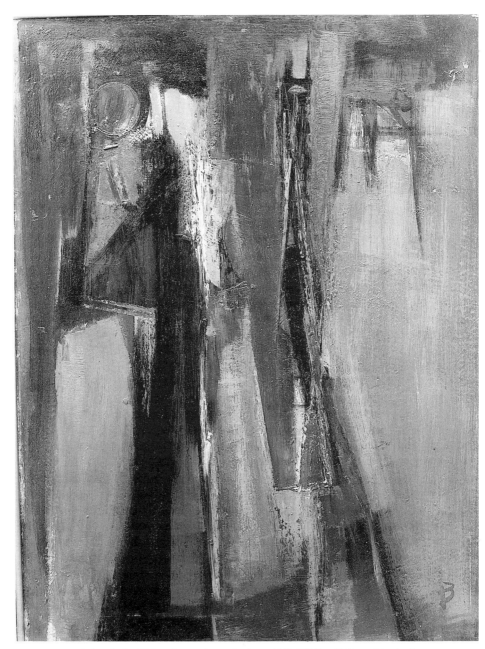

Arthur Ballard Non figurative painting. *Coll: Walker Gallery, Liverpool.*

speculated that "there has been a danger that free abstraction might degenerate into a smart, elegant, international decorative manner." But Sewter declared that Ballard avoided this pitfall by creating tough surfaces, full of textural rigour, possessing "a certain nobility, a full resonance, and an assurance, that mark him as one of the most classical of abstractionists." Roderick Bisson, ever alert painter critic for the *Liverpool Post*, found Ballard's show tough and announced that every "picture worthwhile now presents a challenge." The challenge was proving too much for Roland, the 'safe' dealer in London. Yet in the supposedly provincial atmosphere of Liverpool Ballard was impressing many people with his work. The abstract paintings put on display in Liverpool that autumn outnumbered the representational ones by three to one. In a contemporaneous exhibition held at Salford Art Gallery, organised by Ted Frape and called 'Then and Now', Ballard's six contributions were all non-figurative to stress the now-ness of 'now'.

In early 1959 Ballard once again participated in a mixed British exhibition at Roland, Browse and Delbanco. A co-exhibitor was Adrian Heath, a sure-minded artist who had links with the St Ives middle-generation painters of the time. If Heath was not consciously influenced, then certainly he worked in a style analogous to de Stael's. Neville Wallis of the *Observer* referred to Heath as "one of 2 or 3 British painters able to hold their own against de Stael or Poliakoff."[9] For Roland's money, Ballard's pictures in that group exhibition were "the best of the lot", though the dealer showed his ambivalent hand by rebuking Ballard's statement that figurative painting had no future. Roland wrote to Ballard that his bombast was "very shortsighted, for there is no-one who can foretell the visual experiences and adventures of the future."[10] In the same letter Roland also showed concern about Ballard's bouts of depression which prevented him from working. But Roland was able to relay positive news that William Johnstone, the respected and energetic Scottish abstract painter, wanted to meet Ballard for the purpose of offering him part-time teaching at the Central School in London. That the artist appears to have never taken advantage of this illustrates his loyalty to home life in Liverpool and his reluctance to exploit career opportunities in the south. Nonetheless, a week later Roland wrote offering Ballard a one-man show in July 1959 that would supplement an exhibition of important French drawings on a separate floor.

Henry Roland justified the proposed summer slot as being a good time because "the critics have plenty of space to write, secondly, there is a wave of American visitors." Events did not bear these words out because according to Roland the exhibition was "a complete flop".[11] The American buyers evidently did not come though two sales were made late in the show and the gallery partners stood behind their artist. Further support came from Josef Herman, a figurative and expressionist painter who was by now

a regular exhibitor at the gallery. "I personally and also Delbanco have become increasingly fond of the quality of the pictures and, curiously enough, by far the best comment we received on them came from Josef Herman, who liked the colour and the poetic content."[12] Roland suggested that the clients for abstract pictures "seem to expect something with more decorative qualities, that is lighter pictures." The heavy northern tonalities of Ballard's work, in both its representational and its abstract guise, had a greater appeal, therefore, to Herman's taste, which was more inclined towards the German and northern rather than the French and Mediterranean strains. Keith Sutton confirmed this when writing of Ballard's work as being "clearly romantic and emotional in origin."[13] The *Times* reviewer called Ballard's work a "judicious variation" on de Stael, with "dusty blues and rust reds forming a sombre basis for loosely formal constructions,"[14] a comment that once again confirmed Ballard's continuing links with Paris.

Ballard's own correspondence to Roland at this moment refers much to Jack Smith, the Sheffield-born 'kitchen sink' realist painter who had won the first John Moores competition on Merseyside in 1957. Roland was able to use Ballard's interest in Smith to make constructive criticism once again. Roland felt that Smith had a "certain connection with the world that surrounds us, which you seem to have given up . . . moreover they [his paintings] have a quality of light, which makes the spectator feel good, not depressed." One obvious feature throughout Roland's correspondence was that he could lay down advice and mete out criticism from within, but would not endorse or tolerate attacks from outside the extended R, B & D family. Hugh Scrutton, director of the Walker Art Gallery, was not really an outsider, but the gallery in London maintained a guarded front against such critics, whether from Ballard's backyard or not. Roland wrote to tell Ballard about Scrutton's criticisms based on the fact that he "thinks — and I left him in no doubt that I don't share his opinion — that you have not made progress owing to the fact that you try at all costs to be contemporary."[15] Ballard's adventure with Roland's gallery came slowly to a halt with the new decade, and his output of work underwent a decline and a marked change of style. His first wife Barbara, to whom he was very close, was diagnosed as having cancer and after a prolonged illness she died in May 1966. He was much affected by this. Stylistically his painting underwent changes of a kind that suggested a response to the revival of figurative imagery ushered in by Pop Art.

The late 1950s saw the establishment of the bi-annual John Moores exhibition, and refocussed Ballard's attention on Liverpool. While successfully jumping the final selection hurdles for the first three John Moores exhibitions, Ballard was unable to impress Scrutton, or other judges like Alan Bowness and Eric Newton in 1959 or John Moores and Robert Melville in 1961 that his work was sufficiently original or up-to-the-minute

to win a major prize. For all its personal qualities, Ballard's work from the 1950s was of its time rather than in the vanguard of it, and by the early 1960s started to feel a little obsolescent along with abstract painting generally. The 1959 Moores exhibition included a section for young French artists practising in the by now accepted 'School of Paris' style. Equally relevantly, William Scott's *Blue Abstract* (Walker) and Peter Lanyon's *Offshore* (Birmingham Art Gallery) made great impact, while Ballard himself exhibited a typical landscape abstraction alongside *Summer Painting* by his brilliant student Stuart Sutcliffe.

Lanyon and to a lesser extent Scott were members of the so-called 'St Ives School'. St Ives was enjoying its heyday in the later 1950s. Ballard made a number of prolonged working visits to the art colony during this period, though he found the ambiance a little precious and rarefied. Nevertheless the famous colony was still enjoying — or suffering from — impassioned rivalries, and the Liverpudlian found the community there "racked by divisions". He was also disappointed that "it wasn't as open as one would expect it to be."[16] On one occasion he went down with former students Don McKinlay and Alan Wood (who later settled there) but found Frost and Heron obsessively preoccupied with preparing for an exhibition. One northern painter, Stockport-born Alan Lowndes, settled in the colony at the end of 1959 only to find that, in contrast to the earlier visits he had made when artistic camaraderie was at a peak, the cohesion of the artistic community had been disrupted by a new careerism and opportunism in response to growing professional reputations then in the making. All the same, Ballard greatly admired Peter Lanyon's work with its energetic handling and fusion of abstraction and naturalism, and drank with him in Liverpool pubs when the Cornishman came north to adjudicate on the John Moores panel and also to undertake the large mural for Liverpool University's Civil Engineering Building. Roger Hilton was another St Ives painter whom Ballard knew, and in many ways they became kindred spirits for a while. Hilton's 1963 trip to Liverpool was distinguished by the notorious episode when, anticipating the prize for that year's Moores exhibition, he interrupted the Mayor's speech and broke all the rules of public decorum and civic formality with a drunken outburst. On another occasion Hilton introduced Ballard to Serge Poliakoff during the latter's exhibition at the Tate. Ballard went 'clubbing' in the King's Road with Hilton, and they later went on a trip to the Romney Marshes together.

Not long after his association with those St Ives artists who formed a stylistic link with both Paris and New York, Ballard lost heart with abstraction and returned to imagery. It is unlikely that he was directly inspired by Sam Walsh or Adrian Henri in the 1960s for he had serious arguments with them, particularly with Henri over unorthodox teaching methods that included the introduction of performance art on Hope Street and the

substitution of commercial objects for study for the life model. However, Ballard's work did show some adaptation of the spirit, if not the style, of the swinging new decade. Styles did not change overnight and the osmosis of influence was always much more subtle and unconscious than art historians with their pigeonholing minds sometimes make us think.

Indeed, Roderick Bisson still detected the dominance of the abstract rectangle among the leading painters in the Liverpool Academy's 150th anniversary exhibition of 1960. "Most of the abstract artists," Bisson speculated, "are toning down their individuality in favour of impersonal variations on an accepted theme." Although these same artists were the best then working on Merseyside, he felt that the undeniably eloquent style had reduced content to a "meagre" level. Indeed, Ballard's contribution to the following year's Moores exhibition, *Slate Landscape*, represented a work whose style was of his 1950s period. That year's prize-winning painting, Birkenhead-born Henry Mundy's *Cluster*, was a non-figurative picture that marked a new direction within the ongoing 'tradition' of abstract painting — that is to say, a swing away from the nature-bound, abstract expressionism of the St Ives middle generation towards an urban, plastic abstraction practised by London-based artists of the 'Situation' group. But a St Ives painter, Hilton, won the '63 Moores prize with a freely handled abstract. By 1965 the pendulum seemed to have swung back to impersonal abstraction, when Michael Tyzack won the competition with a quintessential piece of sixties hard-edged 'field' painting. This was a work that echoed the art of Robyn Denny in London and John Edkins in Liverpool. It was not until 1967 that a thoroughgoing 'Pop' picture won the Moores. David Hockney's swimming pool composition encouraged a new alliance between flat colour and rigid photographic composition on the one hand and highly realistic subjects on the other. Maurice Cockrill, John Baum and later Sam Walsh carried on from this point.

Arthur Ballard was always a highly sociable artist who enjoyed art societies and clubs. He regularly visited the Chelsea Arts Club where he was able to keep in the swim and learn of the fortunes of many colleagues, past and present. (In the late '80s he had an exhibition there of watercolours that depicted rivers and picturesque bridges in rural parts of North Wales.) In 1965 he showed his relish for community involvement by becoming president of the Liverpool Academy. In view of his first wife's terminal illness it was a responsibility bravely undertaken. But he took over Nicholas Horsfield's position with verve and enthusiasm. In the autumn of 1966 Ballard married Carol Taylor, one of his former students. Starting a new family also diverted his attention away from the politics of self-promotion. However the marriage, which lasted until 1979, inspired an interesting series of nudes sometimes based on old master themes but always using his beautiful part-English, part-Red Indian wife as the model.

Ballard attacked the job of Academy president with all the passion one would expect from a loyal Liverpudlian. In spite of this, and vociferous campaigning on behalf of Liverpool's generally neglected artists, he was unable to stop the decline of a truly historic Academy and ultimately its demise in 1981. Timothy Stevens, director of the Walker from 1971 to 1987, made it tougher for Liverpool artists to show at the gallery. He did this by imposing meritocratic selection criteria with tougher all-round standards. Local favouritism gave way to a wider competitiveness.

Ballard had rather different ideas at the time. As president he wrote about the situation of the Academy in particular and Liverpool artists in general for *Outlook*, a University of Liverpool bulletin published in spring 1968. After outlining the long history of Liverpool's premier art organisation Ballard concluded that recent policy of the 1960s had been aimed ''to encourage the work of any artist who shows a real involvement in the problems of expressing the ideas of his time.'' But the problems of achieving an authentic contemporary statement were compounded by the nature of Liverpool's provincial situation. Ballard explained this clearly when writing that ''Liverpool has lost many talented men and women to the capital. Unfortunately few who make a reputation because of their special Liverpool flavour, live here after attaining success. If we are to achieve anything really worthwhile something has to be done quickly.'' The hazards of not moving on to the capital after initial success become only too clear when we consider Ballard's failure to capitalise on his real early successes at Roland's gallery in London. George Jardine's work, while using modernist devices such as surrealist collage, is accessible to a wider audience than abstract art. Consequently he was able to build up a local following. In contrast, Ballard's abstract style, rooted strictly in the taste of the period when it evolved, required an informed cosmopolitan audience. Only London could adequately provide this. Maurice Cockrill's successful move south in the early '80s is a striking example of the professional advantages of such a move.

Ballard's presidential address in *Outlook* deemed the John Moores exhibitions to be of ''untold value'', but he needed more than a biannual exhibition to stimulate the local scene sufficiently. In the late '60s he proposed a kind of artists' club, modelled on the old Dover Street I.C.A. His vision was of a club and exhibition centre where local talent could be monitored and where Liverpool's isolation could be eased with incoming exhibitions. He complained about lack of grants and premises — the latter deficiency no longer a problem with all the empty, boarded-up buildings that symbolise the stagnant economic condition of Liverpool since the year of the Academy's death and the Toxteth riots. Happily, the kind of focal point that Ballard advocated has to a greater or lesser extent been provided by a revitalised Bluecoat Gallery, complete with bookshop and restaurant.

43

Arthur Ballard Punch and his Judy. *Oil. See colour section for another painting in this series.*

There is also the Tate Gallery at the Albert Dock, the Merkmal and Acorn Galleries.

During the 1970s Ballard produced a spate of highly figurative pictures using his wife as the model. Carol was much younger than he was, and he used this as a provocative theme in paintings that show the older man, wearing nothing but a pair of menacing sunglasses, perched alongside the young beauty who lies languidly across the bed looking out at the audience. In one version, *Punch and his Judy*, a goggle-headed Ballard points from the picture plane at the spectator, implying that the spectator is a voyeuristic and perhaps even disapproving intruder on the socially slightly controversial scene.Perhaps the rose and stem on the foreground bedding are an inciden- tal metaphor for the generally thorny moral question posed by the painting. On a formal level, Ballard is also making play on painting's ambiguous situation as flat and two-dimensional (paint on canvas) on the one hand, and a mimetic representation of three-dimensional reality on the other. The paintings of this series are exceptionally well executed. The excellent life drawing of the nudes is handled with fluent, confident flesh tones, while the art historical pastiche of Manet's *Olympia* adds a further twist to the episodic character of the theme. There is a further pun in the work's title, which refers to the artist's earlier career as a punch-happy boxer. There is no doubt that marriage to a younger woman gave the ageing artist a new lease of life and stimulated a very worthwhile figurative phase within his *oeuvre* at this juncture.

At the end of 1974 the Walker put on 'Communication', an exhibition sponsored by the *Liverpool Daily Post* and *Echo*. Paul Overy, reviewing the exhibition for the *Times*, reproduced Ballard's *Punch and his Judy* on a large scale. Overy noted that, "He's old enough to be her father. Private lives are made provocatively public."[17] The provocative, public nature of changing personal mores is a factor that the individual members of the Beatles — as part of the wider permissive movement of the 1960s — had made very apparent. As prejudices came down so the 'stars' of that time could, with the help of the media, claim provocative publicity for their private lives. In spite of the permissive '60s Overy could write, in 1973, that the Ballard picture was a "subject which might still shock some." Adrian Henri had encouraged fellow Liverpool artists to paint pictures based on old master themes at this time, so it is possible that Ballard's clever idea may have been initially stimulated by this particular call. Not surprisingly, Overy found the figurative art in the exhibition to be of much greater interest than the abstract or conceptual pieces, which he hinted were excessively "to do with national (and international) trends in art." The figurative art was considered not "to have anything at all to do with local happenings," though Overy did note that the private lives of the artists were sometimes depicted in the classic manner of autobiographical narrative

painting. In addition to the instance of Ballard's *Punch and his Judy* series, the earlier work of Cockrill, McKinlay, the blow-up portraits of Walsh, and the work of Henri all showed a tendency to draw directly on autobiographical themes, thereby tapping the rich vein of subjectivity that is at the heart of all art.

There seem to have been two sides to Arthur Ballard's position within the Liverpool art scene. The private and public aspects of any artist's life came often to intertwine in confusing ways. For some he was the object of a love-hate relationship. He had his ups and downs, and no-one was left in any doubt about this. The outer persona of belligerent ex-boxer, abrasive, left-wing Liverpudlian and uncompromised visual artist, contrasted with his placid, reflective moods, when he became the most supportive of art teachers. He had a belief in younger artists' work and moved mountains to protect them against bureaucracy, detractors or any adverse circumstances. In the final analysis he has to be remembered as a most powerful character, the pivotal member of the post-war Liverpool art scene, and a gifted artist who put family and friends firmly before vanity and the shallow ambition of fame. Ballard was not one to sell out. History should remember that before finally judging his contribution to an important period in Liverpool, and British, art.

NOTES

1. Conversation with the author. Corwen, North Wales, September 1990.
2. ditto.
3. Henry Roland to Ballard, letter dated 3.5.57.
4. ditto 14.8.57.
5. ditto.
6. *The Times*, 10.1.57.
7. *Art News and Review* 1955, Edgar Sand, 'The Steep Way Up'.
8. Roland to Ballard 18.8.58.
9. *Observer*, 25.1.59, Neville Wallis.
10. Roland to Ballard, 21.1.59.
11. Roland to Ballard, 16.7.59.
12. ditto.
13. *Art News and Review*, July 1959, Keith Sutton.
14. *The Times*, 8.7.59.
15. Roland to Ballard, 20.7.59.
16. Conversation with the author, September 1990.
17. *The Times*, Paul Overy, 19.12.73.

Pop goes the easel: Sam Walsh

In many respects the wind that deserted the sails of Arthur Ballard's ascendant career at the end of the 1950s reflected a great seachange in international art. The romantic auto-expression of the informal abstract and tachiste schools in Paris, New York and Cornwall gradually lost vanguard status to proto-Pop, neo-Dada, post-painterly abstraction and of course to Pop Art itself. Also, the high ground of modernism itself came under attack. What we now, sometimes narrowly, refer to as 'Post-Modernism' was a much wider tendency that began in modernist painting's own heyday. The attack on accepted aesthetic standards, on formalist language (be it abstract or representational) and on a philosophical modernist tradition came in many shapes and sizes and from many quarters. Ballard belonged to an early post-war group which was educated in the classic traditions of painting, but which subverted conventions of representation and developed a high-minded approach to the cult of painting based on gestural expression, pronounced *matière* and 'metavisual' forms conjured up with direct existential energy. Its avant garde status would soon be open to attack because such an ethos of painting, particularly one shorn of subject matter, was a kind of entrenched formalism and even academicism.

Ballard's rebellious student John Lennon, unknowingly a symptom of a post-modern disaffection, deemed that avant garde was "French for bullshit". The appearance of a new generation possessed with an independence of spirit clearly came as a threat to Ballard, and no doubt to some of his contemporaries. The challenge showed up Ballard as a formalist of the old school. In a feature article on his former student, Ballard declared that Lennon "had talent. If I'd had my way he'd never have left and become a Beatle." If he'd had his way Ballard would have restricted an unusually wayward creativity and hindered it from finding its eventual expression as a leading force in a social revolution.

The stylistic eclecticism that is a salient feature of much art since the sixties is therefore a symptom of the deconstruction of a monolithic culture mainstream. Perhaps the new pluralism was visual culture's survival response to the uniforming effects of the McLuhanist media revolution. In the catalogue introduction for Sam Walsh's large memorial exhibition, held in the early months of 1991 at the Walker, Adrian Henri put all this very succinctly. He wrote that "Liverpool in 1960 had a flourishing Academy . . . the John Moores Liverpool exhibition had started in 1957 . . . the

47

prominent local tone was Parisian, concerned with informal abstraction, and dominated by the charismatic figure of Arthur Ballard; the situation was ripe for a take-over, by Walsh amongst others.''[1]

Sam Walsh was a much loved Irish Liverpudlian pop artist who worked from pop culture photography and who displayed virtuoso skills both with commercial techniques (like the spray gun) and with traditional media (like the pencil). He settled in Liverpool during 1960. The '60s libertarian wind of change opened the door to Walsh who, having spent the second half of the '50s drifting in London, was able to enter C.F. Mott College on a three-year teacher training course in 1962. This course opened up the teaching profession for the first time to many disaffected working-class men and women who hitherto had been denied access. The expansive opportunism of the period, together with the growth of social sciences, gave a radical edge to education. The anti-establishment tone was set by the London School of Economics. Hugh Adams explained that ''Sociology . . . boomed as an academic discipline,'' and yet the new social objectivity was accompanied by ''a discernible willingness to suspend an intellectually rigorous, critical approach on the part of artists.''[2]

Pop art itself therefore was never overtly political, settling instead for an ironic commentary on art history and contemporary culture. George Melly stated that there were ''politically activist pop fans and even pop artists, but they are few in number and in effect political activists who like or play pop.''[3] Indeed, on very few occasions did Walsh's work allude to his Irish Republican roots, one example, *Ambush Party* (1966), possessing more the ambiance of a Hollywood stage set than a connection with the realities of the Irish struggle. The picture was described in consequence as being a ''gesture of remembrance''[4] to the Easter Uprising of 1916. Similarly, Richard Hamilton, the father of British Pop, only introduced socially sensitive themes when his own moral conscience had been pricked. Gaitskell's nuclear policy and Mick Jagger's drug arrest provided rare examples of such themes in his work.

The provinciality of Liverpool was abated by the general current of social change and by the emergence of the Beatles out of a local, if distinctive, Merseybeat scene. Their spectacular rise to global prominence in a couple of short years put Liverpool on the map, and popularised a spirited city that was actually in relentless economic decline. While injecting much needed confidence, the success of the Fab Four, together with a host of other music bands and entertainers, must have left a vacuum in a city that by the mid-'60s had been largely abandoned for the allure of 'swinging' London. Sam Walsh's entry into Liverpool was important for a small, but robust and self-perpetuating, art scene that while being proud of its past, was also for a time noticeably responsive to the present. The biannual John Moores exhibition from 1957 onwards, a contemporary-minded local

Academy and a vibrant art college to some extent mitigated a provincial situation.

The conflicts between provincial reality and the allure of a cosmopolitan mainstream were at the heart of Sam Walsh's position as a painter. His art is underpinned by a confused set of premises, manifesting themselves in unresolved stylistic and thematic problems. Yet he was a gifted, if at times careless, technician. On top form he produced memorable images, well crafted paintings, and above all relevant statements that give him a warranted, if peripheral, place in Pop's hall of fame. As often as not, fame was a theme that actively motivated Walsh's imagery. He did not display the same will to fame that drove Adrian Henri's multi-faceted project as a painter, poet and performer. Yet to use Anthony Storr's distinction between the schizoid and the manic-depressive creative personalities, Walsh revealed the latter category's need for the approval and feedback of an accepting audience. He compromised his portrait painting by undertaking commissions from local professionals, dignitaries or friends. The uneasy mixture of such portraits with his detached, photo-derived images of world celebrities (whom he had never met) added a note of incoherent mismatch to his overall project as a portrait painter.

In contrast, the New York Pop maestro Andy Warhol was able to raise portraits of anonymous executives to a uniform level of celebrity. Certainly, in Walsh's case, one can excuse the comissioned portrait painting as the result of succumbing to sheer economic pressure and in fairness the artist was frequently less than happy with the results, as was the case with the early Lady Entwistle and late Paula Ridley portraits. In retrospect, Walsh can be seen as a protagonist, whose undoubted gifts as a painter and whose personal charms (he had no enemies) came up time after time against the antagonistic circumstances of Liverpool's economic and cultural decline. Professional patrons, such as his friends within the university, hospital and local government hierarchies, were a great support in an economic and emotional sense, but were not always the best critics of his work.

Arguably, Walsh will be best remembered for his blown-up portrait heads of a kind that ape the scale and immediacy of adolescent pin-ups in bed-sit land. Bed-sit land was Walsh's domain, he was a Bohemian and well suited to the Liverpool 8 district where he lived for much of his earlier life on Merseyside. George Melly explained that this Bohemian quarter "provided cheap rooms and flats for a colony of native artists, musicians, poets and layabouts." The decaying Georgian area was one that in London "would certainly have been reclaimed by the trendier middle classes."[5] The problem with Walsh's Bohemian character and affable Irish sociability was the incessant drinking (a manic defence perhaps) and the fact that it endeared him to people who inadvertently encouraged him in his self-destructive lifestyle. Again Melly is useful in locating Walsh's position as a

serious fine artist in an engulfing tide of popular and commercial culture when he wrote how "'high' pop is only interested in depicting the objects which obsess it at one remove; that is in imitation of the way they have already been formalised in 'low' pop."[6] The pin-up poster, produced by the commercial arts for mass consumption, popularised heroes and idols of the '60s. Both Peter Blake and Andy Warhol, as well as Sam Walsh, made ironic use of already current images of the Beatles as reference points for their own more elevated depictions. In the early portrait of Paul McCartney, whom he had known on the early '60s Liverpool scene, Walsh uses an image taken from a secondary source, that is a photograph. The oblique title *Mike's Brother* accentuates the indirectness, though also reveals in an honest way the fact that Walsh had known Mike McGear — Paul's brother — far better than the subject of the picture himself. The basis of Walsh's claim to being a genuine contributor to Pop Art is clear in this early work which contains all the irony, detachment and allusion to a mass-produced image of a subject rather than the subject itself.

A crucial point about Pop Art is made by the distinguished American critic Barbara Rose when she pinpoints the specialised and elevated context of the fine artist who begins for the first time to plunder the humbler visual culture of the popular media and the commercial arts. Yet Pop Art was not the same as popular art, the latter a category defined by R.H. Wilenski in his illuminating book about the modern movement. Wilenski defined popular art as being sentimental, weakly fashionable or erotic. The use of popular or debased imagery by the sophisticated fine artist was therefore for Rose "the irony at the heart of pop art."[7] The same writer referred to the way that the sophisticated Pop Artist "appropriated the techniques and images of commercial illustration and advertising," while retaining the detached, parodying and critical tone reserved for the elevated ambiance of fine art. In Sam Walsh's case such appropriation assumed relatively discreet proportions, suggesting he was influenced by such tendencies rather than having a total commitment as an originator of them. His presentation of larger-than-life faces that take up most of a large picture plane conformed in the most general way to a basic feature of most 1960s art, namely, the creation of a gestalt effect from a singularly cogent overall image, immediately graspable in one moment. The effect needed to be immediate, however complex the formal relationships may have been within the complete object itself. Rose explained that in the 1960s "artists became involved with instantaneously communicated images during a decade when the present was exalted over the past by a youth-oriented, tradition-defying, anti-authoritarian culture."[8]

Walsh's discretion was such that he never drew undue attention to the fact that photographs were the source for many of his paintings. Neither was the ever more sophisticated handling of commercial techniques blown

out of fine art proportions. He made use of mechanical techniques such as an episcope, allowing the exact projection of photographic imagery onto a blank surface. He used aerosol cans, compressors and air brush to dispatch paint automatically across the canvas. And he sometimes used car enamel and cellulose paints. In the American photo-realist tradition of Richard Estes, Malcolm Morley and Chuck Close such techniques were used to produce a certain precision of image implicitly taken from snapshots rather than real life. It all added up to what George Melly detected was modern art's tendency — epitomised in collage, cut-outs, *objets trouvés* and screen printing — to emphasise "the relative unimportance of the human hand in the creation of a work of art in the twentieth century context."[9] When Walsh used well known, art historical themes they came less in the form of brash parody than gentle copyism. One feels that Walsh's occasional choice of such themes was motivated by the appeal of poetic narrative rather than a need for provocative art historical paraphrasing. John Clem Clarke's copies of old master subjects, Lichtenstein's mechanical parody of Léger and the Cubists, Warhol's subversion of the most famous picture in the world, the Mona Lisa: these were far too brash for an artist of Walsh's more gentle intention. As the 1960s wore on, the Irishman was instead moving closer to the post-'60s style of photo-realism, another instance of his adaptability, uncanny ability to stay in the swim and enduring formal interest in the photograph.

Walsh's career-long flirtation with photography as a source for his painting expressed itself in several ways. Earlier on, he chose a fluid, gestural approach to paint the portraits. The paint frequently dribbled and the flesh tones and anatomical features were constructed with loose gestures of the brush. The photographic or cinemascopic sources for the facial images were acknowledged by the use of a white background with the loosely handled paint imitating the wet textures of the developing room. The amplified scale aped the cinemascopic, silver screen format. In later years the allusion to photography becomes subtler with a photo-realistic control and clarity of detail and with a sprayed paint texture of such refinement that the effects of the flashbulb or electric lighting on domestic objects are vividly conveyed. Never did Walsh aim at a deliberate and literal pictorial representation of a photographic format. Both David Hockney and Malcolm Morley surrounded their respective swimming pool and ocean liner pictures with a pronounced border that would emphasise the polaroid and postcard sources of their paintings. Yet no photograph has ever, as an independent work of art, attained the cultural significance or universal recognisability of a painting like the Mona Lisa. Artists like Warhol have needed to use photographs only as an aid, a tool towards an artistic end. It was not the photograph that was the chief area of interest but its reproductive power to popularise the subject of a photograph — a celebrity, a disaster, a banal

object, a mass-produced image and so on. For all the cultural interest loaded in photographs, Walsh more than most had an esoteric interest in the formal content of photography, such as the surface effects, focus shifts, perspectival tricks, accidental blemishes, psychological impact and so on.

The three greatest formative influences on Sam Walsh seem to have been Francis Bacon, David Hockney and Andy Warhol. Bacon exerted a mercurial influence on younger artists at this time, though one suspects that the inimitable Bacon influenced his fellow Irishman on account of temperamental rather than purely formal factors. It is true that Walsh attempted Bacon's easy virtuosity of handling, the sense of conjuring an unfocussed image in one fell swoop out of the substance of the paint itself. As late as 1976, in his *Man with Suitcase*, Walsh presents an Edward Muybridge-inspired human figure in the extraordinary squatting posture that the photographer favoured in order to emphasise the hidden strangeness and versatility of human movement. Muybridge's photographs were an important source for Bacon's wild human zoo, and so it is probable that in *Man with Suitcase* Walsh was again making an indirect reference to one of his early heroes. The nude sitter, or rather squatter, in *Man with Suitcase* also wears a self-conscious grin, aware that he has been caught in a candid moment. He gropes for the suitcase as if quickly to find some clothes. A nude girl is caught in a similar moment in another spray painting in the collection of Bob Simm. Such themes also clearly relate to Allen Jones's and Richard Hamilton's series of surprised women.

Walsh's *Burnt Torso* (1961) is a tactile, densely textured rendition of a figure. The influence of Bacon is apparent as indeed it is in *That's Red Down There* (1962). Walsh uses Bacon's compositional device of locating a nude figure at the junction point of two confining walls and a floor. *That's Red* was exhibited in the year of its execution at the Hope Hall Gallery, where it was purchased by George Melly. The picture is notable for the way it heralds another important though probably less conscious influence, that of David Hockney. Smeared paint is used to give the effect of movement. Whimsical imagery first seen in *That's Red* and then in *Adjust the Horizontal Hold* (1962) is another link to Hockney. Hockney's freewheeling pictorial approach, breaking down academic codes and rules, was inspired by a large Picasso exhibition at the Tate Gallery in 1960 which as an enquiring student he had seen. It has been suggested that at the time Hockney was disturbed "by the apparent lack of content in abstract art, but not yet ready to reassert figurative references for fear of appearing reactionary, Hockney found in words a way of communicating specific messages without confronting the dilemma of illusionism."[10] Carel Weight encouraged Hockney to leave abstract art alone and try etching in the college's print department. This he did under the guidance of Julian Trevelyan and discovered his true talents as a graphic artist.

Sam Walsh That's red down there. *Oil. Coll: George Melly.*

Sam Walsh Emmett
Dalton in Hollywood,
*1965. Coll: Walker
Gallery, Liverpool.*

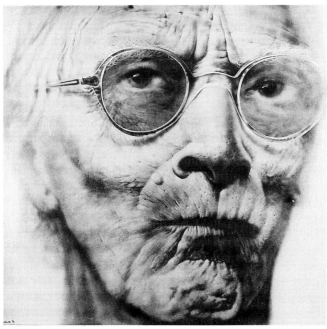

Sam Walsh Ivon
Hitchens, *1974. Coll:
Jackson and Canter.*

54

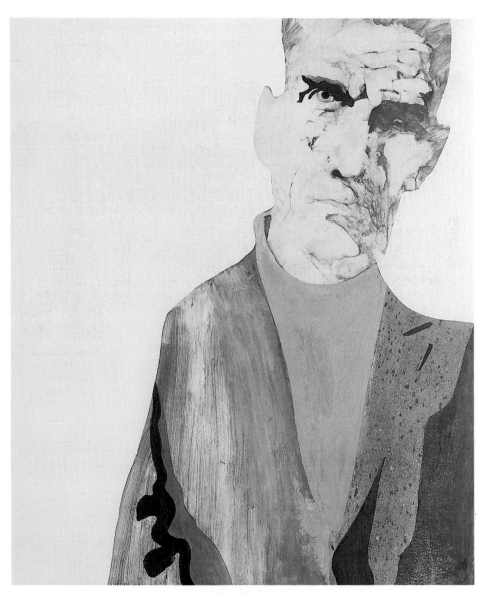

Sam Walsh Samuel Beckett, *1965. Coll: University of Liverpool Art Gallery.*

Hockney was also inspired by Dubuffet in the early 1960s, particularly by the ethos of painting that emulated the rawness and innocence of art by children or the mentally ill. Dubuffet's graffiti, a private hieroglyphic language made public, also had an effect. In the pictorial context it seemed to attack the safe standards and polite conventions of academic art. One cannot know with certainty whether Walsh had seen Hockney's *The Cha Cha that was Danced in the Early Hours* (1961) but if he did then it must surely have directly influenced *That's Red*. The untouched backgrounds of *That's Red* (coarse-textured hardboard) and of *Horizontal Hold* (rough canvas) are matched in Hockney's early 1960s pictures. The untouched areas serve to reduce illusionist depth and thereby to restate the pictures' flatness as autonomous objects. Oblique reference is made to the cult of tactility, evident in the informal abstract works of Tapies, Burri and Dubuffet. The introduction of lettering and the depiction of consumer objects like the tea packets of Hockney's *Tea Painting in an Illusionistic Style* (1961), presented Walsh with ways forward. The Mars bar featured in Walsh's *Horizontal Hold* clearly relates to the Ty-Phoo packets in the Hockney, or the toothpaste tube of Derek Boshier's *First Toothpaste Painting*.

If any further evidence were needed of the important links between Walsh and Hockney then it is provided by the fact that the Yorkshireman was every inch as in awe of Bacon as was Sam. Hockney had been impressed by a Bacon exhibition at Marlborough in 1960. Bacon's rejection of pure abstraction as a decorative cul de sac carried with it the implication that painting needed to act directly on the raw nerve of sensibility and real experience. Expressionism in its broadest guise was the best vehicle for this though both Hockney and Walsh would soon resist Bacon's journey into full expressionist rawness. In the early 1960s both burgeoning Pop painters were looking for ways to invest figurative painting with the tough plasticity and object-quality that had hitherto best been emphasised through the textural cogency and visual punch of informal abstraction. Jasper Johns's flags and targets led the way to investing the pictorial work with the status of an independent object.

What Walsh could not carry with Hockney and Bacon was the increasingly fashionable and therefore advantageous homo-erotic baggage of the gay world. Walsh was left in the conventional position of the 'straight' world, but he filled the void by embracing the encroaching influence of the media and new youth culture. Yet the subjects of Walsh's world — the portraits and genre scenes — are overwhelmingly male. Even the late, memorable *Dinner Party* — a private fantasy based on Millais' Pre-Raphaelite picture at the Walker — depicts all his friends and colleagues, the majority of whom are male. This does not imply any misogynous position; on the contrary, Walsh spent most of his adult life married to, or living with, a woman. But it does reveal, I think, the macho culture of

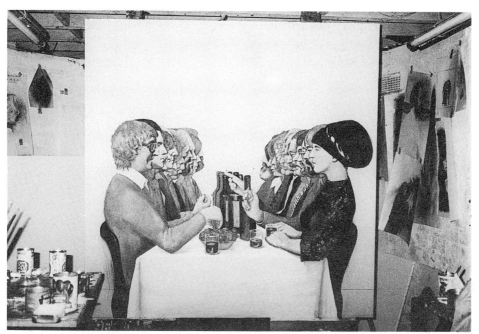

Sam Walsh Dinner Party (22 people and me), *1983, in the artist's studio.*

Sam Walsh.

proletarian Liverpool, Newcastle and Glasgow as being excessively male-oriented. The women are reduced to the cultural status of followers, mere adjuncts or support casts. The screaming girls of Beatlemania perhaps provide one illustration of this fact.

Sam Walsh's interest in a variety of art sources reveals an idiosyncratic, rather than systematic and intellectual approach to his art. He evidently admired a number of artists' work for an odd mixture of formal and thematic reasons. He shunned the overly intellectual, was impatient of prolonged discussion on art, and pursued very little art historical reading. At Walsh's funeral in early 1989, the deceased artist's friend and fellow painter Maurice Cockrill remembered seeing a library of books which contained no art history volumes, but novels by revered writers like Beckett, Joyce, Mailer and Burroughs. Walsh's portrait heads of Beckett, Burroughs, Hemingway and Auden were therefore in the conventional genre of homages to literary heroes, and as such were on the level of subjective reverence rather than on the objective Warholesque level of impersonal commentary on the literary genius as star. Walsh's probable motive was the portrayal of those great people who, through the more direct media of literature, drama or film, communicated the experiences and meaning of the human situation.

By the mid-1960s Sam Walsh was a driving force in a Liverpool art scene that prompted John Willett to write that Merseyside artists conveyed in their work "topical references, realistic elements and a certain humour."[11] Roderick Bisson went even further in explaining how art on Merseyside had developed with the changing times. "Three years ago," he wrote, "a picture was the playground or the battlefield for exuberance or neurosis. Now it assumes the alertness of a poster beckoning the passer-by with a message."[12] Walsh's portraits certainly contained the alertness of the poster, borne out by the fact that when he painted a portrait of the popular Cuban revolutionary Che Guevara, it became a trendy poster that was one of the icons of sixties pop culture. Although seduced by the psychological amplification given to celebrities by constant media reproduction, Walsh loved people's faces for their own sake. Using scale to express the larger-than-life aspects of fame, he was also thereby able to experiment fully with paint and texture. He had a romantic interest in the character of faces (particularly as blueprints for the ageing process). This moved him to 'pick up' on Francis Bacon's gently pronounced jaw (1963), Mick Jagger's lips (1964), McCartney's "mother's eyes" (1964), Samuel Beckett's long face (1965), and much later Ivon Hitchens' wrinkles (1974), Robert Mitchum's chin (1983), George Melly's grin (1985) and finally John Lennon's decisive nose and mouth (1987).

The Mitchum and Melly portraits were mechanically drawn from photographs projected through an episcope onto the sheet of paper or

canvas the artist was using. This device was not a cheat but was rather a deliberate attempt by the artist to cast himself in the role of a creator of secondary imagery siphoned through primary photographic or media sources. The choice of Mitchum was an outcome of Walsh's Hollywood interests. He enjoyed thriller films and from there developed an interest in neat, impersonal rooms where there is the foreboding of a violent upheaval which could disrupt the pregnant silence at any moment. Patrick Caulfield's interiors trade on the suspense of the empty moment, while Malcolm Morley's liner interiors would also have impressed Walsh. The shining metal handrails, impersonal decor and meticulous order of an empty room affected Walsh with their charged atmosphere and Caulfieldesque understatement, as we can see in the Liverpool artist's impressive *Private View* (1970).

Walsh's successes led to his election, in early 1965, as an associate member of the long-standing Liverpool Academy. That year's Academy selection displayed as many as six Walsh pictures. These contributions were recorded by Bisson in his *Post* review as containing the main points of controversy and interest in the entire exhibition. The emphatically sexual imagery of *Two Figures on a Bed* was cited as one example of the provocative nature of Walsh's humour. Eroticism frequently surfaced in Walsh's work, no more so than in the virtuoso spray painting with the enticing title *Summer Curtains* (1971) which features a couple making love in a corner. But other pictures in the 1965 sample contained hints of ritualistic violence (*Pyramid of the Sun*), homosexuality (*Three Figures in a Warm Climate*), Hollywood gangsters (*Emmett Dalton in Hollywood*). Such works are of considerable formal interest because they show that the artist had begun to use a loosely handled, landscape background as a foil to a hard-edged, stencil-cut foreground. The foreground figures were painted to look like photographic images cut out and collaged onto the naturalistic, thinly painted landscape backgrounds. In 1969 Walsh painted a curious picture in this vein, *Paul Cézanne on the M6*. Cézanne's cultural dislocation with his paintboxes on the edge of the M6 motorway, has an air of surrealist whimsy. Such whimsy surfaced again in his most notable late painting *Dinner Party*. Conveying all his friends — who in reality had never assembled together in one place — at a dinner table, Walsh perhaps adopts the idea of surrealist gatherings. Famous photographs of surrealist or abstract expressionist ensembles probably encouraged the idea behind *Dinner Party*. Another dislocation occurs in *Mao Tse Tung in Concert* (1969). This absurd subject plays on the correspondence between the Chinese leader's famous political handclap and a rock band's clapping during performance into a stage microphone. Both Mao and the music band use a piece of modern technology, the microphone, to address a mass audience. The subject of Mao may have provided Walsh with the opportunity to utilise, and subsequently subvert, one of Warhol's best know icons.

By early 1966 Walsh had already enjoyed a second exhibition at Lionel Levy's Portal Gallery in London, and also that year he was elected a full member of the Liverpool Academy. He repaid the honour of membership by showing five new pictures which Edward Lucie-Smith detected "combine influences from Schiele and Francis Bacon".[13] In the same article Lucie-Smith drew attention to Pop Art's "ironies and subterfuges" as opposed to the greater directness of contemporaneous pop music. Walsh and Henri were attempting, as visual art representatives of the Liverpool scene, to give plastic form to the music-generated excitement of the current pop scene. Lucie-Smith concluded that "it is still very difficult for an artist to represent his own experience directly — which is what the cultural climate in Liverpool seems to require."

In the next few years Walsh began to experiment for the first time with collage and spray gun techniques. His 1967 contribution to the Academy again numbered six items, among them a 'pin-up' painting of James Joyce. He also lent two works to 'Art in a City', the London exhibition at the I.C.A. that launched John Willett's book of the same name. Willett summarised Walsh's achievement up to this point by declaring that "no Liverpool painter has developed faster in the past three or four years and his paintings are in increasing demand."[14] In the 1968 Academy exhibition, held in that year's glorious June, Sam Walsh exhibited spray paintings for the first time. Bisson referred to this technical innovation as the "big brother to the commercial artist's air brush."[15] Among the Walsh sprays was a portrait of Roger McGough, a prominent Liverpool scene activist at the time. In the autumn of that year he began teaching Foundation Studies at the Liverpool College of Art, and celebrated the fact with another show at the Everyman Theatre. By the end of the 1960s Walsh had consolidated a hard-won reputation, with a deserved following, as a consistent producer of quality paintings.

With the aid of the spray technique, Walsh was able to produce some of his clearest images. The genre could still vary widely, from a Hockneyesque interest in modern decor evident in *Interior* (1968), *Private View* (1970) or *Summer Curtains* (1971), to the close-in view of physiognomy in *Ivon Hitchens* (1974). The Hitchens portrait parallels the work of the American artist Chuck Close. Despite its large size, Walsh's portrait conformed to his dictum that a picture should remain small enough after stretching and framing to fit into a taxi, the implication being that the taxi was the poor man's way of sending work to exhibitions. Close had no use for taxis or other makeshift forms of transit, as his much larger scale works reveal. Walsh showed greater willingness than Close to translate into paint the inconsistent focus or commercial gimmicks of photographic imagery. Close favoured the camera for its "one eye view of the world",[16] though he accepted that it was also possible to incorporate blurring or fleeting visual

effects into painting only because of photography's inherent ability to formalise and trap ephemeral lighting conditions. In contrast, Walsh's employment of imagery was less deadpan, tinged more with glamour, or at least a romantic kind of visual interest. The photographic source or poster format were the contemporary forms that best encapsulated such glamour or romantic interest. Close's deadpan use of the photograph was a self-imposed means of filtering the glut of potential imagery for his painting or printmaking. The American chose the photograph for more purely formal visual ends. Close's imposed limitations, a probable symptom both of North American puritanism and modernist formalism, showed up Walsh's work in a cavalier light. Adrian Henri confirmed that though he "was always an uneven artist, and had a fairly cavalier approach, Walsh made a peculiarly individual contribution to the revival of figurative art."[17] The Liverpudlian also, as a part of the romantic tenor of his project, strayed away from a strict Chuck Close-type involvement only with subjects who were friends. The whole point about Walsh's use of photographic sources was that they allowed him access to people whom he had never known.

Texture in Walsh's later work could either be a piece of illusionistic artifice or literally incorporated into the tactile surface of the work through collage or spray techniques. In *Affirmation and Negation's the Name of the Game* (1973), Walsh emulates Caulfield with a realistically painted surface that attempts to impersonate the actual granular texture of a shining, dark marble wall. The work is a high point in the artist's *oeuvre* and tries to dislodge in the eyes of the onlooker a sense of pictoriality. So vivid is the contrivance of an uninterrupted marble background that we are tempted to see it as an actual piece of marble. Richard Estes's photo-realist paintings of the modern American scene — streets, shop fronts, escalators and most importantly telephone booths — are recalled here. Estes's meticulously painted images of gleaming, stainless steel telephone booths are the obvious prototype for Walsh's *Affirmation and Negation*.

Most representational art is, of course, to some extent artifice and impersonation, but in this episode Walsh takes pictorial artifice to extreme lengths. Artifice is also at the heart of Walsh's topographic close-ups of terrain in which the artist used crumpled or creased paper and spray effects to emphasise the tactile features and visual incidents of, for instance, a small stretch of sandy beach or a rock outcrop. If not actually closing the gap between art and life, Walsh was at least operating in an ironic capacity within the no man's land in between.

Two later works return to Liverpool themes. Walsh's problematic relationship with the local art establishment led to *Our Leader*, a full-length portrait of Timothy Stevens (Walker director from 1971 to 1987), in characteristic garb of mackintosh. An apparently accurate characterisation of Stevens, the portrait was deemed to be "not without affection and

insight.''[18] The picture was once again based on a photograph, a fact advertised by the artificial lighting on wooden floorboards, dark brogues and reflective spectacles. Stevens imposed tougher standards on the local art community, who were no longer guaranteed an annual showing of their work on William Brown Street under the umbrella of the Liverpool Academy. Walsh's posthumous 1991 retrospective at the gallery does however illustrate the tradition of the Walker establishment for withholding the spotlight from its living artists. The other notable late painting, and one of the artist's last, is *Lennon*, based on the photograph taken by Annie Leibowitz at the ex-Beatle's Dakota apartment on the day of his assassination. The poignancy of this fact is nothing more than an implicit theme in the work, since knowledge of the photograph's dramatic context would have been known only to the most informed of Lennon's followers. With both the Lennon portrait and the other late canvases, Walsh made a number of preliminary drawings. Thus the artist worked his way up to the grand statement via the conventional route of a preparatory series. Nothing could be further away from the mechanical serialisation of themes and images that formed the basis of professional practice for many purist American artists of the period.

Walsh's openness to his times, his ambivalent position as a provincial artist conducting a dialogue with the cultural mainstream certainly led to the unevenness and cavalier approach referred to by others. But they also resulted in a happy balance within his work between good and bad taste, conformity and revolt, pastiche and originality, seriousness and humour. Throughout his work flow a moderating current, a humanism and a gentle wit that bring to the brasher aspects of mass culture the traditional values of the fine arts.

NOTES

1. Adrian Henri, *Sam Walsh*, p.5. National Museums and Galleries on Merseyside, 1991.
2. Hugh Adams, *Art of the Sixties*, p.9. Phaidon, 1978.
3. George Melly, *Revolt into Style*, p.120. Allen Lane, 1970.
4. Alex Kidson, *Sam Walsh*, p.31. National Museums on Merseyside. 1991.
5. George Melly, *Revolt into Style*, p.213.
6. ditto, p.128.
7. Barbara Rose, *American Art Since 1900*, p.184. Thames and Hudson, 1975.
8. ditto, p.207.
9. George Melly, *Revolt into Style*, p.414.
10. Marco Livingstone, *David Hockney*, p.18. Thames and Hudson, 1981.
11. John Willett, *Liverpool Post*, 19.3.64.
12. Roderick Bisson, *Liverpool Post*, 6.6.68.

13. Edward Lucie-Smith, *Studio International*, August 1966.
14. John Willett, *Art in a City*, p.182. Methuen, 1967.
15. Roderick Bisson, *Liverpool Post*, 6.6.68.
16. Chuck Close, *Art in America*, November 1972.
17. Adrian Henri, *Sam Walsh*, p.5, 1991.
18. Alex Kidson, *Sam Walsh*, p.40, 1991.

Merseyside sculpture: the public view

Merseyside possesses both an abundance of public monuments and an un-expected richness and variety in the principal public and private collections. This sculpture legacy owes much to publicly-minded, philanthropic businessmen and shipowners who operated in a time of great prosperity on Merseyside. Despite a gradual decline throughout this century the Mersey was still a bustling shipping channel afloat with ocean liners and large cargo vessels as recently as the 1950s. The wealthy businessmen collected art, much of it later dispersed among local museums or other public institutions. James Smith, the wine merchant, stands out prominently in the earliest years of our century; he left his fine collection of six bronzes by Auguste Rodin to the Walker Art Gallery in the 1920s. They were acquired not through his Liverpool connections but as a result of an involvement with the Glasgow art scene, where he knew painters and dealers, in particular Alex Reid. In 1903 he met Rodin in Paris and purchased from him a marble, *Mort d'Athènes*, to be later bequeathed to the Walker Art Gallery along with the other pieces in 1927. In later years sculpture patronage tended to come through ecclesiastical, academic and architectural channels, highlighting the growth of institutional patronage on Merseyside from both the Anglican and Catholic church, an expanding university and a progressive architectural establishment.

Perhaps the most legitimate line of enquiry in this survey of sculpture involves looking at two factors: how locally born or trained sculptors fared in their subsequent careers, and how others settled in the region and developed in what has been a provincial context. The extent to which both categories depended for success on nurturing professional links outside Liverpool in the fluctuating economic climate is also worth consideration. Later, Arthur Dooley and Sean Rice are used as case studies to see how indigenous sculptors dealt with these factors. Despite its provincialism — provincial, that is, to London and the heartland of western Europe — Liverpool has always displayed a vitality and cosmopolitan outlook befitting a busy port on the Atlantic seaboard. Perhaps this explains the large amount of public sculpture by non-Liverpudlian artists. This is particularly apparent in the University's collection. According to Janice Carpenter, the collection was assembled as a 'monument to the determination of the University and its benefactors to provide its students with an education in the culture as a whole, not simply in their chosen subjects.'[1] The collection

of post-war sculptures, including good examples by Frink, Phillip King, Hepworth, Epstein and Hubert Dalwood, offers a stimulating contrast to the Walker's earlier neo-classical sculpture and the statues of dignitaries in St John's Gardens. An informative and scholarly study of the history of Merseyside sculpture is *Patronage and Practice* — published in 1989 by the Tate and the National Museums on Merseyside.

It is possible to summarise the history of twentieth century sculptural patronage and practice on Merseyside by treating the two world wars as the cataclysmic events that triggered distinctive periods of sculptural activity. To suggest that the wars themselves gave rise to significant sculptural styles is plausible only if we associate, indeed confuse, style with content. But it is certainly not the intention to suggest here — as Peter Fuller did in his more controversial moments — that significant, as opposed to derivative or decadent, art could be produced only in times of strife, warfare or disaster, as if traumatic shock to the collective consciousness was necessary to liberate true artistic feeling. What is plausible, though, is that the aftermaths of the two wars created social moods that conditioned the premise and practice of sculpture. The 1920s were the great era of the war memorial; the fact that the countless memorials erected to the ''war to end all wars'' were seldom emulated after the 1920s, and certainly not after the second war, is attributable to popular perceptions of, and social attitudes to, the nature of war itself.

The less intimate, technological warfare of the 1939–45 conflict led to the adoption by the combatants of a more pragmatic stance. This differed greatly from the mood of romantic chivalry and unthinking heroic sacrifice that characterised the last of the great imperial wars. The simple goal for the western nations in the second war was to win the war and impose a new democratic, international order. Despite a spirit of reconstruction and optimism in the immediate post-war years, the realities of a developing cold war between East and West soon tempered the mood. The atomic age brought new tensions, social as well as political, and the critic Herbert Read labelled sculpture's responses to such anxieties as the 'geometry of fear'. The threatening, brutalised imagery in the sculptures of Butler, Armitage, Chadwick, Paolozzi, Turnbull, Meadows and Frink not only convey an anxiety engendered in part by the spectres of possible atomic warfare. The works also allude to the fragility of human values in the new cold war context. Yet belief in the positive value of technological progress and a desire to break with the past also led to a more constructive and archi-tecturally conscious kind of abstract sculpture. A universal but impersonal and clinical approach to form characterised Barbara Hepworth's serene, classical vision. In this vein a number of sculptures were commissioned or acquired for Liverpool during the 1950s and 1960s. They were architectural pieces — large scale works less preoccupied with introspective neurosis —

65

that addressed themselves positively to the outside, surrounding environment.

The years after the Great War saw the erection of numerous war memorials, and the years after 1945 saw the birth of new towns, reconstructed city centres and architecturally conscious modern sculpture. Owing to the solemn purpose of the war memorial, and also to the directives of the government-funded Imperial War Graves Commission — which required a classical, impersonal approach to memorial constructions — many are of marginal artistic interest. Southport's memorial, in the form of a classical pavilion, was especially obedient to the directive, but is redeemed by its fine surface embellishment by Herbert Tyson Smith. Three particularly noteworthy memorials in the Merseyside area are the responsibility of a trio of prominent though contrasting sculptors. The first is by Charles Sargent Jagger and is a realistic depiction of a soldier in an informal but upright pose at the base of the stone obelisk in Hoylake and West Kirby (1922). The second is by Goscombe John — random bronze figures of soldiers, women and children circled around the stone column of the Port Sunlight war memorial (1919–21). The third is by Tyson Smith — a 30-foot long bronze plaque for Lionel Budden's cenotaph outside St George's Hall. These show an interesting variety in their respective formal approaches. Goscombe John justifies his occasional nickname as the 'Welsh Rodin' when, at Port Sunlight, he surrounds the base of the column with contemporary Port Sunlight figures, animated to suggest their posture as defenders of Port Sunlight village itself, if not also of the realm. The figures show up John's ability as a vital modeller. The Tyson Smith bronze reliefs are by their very nature two-dimensional and therefore subject to different formal qualities — his cenotaph figures are principally expressed by a prominent and stylised line that is as faintly art deco as it is futuristic. The Jagger at West Kirby, on the other hand, seems closer to the robustly realistic trench soldier portraits that were created by sculptors like Francis Derwent Wood (witness his own Merseyside contribution of a rifle-carrying trooper for Liverpool's Cotton Exchange Memorial, 1922), Eric Kennington and Jacob Epstein.

Among these artists one — Goscombe John — has a significant piece in the remarkable grouping of large-scale bronze monuments in St John's Gardens at the back of St George's Hall, and immediately opposite the museums on William Brown Street. The memorial to the King's Liverpool Regiment was the first of John's public sculptures for Liverpool, unveiled in 1905. A conventional, standing Britannia is flanked at the base of her stone pedestal by a remarkable group of figures — a cavalier from the year of the regiment's foundation in the late seventeenth century, a khaki-clad soldier from the Boer War, and behind a seated drummer boy lost in a maze of accompanying heraldic paraphernalia such as flags, drums and

weapons. It is symbolism of a very frank kind allied to a realistic depiction of the regiment's history as seen in differing period costumes. By 1916 John had contributed a monument to labour in the form of his *Engine Room Heroes* commission at Pierhead. The piece was intended as a memorial to the engineers who had volunteered to go down with the Titanic in order to save others on board.

However prominent a legacy these memorials are to the inter-war period, by the time of the second war the solemn tone and heavy physicality of large bronze-cast memorial figures seemed anachronistic. The Festival of Britain in 1951 wished to forget and look instead to a future with zest and hope. The festival was a national showcase which, with the Battersea open-air Sculpture Park and the Venice Biennale, provided a talented emerging group of sculptors with suitable opportunities. These lessons were not lost on Liverpool whose University began substantially adding to its collection after 1945.

For the most part not by contemporary Liverpool sculptors, the kind of modern sculpture commissioned or collected by the University provided a context for all practising sculptors, whether they were local or not. Eric Kennington's figure for the outside of the Harold Cohen Library was the last contribution before the war, and by working on it in situ, he provided his traditionalist style with an upbeat, direct and indeed modern method of working. The same campus's Mathematics building has a long, open-grid, metal panelling at its entrance, designed by John McCarthy. The feel of this elaborately linear, metal arabesque is unmistakably 1950s, and it perhaps resembles most of all the abstract and freewheeling compositional gestures of post-war Ecole de Paris paintings. Indoors, the University's gogglehead by Elisabeth Frink, despite its '60s-style smooth modelling to convey the trendy image of a slick thug, also has its antecedents in the 1950s. A craze for the head motif originated as a leitmotif of 1950s sculpture with Moore's *Helmut Head* series, Hepworth's marble *Cosdon Head*, and in the more abstract forms of Turnbull's ovoids and early Butler and Paolozzi pieces.

Basil Spence, the celebrated architect of Coventry Cathedral, designed the Physics building on the campus. It has a sculpture of three upright forms of Bristol-born Hubert Dalwood (1912–76) sited outside. Dalwood had an open-ended approach to sculpture and his works, while comfortably taking their place in outside settings, whether modern architectural forecourts or oriental gardens, often contained more than a hint of the anthropomorphic. By so doing, social or religious ritual, functional shape and tribal symbolism became synomous with each other. Dalwood knew Barbara Hepworth through his many St Ives connections and her *Square with Two Circles* is a tall, slim, rectangular totem pierced with a pair of circles. These open up the bronze surfaces to the outside, and leave visible a crescent-like deposit

of the interior width of the displaced volume. This work is typical of her late style, which is characterised by a still greater degree of abstraction and refinement through simple geometric shapes. The Liverpool piece is similar to the stacked planar forms found in the sculpture gardens of Hepworth's Trewyn studios in Cornwall.

The exterior of the Sydney Jones library has a large welded steel assemblage by Phillip King (born 1934) made in the year 1971. King, ten years younger than his mentor Anthony Caro, belongs to the 'New Generation' sculpture boom of the 1960s, which was largely centred on St Martin's School of Art. St Martin's sculptors reacted to what they saw as the romantic, organic residues that compromised the abstract sculpture of Moore and Hepworth. The New Generation sculptors were not, however, the first to react against Hepworth (though theirs was perhaps the most self-conscious reaction). Reg Butler, along with Robert Adams, had used direct welding in their metal sculpture some considerable time before Caro's adoption of the technique in 1959. Indeed Butler, one of the 'geometry of fear' sculptors, had deliberately sought what he termed a "denial of the value of mass" in order to make his work genuinely dynamic and modern. It has even been suggested that he objected chiefly to Hepworth's "remoteness from the tensions of modern life, its nostalgia for an innocent, archetypal order."[2]

Phillip King's University of Liverpool sculpture is called simply *Red Between*. It has been written that the piece "introduces a new intricacy and casualness of design."[3] This means that the components — steel piping, bars, curvilinear offcuts and other shaped planes — function as improvised units within a decentralised cluster of stacked forms. The simple monumentality of King's 1960s works — the cone-like *Rosebud* and *Genghis Khan*, or the pyramidal *Twilight* (made in part or whole from plastics) — has been eschewed by the early 1970s for a looser, rhythmic style. In the earlier painted plastic works King created a sense of volume, that is to say a sense of the sculpture taking up space while cleverly minimising a feeling of mass. The apparent emptiness inside the 'wigwam' of *Genghis Khan* is suggested by a slit that exposes an under-skin beneath the sculpture's outer surfaces. Space is also a governing, if intangible, feature in the organisation of the Liverpool piece, but this time there are no enclosed areas, only a jostle of dancing shapes that 'move' as the viewer circumnavigates the piece. It is well suited to a post-war campus for the sculpture has "an architectural aura rather than an animate organic life."[4]

The exciting installations of work by important post-war sculptors like Dalwood and King had abated during the recession-blighted 1970s and 1980s. But two recent eccentric examples of sculpture installation stand out by virtue of their unusualness. The *Sea Circle* by Charlotte Mayer is as successful in its unusual way as the over-stylised and all-too-obvious reading

of a familiar theme (an embracing couple) by Stephen Broadbent is a failure. Broadbent's badly proportioned sculpture is sited half-way up Bold Street, a busy shopping precinct. Charlotte Mayer's coiled and wafer-thin bronze has a pronounced texture that, despite its green verdigris, is reminiscent of crumpled silver paper (the original maquette submitted to the commissioning planners was apparently cut out of tin foil). Commissioned by Merseyside County Council for a new roundabout on the hill above Lime Street, Mayer's sculpture is a prominently public and appropriately symbolic monument. Its subtle, if oblique, reference to Liverpool's situation as a once-great seaport lends it relevance. Alex Kidson, while interpreting the sculpture's spiral as a symbol for the life of sailors "setting out on journeys and returning home again",[5] overlooks the fact that its shape echoes the circulating movement of traffic around the roundabout itself.

Other meanings issue from this ingeniously spare, yet evocative image. The organic spiral, blandly condemned as "a piece of orange peel" on local T.V., is a quintessentially feminine form, used in the 1970s by women artists like Jennifer Durrant (with whom Mayer participated in the 1978 Hayward Gallery women's show). Durrant's *Sweet Pea Painting* of the late 1970s is a large, post-painterly, colour field picture that introduces the organic, suggestive spiral in place of impersonal, hard-edged shapes. The inspiration probably stems from late Matisse, whose 'cut-outs' represent the artist in his most playful, lyrical, domestic and perhaps feminine mood. In her *Cantate Domino* Barbara Hepworth also created a hollowed-out, rhythmic, 'orange peel' sculpture. Compared to some of the jokey, populist and deliberately ugly sculpture shown at the Garden Festival and after at the Liverpool Tate's early 'Starlit Waters' exhibition, Mayer's sculpture achieves a classic balance between the orthodoxies of modernist formalism and the individualist impulses of the pluralist era.

Having outlined the inter- and post-war public sculpture legacies, it becomes useful to look more closely at two Liverpool sculptors whose noteworthy local careers embraced both eras. The work of Herbert Tyson Smith and Edward Carter Preston, though traditional, form an important backbone to the story of Merseyside sculpture this century. Indeed, the long career of the Liverpudlian sculptor Herbert Tyson Smith (1883–1973) is synonymous with the story of significant architectural sculpture and war memorial decoration on Merseyside.

A loyalty to his native city (he seldom worked on projects outside Liverpool), coupled with his close working partnership with architects and planners (which of necessity precluded more adventurous or self-expressive work) have conspired to make Tyson Smith somewhat of an overlooked figure within the mainstream of 20th century British sculpture. He was born into a craft background, his father being a Liverpool lithographic printer and engraver whose failure to keep the business on sound financial lines

meant the involvement of both his mother and then Herbert himself in the enterprise. He was thus forced to leave school early and became an apprentice letter cutter in Sefton Park. He did not much desire the chore of running the family business, however, which he left to his mother, and instead enrolled for evening classes at the college of art. Here he studied clay modelling, plaster casting and stone carving. He studied drawing under Augustus John at the 'Art Sheds'. John was perhaps the most exciting of all contemporary draughtsmen, with his combination of old masterish classicism, occasional Rubensesque exuberance, and spontaneous loose line with expressive hatch work. Contact with John also enabled him to express himself socially, for Tyson Smith got on very well with the well known gypsy-loving Bohemian whose easy way of life Neville Bertram felt had "preference to his rather stilted circumstances."[6]

Two fellow craftsmen who helped set young Tyson Smith on his way early in the century were Charles Allen, head of sculpture at the University School of Art that Tyson Smith attended, and Frank Norbury, an architectural sculptor and carver who instilled most of the professional lessons needed by Tyson Smith in order to set up his own business before the Great War. Allen had been assistant to Hamo Thorneycroft on the influential Arts and Crafts Baroque style of the chartered accountants' headquarters in London. Allen honoured the example by contributing caryatids and typically florid figure panels for the Philharmonic Hotel, a building described by Gavin Stamp as "that most exuberant realisation of arts and crafts ideals achieved by artists from the University School of Art". Frank Norbury has also worked on the same building. The Philharmonic, which was — appropriately — completed in 1900 is a quintessential monument to a dying fin de siècle idiom. Stamp wrote that "the new century saw a reaction against both ebullient decoration and freely expressive architectural sculpture."[7] It was precisely in the dawning modern age of stricter architectonic order and formal austerity that Herbert Tyson Smith matured as a professional architectural sculptor. His language would embrace not the florid and baroque ebullience of previous art nouveau styles but rather the elegant linearity and stylisation of art deco relief carving and classical revivalism.

Tyson Smith joined the Royal Engineers at the outbreak of the 1914 war and trained at Enfield. Later he was stationed at Dymchurch, the Kent seaside town whose prominent jetty and front were immortalised in paintings by Paul Nash. He ended up a gunsmith in the Royal Flying Corps, though unlike Charles Sargent Jagger never saw actual armed conflict. This fact perhaps explains the distant idealisation and abstract stylisation (as opposed to Jagger's realistic war imagery) that marked many of his later war memorial designs. He was discharged from war duties in 1919, and thereupon returned north and continued his business based in premises at

Herbert Tyson Smith at work.

the back of his house on Grove Street. He had married as early as 1909 in Suffolk. He met Edith Saunders in Leicester while working there on a temporary job. They had four children, and added to Tyson Smith's growing family was a professional colleague, fellow sculptor Edward Carter Preston, who married Tyson Smith's sister. These happy developments helped him settle down to the arduous task of creating what was to become a renowned, hard working and prolific sculptural and architectural relief studio. This business had its counterpart in the world of photography, E. Chambré Hardman forming a photographic firm with Frederick Burrel in Liverpool. Burrel looked after the business, leaving Hardman to take some of the most poetic and documentary images of old Liverpool as it existed before post-war redevelopments. Perhaps workaday Liverpool, before the age of real industrial unrest and decline, was a good place in which to work for the vast amount of sculptural and decorative art produced by Tyson Smith for both secular and sacred buildings around Merseyside is a reminder of just how busy and successful his business became.

The 1920s saw Tyson Smith contribute to many war memorials in the north-west; the so-called decade of the 'roaring twenties' actually witnessed a sobriety of purpose and an air of mourning regarding the erection of war memorials with their various sculptural adornments. Nothing lacked in the gaiety and high-spirited joie de vivre of Tyson Smith's social life, as readers familiar with Roderick Bisson's account of the Sandon Studios Society (published by Parry in 1965) will know, but the requirements of his working life were quite different. In 1925 he moved his studio out of the back of his Grove Street house and into the Bluecoat studios, where he was able to work on a bigger scale, employing stone masons, and where he was able to make use of a crane and hoist.

The serious, often solemn tone of the work of this time, allied to the strict architectural guidelines within which he had to work, seems to highlight what Ann Compton has written was "a certain lack of boldness and independence in Tyson Smith's work." Nevertheless his work was characterised by a "sense of authority and assurance"[8] according to the same writer. One of the earlier of his memorial pieces was unusual for its presentation of a sculpture-in-the-round, in this case an immaculately conceived and executed Britannia, carved in marble. The piece was executed in 1924 for the Post Office and erected at Whitechapel. The evidence of the mourning Britannia betrayed the artist's work as being best when integrated into an architectural context, rather than left as a free-standing sculpture. The contemporary critic Kineton Parkes had identified Greek temple carving and Egyptian reliefs as Tyson Smith's real sources of stylistic inspiration. For the Britannia commission a leading Liverpool mason, George Stocks, helped Tyson Smith on the base mouldings and Westmorland slate panels. The sculptured figure is rigidly classical in

design though with hints of art deco stylisation in the outline and surface drapery patterns. The Post Office memorial was made in collaboration with Charles Reilly, professor of architecture at Liverpool University. Unhappily Reilly himself saw few of his own designs realised in buildings, a fate not uncommon among architects or artists stuck in an ivory tower for most of their working lives. An exception was his church at Shackleton Green, for which Tyson Smith contributed a rood screen.

Only a few years after the Post Office memorial, Tyson Smith completed two all important commissions, the one reliefs and other surface embellishments for the Grayson, Barnish and McMillan Southport war memorial (1927), the other the decorative friezes for Liverpool's cenotaph (1930) that consolidated his reputation and for which he is best remembered today. These contributions represent the pinnacle of his many achievements in memorial work that took up most of his professional life during the 1920s. Work on the two 30-foot-long bronze reliefs for Lionel Budden's cenotaph outside St George's Hall alone took up most of two years. Lionel Budden was, like Reilly before him, a professor of the school of architecture at Liverpool University, and he helped Tyson Smith obtain the cenotaph commission. Indeed, Budden was chosen to design the cenotaph by his predecessor Reilly from an open competition. Ever since his first collaboration with architects, a scale model of Port Sunlight Village, Tyson Smith had relished working with architects for he believed that the architectonic element learnt during collaborative jobs strengthened his carving and design, anchoring it within an objective context. Nowhere did the classical call to order become more concrete than in these team jobs. Lionel Budden, like Tyson Smith a Sandon member, was also responsible for getting his sculptor colleague to make a bronze death mask of Sir Robert Jones, the leading bone specialist.

The cenotaph was unveiled on St George's Plateau on Armistice Day 1930, a delay having been caused by the removal of Charles Bell Birch's large Disraeli statue that had formerly occupied the position in front of St George's Hall.[9] A few years before, in 1925, Tyson Smith and Budden had seen the unveiling of their first local cenotaph, that in Birkenhead's impressive Hamilton Square. This unveiling had been witnessed by a crowd of some 20,000 people, a ceremony repeated a few years later for the main St George's cenotaph. The fact that the Birkenhead and Liverpool cenotaphs were not written up in the local press for their aesthetic merits as individual works of art, but instead for the incidents and pomp occasioned by the ceremonies themselves, should tell us right away that public consciousness of the visual artistic quality was low. Ann Compton's remark that "as was typical of most reports of unveilings of war memorials the press were more or less indifferent to the monuments' aesthetic merit and concentrated largely on the ceremonial"[10] is well borne out by the whole front page coverage given to the 1930 unveiling by the *Liverpool Post*.

What the newspaper failed to realise, though, was that the cenotaph represented a well-matched collaboration between architect (Budden) and sculptor (Tyson Smith). Modernity was assessed to have crept into the imagery of the latter's bronze reliefs. The mourners who adorn the frieze that faces onto Lime Street are literally as well as stylistically modern for they are presented in contemporary '20s garb. On the hidden St George's side of the memorial, cohorts of soldiers march resolutely and uniformly forward with a rhythm, force and symmetry that Ann Compton correctly indicates are "almost futurist".[11] The subject of marching soldiers is a rare piece of realist vernacular in Tyson Smith's usually classical imagery for "by the late 1920s the war had lost some of its immediacy." In addition to this masterpiece, Tyson Smith also contributed to other memorials, carving letters and reliefs for Accrington, and for the Royal Navy memorial designed by Blythin and Smith at Liverpool's Pierhead, a more congruous piece than Henry Pegram's classical nude warrior for the top of Willink and Thicknesse's tall, columnar *Cunard Memorial* (1921) also at Pierhead. The problem with the latter memorial was its visual discord with the Cunard building behind, a distinguished piece of recent architecture that Tyson Smith had also unofficially worked on.

After the 1920s Tyson Smith found himself busily engaged on many restoration or letter-cutting jobs, on buildings at home and even — on occasion — in other parts of the country. In the late 1920s, for example, he produced a garden ornament and fountain in red sandstone for Kenwood House in north London. He had another successful collaboration with an architect, this time with the Liverpool architect Herbert Rowse, whose Martin's Bank in Water Street represented one of the best American classical commercial buildings in the country. Tyson Smith produced all the hand-carved embellishments and bronze gates for this interesting building, an enormous job for which he employed as many as 30 carvers at any one time. The economic slump of the 1930s considerably slowed down building projects, which became plainer and less artistically ambitious. Neville Bertram later recalled the period as offering a "dribble of minor jobs all the time but nothing of importance."[12] He was even forced to make display models for Owen Owen.

Many restoration jobs came to him during the 1930s and then, with the 1940s, a fair number of improvement projects on war-damaged buildings (a task undertaken with Norman Hapgood). But the era of carved decorative work for buildings had largely passed by the mid-twentieth century. Bertram later recalled how "it was the end of his profession, virtually." Tyson Smith felt unhappy with the post-war trend — necessitated by the need for the erection of functional buildings in a more secular and abstract style — of decorating building facades with ciment fondu, abstract relief sculptures cast from a polystyrene mould. During the 1950s he produced

capital lettering and architectural features for the modern Littlewoods store in Church Street, not far from his Bluecoat studio. The responsibility for decorating modern buildings had assuredly passed into the hands of a younger generation, with craftsmen artists like Robin Riley and William Mitchell taking over. Riley was commissioned in the early 1960s to produce a long, horizontal, abstract relief for the outside wall of a Catholic school in Kirkby. This work is a typical post-cubist relief that uses geometrical shapes, shallow linear contours and intervals to create a forceful rhythmic interplay of successive elements. William Mitchell produced another slim, decorative panelling, this time around the entire facade of a Hope Street building. This is in a style superficially reminiscent of Paolozzi, with its pronounced graffiti of scoured, linear markings embedded into the grey, metal-like surfaces.

During the war Tyson Smith performed fire-watching duties and was responsible for diverting the attention of stretched Rochdale fire fighters in order to save the Bluecoat Chambers after one of its wings had been gutted by fire from a bombed adjacent building. After the war he worked on many Catholic churches in Merseyside and Cheshire localities, though he never contributed to the main Catholic Cathedral which lent itself to much more modern themes than the ones to which Tyson Smith had customarily addressed himself. Instead he often undertook jobs to make conventional wood reliefs for alterpieces. He had made a foundation stone in 1910 (having won a student competition) for the Anglican Cathedral but did not want to be laden solely with demanding work for Sir Giles Gilbert Scott's huge building whose Gothic Revival style proved more suitable for Tyson Smith's brother-in-law Edward Carter Preston. The emotional tenor of Tyson Smith's work belonged to a world of classical decoration rather than to the realm of northern Gothic.

As a president of the Sandon Studios for many years Tyson Smith was in the centre of the artistic life of Liverpool, a position that reflected his liking for a lively social life. Among the many friendships were especially close rapports with Roderick Bisson and Rowley Smart, the former putting his natural discernment and individuality of taste to the test with many years of perceptive art criticism for the *Liverpool Daily Post*, the latter leading an itinerant, Bohemian lifestyle and therefore calling in casually and without warning at the Tyson Smith household. Tyson Smith also knew Hinchliffe Davies, the well-known Liverpool architect whose son Austin married Beryl Bainbridge and became an influential teacher and contemporary painter at the college of art. An active involvement in a lively milieu notwithstanding, Tyson Smith moved across the river to the Oxton area of Birkenhead in the late 1960s, living in the attractive, old, white house in Caroline Place that had once been the painter Will Penn's home. He lived there until his death in 1973 with his eldest son Geoffrey, who unsuccessfully tried to keep the family business going.

Tyson Smith's bronze portraiture is one final feature of his work that is inevitably eclipsed by the far more numerous examples of stone carvings executed for architects. Birkenhead library has a bronze bust of George V by him, and on the Kingsway entrance to the Birkenhead tunnel he produced a bronze bust of the king and queen placed symmetrically on either side. On occasion he exhibited small bronze plaques at the annual Liverpool Academy exhibitions. At the end of the 1960s, about the time of his move to the Wirral, the *Birkenhead News* reported that, modestly, Tyson Smith was "unconcerned that he is virtually an unknown artist to most people even though he has been responsible for some of the best architectural sculpture in the district."[13] Perhaps he may have been able to court the false gods of a spurious kind of popularity had he not turned down — on the grounds it represented a vulgarisation of his profession — the suggested job of creating the mould for mass-produced, plastic souvenir busts of the Beatles in the initial 1962–3 period of Beatlemania. He would have accepted the invitation to make a proper, artistic, bronze bust, perhaps along the lines of the one that David Wynne produced, for that would have equated with his principles of craftsmanship. There was therefore nothing personal in his refusal to make the souvenir image; being musical, social and Liverpudlian he welcomed the advent of the Fab Four.

The career of Neville Bertram owes much to his distinguished father-in-law. Born in Northumberland in 1908 into a sympathetic artistic background (his father was a design lecturer at Durham), Bertram began his studies at Durham, not in sculpture, but in painting. Despite the encouragement at home, father looked back to the nineteenth, Neville forward into the twentieth century. In 1933, when aged 25, Bertram moved across to Liverpool from Newcastle. By this time he had already experimented with clay modelling and carving to an extent that he wanted to work exclusively in sculpture. The break came in Liverpool, with a local architect recommending him to Tyson Smith, who duly employed him as a studio assistant. Privately, the young sculptor was producing formalised animal carvings in a smoothly surfaced and modified figurative style that owed something to the contemporaneous work in the same genre by Alan Durst, John Skeaping and Eric Gill. But the most practical lesson learnt at the time, one taught by Tyson Smith, was letter-cutting. It was the bread and butter of a professional sculptor's career. Successfully settled in Liverpool, Bertram maintained beneficial contacts with his native north-east. He returned, to produce lunettes, altar furnishings and font alterations for the Church of the Venerable Bede in Newcastle. He also produced tombstones and worked for architects. Bertram used a Gateshead firm to make cement castings out of the plaster moulds that were produced from clay models. The result was a cement relief over the door of St Michael's Church in Sunderland. Bertram also painted a number of heraldic pub signs.

In 1936 Neville Bertram married Danae Tyson Smith, extending a professional liaison with Herbert Tyson Smith into a personal one. Bertram's recollection that Tyson Smith "treated me like a son" took on literal meaning after 1936, adding significance to the previous teacher/ student relationship. However, the younger man felt that "mentally none of his ideas rubbed off very deeply", which is not to say that the technical value of Tyson Smith's craftsmanship went unappreciated. He declared his father-in-law to be "an excellent craftsman in all sorts of media", even though these skills were not adapted to an inspirational or self-expressive end. Tyson Smith's shallow relief style, so suitable for architectural facades, seemed better suited to the marble buildings of the classical Mediterranean world. The northern climate and culture required a more robust volume to form that would enhance shadow and make fullest use of inevitably dimmer sources of highlight. The northern climate therefore dictated Gothic projection, perhaps more adequately expressed through sandstones rather than the marbles that in the Mediterranean world enabled the kind of fine detail favoured by Tyson Smith. Yet he was tolerant of other more expressive kinds of sculpture and approved of Bertram's abstract wood carvings.

Unknown to the newly married couple, war was fast approaching, and Bertram lost the threads of his career over the following few years. They moved first to Tynemouth in Devon then to Bristol for three years where Bertram did engineering work for the air ministry. Quite by chance he discovered in Bristol's Knowle library a magazine that advertised a teaching job in modelling and sculpture at Liverpool Art College, where he already knew the staff members Huggill, Bell, Penn and Tankard from earlier in the 1930s. Bertram began teaching with them in 1945, serving in the threadbare sculpture department under Charles Gardiner, a man whom Bertram later described as a "canny, pleasant little man but he had no idea of how to run a department." This department was not to be radically overhauled and expanded until George MacPherson's appointment, which is discussed, along with Bertram's own mature career, in the succeeding chapter. Bertram later became deputy to MacPherson, teaching lettering, modelling and anatomy. He embarked on teaching at a favourable time in that the new influx of worldly ex-servicemen proved a vigorous departure from the intimate middle-class scenario that typified pre-war art schools. Outstanding among Bertram's later students were John Hart, later to become a teacher at the college, and Stuart Sutcliffe who excelled, as in all else he dabbled in, at wood carving. Bertram remembers this outstanding young man as producing "a mother and child that could have been a Henry Moore."

In a city like Liverpool cultural divisions between the Catholic and Protestant communities might have been expected to manifest in two distinct visual cultures — one leading to the idealist, classical and formal

approach of the theocentric Latin world, the other to Gothic and romantic forms of expression. Expressionist art belongs of course to the northern European world and there is little doubt that an expressionist tenor runs through the art of both Liverpool and Manchester artists this century. The large Jacob Epstein bronze, *Spirit of Liverpool Resurgent*, placed above entrances to John Lewis's store and perhaps the most prominent piece of modern sculpture in Liverpool, is, in its post-Rodin way, strongly romantic both in posture (content) and handling (style). Certainly, obvious differences of taste are apparent in the city's two large cathedrals that face each other and which in their contrasting ways contribute such an unmistakable silhouette to the architectural skyline of Liverpool. The R.C. Cathedral, mockingly referred to by some as 'Paddy's Wigwam', has the more interesting story to tell, thanks largely to the unusual architectural design by Sir Frederick Gibberd (but realised in poor quality materials). The cathedral has stained glass windows in an abstract design by John Piper, while George Mayer Marton's large mosaic of the Ascension was transferred there in 1988 from an outlying church in Bootle thanks to the patient craftsmanship of Robin Riley. The cathedral also has figures by Arthur Dooley, providing examples of the visual modernity which the architect wished to express. The Anglican Cathedral, built in Gothic Revival style by Sir Giles Gilbert Scott, is much more sober and traditional in its taste, sharing none of the Catholic Cathedral's abstraction. Instead we have the solemnity of Edward Carter Preston's numerous elongated Gothic figures created for Scott's huge and awesome perpendicular building.

Edward Carter Preston, a local sculptor born in Walton in 1885, was engaged for a quarter of a century (1921–1955) on the sculptural decorations for Scott's cathedral. It is hard to imagine Tyson Smith having the patience to work under an at best highly modified range of expectations. The two sculptors, though later related through marriage, were "a touch scathing"[14] when they spoke about one another, and if this reflected professional rivalry then Tyson Smith seems, at least in retrospect, to have the edge in terms of overall quality. It also has to be said that Carter Preston spent a large part of a career which spanned the 1930s and '40s working on a massive project that ultimately gave him even less room for individual creativity and self-expression that the average architectural commission. But he was a dedicated craftsman with a suitably accommodating and moderate temperament to allow for team work within a rigid set of circumstances. His home was kept like a museum, displaying to best advantage oriental pots, fabrics and other decorative items. It seemed that Sir Giles Gilbert Scott, architect, and Frederick Radcliffe, alternately treasurer, chairman and secretary of the Cathedral Committee, had an ideal collaborator in Carter Preston, the man whom the Bishop of

Edward Carter Preston Angel with censer, *8' high.*
Anglican Cathedral Liverpool. Courtesy: Julia Carter Preston.

Roger Leigh Sagitta II, *1965. Bought for Mutley Properties offices in Bootle.*

Liverpool had described at the project's outset as "the finest kind of agnostic".[15]

Edward Carter Preston was the oldest of a large family which originated in the old Lancashire gentry. His earliest artistic training was at the so-called 'art sheds' in 1901, that now legendary adjunct to the University's School of Architecture. The sheds became absorbed in 1905 into the new Corporation College of Art. At the sheds Carter Preston met Tyson Smith and studied drawing under Augustus John, who recognised his basic talent for draughtsmanship. Perhaps as a reaction to his father's brewing interests, young Carter Preston shunned drinking in a way that precluded much socialising after hours with Augustus John and his Bohemian circle. But there was nothing sober in his approach to study for he used the Anatomy School which was a part of the University Medical Department. The product of these early studies was floral still life paintings that, together with similar works from the hand of Gerard Chowne, reflected an impressionistic mastery of tone, an academic control of composition, and an arts-and-crafts relish for the pattern effects of flowers in a discreet, impartial, domestic setting. Maxwell Gordon Lightfoot, the precocious but short-lived painter who became associated with the Camden Town artists, was a companion to both Carter Preston and Chowne on outdoor sketching trips in the Wirral.

Glass decorating was a skill that Carter Preston learnt while working for a local firm. Later, as a pacifist and unfit for army life, he used such skills when making glass designs for Pilkingtons. More importantly he learnt modelling under Charles Allen, another of the leading turn-of-the-century figures in Liverpool art. By 1905 Carter Preston was in the thick of the rapidly developing art scene in the city, being a founder member of the Sandon Terrace Studios. The Sandon group moved down the hill to the Bluecoat Chambers where it adopted the name Sandon Studios Society. Two years later in 1907 Carter Preston shared a studio at the new premises with the sculptor George Capstick who, like Tyson Smith, became a brother-in-law. Capstick was responsible for the art nouveau figures in the Philharmonic Hotel, the building described by Gavin Stamp as "that most exuberant realisation of arts and craft ideals achieved by artists from the University School of Art."[16] He also produced the tall, highly schematic, art deco stone figures for Herbert Rowse's Mersey Tunnel ventilation tower. Capstick's partner on the ventilation figure was Edward Thompson with whom he went into business as a monumental sculptor.

Beginning as a painter, Carter Preston moved into the third dimension through the intermediary craft of medal and plaque making during the Great War. Here he learnt a mastery of fine detail that would be so useful for his later shallow relief and tablet works. An early success was winning

the competition for a next-of-kin-medallion, an achievement that was later repeated when the artist produced medals for the second war. He even designed coins for Edward VIII, which were never actually minted due to the early abdication. Before outlining the mature years of Carter Preston's professional career as a sculptor it is useful to emphasise his links with painters, the product of his own early studies in painting. Ever since the days of trips to nearby countryside with Lightfoot and Chowne, Carter Preston had always enjoyed outdoor sketching with watercolours and pencils, and even as a sculptor kept his visual responses to nature suitably sharp with extended topographical studies of Wales or the Lake District, areas of outstanding beauty that he frequently visited. By the 1950s he was even making abstract variations on rock and river forms. He was capable of a positive response to the work of Henry Moore and George Braque. Carter Preston numbered among his painter friends not only Lightfoot, but also Bernard Meninsky, that most sculptural neo-classical interpreter in paint and two-dimensional graphic form of the naked female figure. Meninsky was a regular visitor to Carter Preston's home on Bedford Street, where the sculptor modelled a portrait head of the painter which was later cast in bronze.

But however interesting all this is from an historical and biographical viewpoint, the early period was but a prelude to his engagement after 1930 on the sculptures for the Anglican Cathedral, a project that forms the backbone of his professional achievement. Dean Dwelly was the essential connection, who liked the work he had seen in a local church. Once engaged on the project, however, Carter Preston liaised constantly with Frederick Radcliffe (of whom he made a portrait bust) and Giles Gilbert Scott. The volume of correspondence between the trio down the years testifies to the extent of supervision over the sculptural schemes. Penelope Curtis has used this correspondence to emphasise the extent to which Carter Preston's numerous figures — originally modelled in clay in his Bedford Street studio before being cast into solid plaster as prototypes for the final carvings that we know today by a team of assistants using pointing machines — were subject to continual scrutiny by Scott and Radcliffe. Perhaps this explains why the end product, though "competent and smooth" was deemed by Gavin Stamp to be lacking in expressivity and originality. Stamp summed up the new century's air of architectural rigour and conformity imposed on accompanying sculpture when talking of the new Anglican Cathedral. "There is a vast amount of sculpture and carving in the building, but it is all of a consistent character and completely subservient to the sublime vision of its architect Giles Gilbert Scott." Stamp continued by declaring that in spite of Scott's own versatility and variety in the use of materials, "as regards sculpture, he rejected the creed, preached by Ruskin and Morris and proclaimed by the Arts and Craft movement,

that it was the free expression of the workman's chisel that was most important in architecture. Just as Scott classicised Gothic, so he made sculpture an affair of ornament and detail within his total architectural conception. He only used accomplished but second-rate sculptors who did exactly what he wanted.''[17]

The term Gothic Revival needs to be treated with some qualification, if not caution. In a peripheral northern country like England architecture was certainly slow to move out of the medieval age. Indeed, Gothic styles were still used when, a couple of centuries after Brunelleschi and the Italian Renaissance, a self-conscious Gothic Revival style began to emerge. Wren and Inigo Jones had helped to integrate the natural balance and elegance of classical architecture into pre-existing Gothic vernacular styles. Kenneth Clark in his early book on the Gothic Revival (1928) argues that the Gothic never really died out, but formed a continuum between the medieval and modern age. Scott's cathedral thus uses the tradition in the modern era. Even allowing for literary, antiquarian or romantic interest in the Gothic — exemplified in the Oxford Movement — the source for this durability lies chiefly in an essentially visual drama and complexity inherent in northern European culture.

Whether Carter Preston's subservience to the ecclesiastic authorities betrays his status as a second-rater is clearly open to debate. The Anglican works are neither peaks of individual expression nor contributions to innovative sculpture. But the consistent quality of the vast amount of sculpture is a remarkable achievement. Adherence to Giles Gilbert Scott's perpendicular style was not the sole limiting influence with which he had to contend. If the architect dictated visual and aesthetic requirements, then Frederick Radcliffe ensured that symbolic features of Carter Preston's work — the content as opposed to the style — remained suitably restrained to match the mood generated by a uniform and conventional place of worship. The controls exerted on the sculptor by Scott and Radcliffe were not lessened by their both living in the south; indeed Carter Preston sent small clay sketches down to them before starting out on any scale models. Within strict parameters Carter Preston insisted that a small degree of improvisatory licence was a matter of necessity, an inevitable by-product, that is, of the actual working process. The limitations imposed deadened genuine exploration of expressive form, yet stimulated ingenuity.

The 1930s were Carter Preston's busiest years when the sculptor achieved the essential ground work on the massive project. The 1940s were interrupted constantly, while the 1950s saw the final completion of schemes started many years earlier. The numerous figures certainly have a pronounced perpendicularity in keeping with the building. The sculptor's central aim was to fit his work into Scott's architecture "with the least ostentation". But they are neither, on the one hand, literal copies of an

authentic Gothic style, nor on the other genuine examples of contemporary vernacular. The surfaces are very smooth, interrupted only by highly stylised linear drapery. In addition to numerous bas reliefs, Carter Preston produced figures both for the pulpit and the font. When not engaged on the cathedral, he enjoyed wood carving and made a number of small bronze portraits using local children as models. He taught furniture making though not art. In later years, using a shipwright's blade, he carved a huge, 3½-ton, teak 'Nelson' for H.M.S. Conway moored at Liverpool. The pre-war work produced for royalty was repeated when he created the seal for the Duchy of Lancaster using the familiar image of Queen on horseback with corgis. He also produced a coronation medal and made several visits to Buckingham Palace in order to do the preliminary sketching for his designs.

NOTES

1. *Patronage and Practice*, 1989, p.62.
2. *Reg Butler, the man and the work*, R. Calvocoressi, p.10, Tate Gallery, 1983.
3. *Phillip King*, Lynne Cooke, p.56, Arts Council, 1981.
4. ditto.
5. *Patronage and Practice*, p.117.
6. Interview between Neville Bertram and the author, West Kirby, summer 1990.
7. *Patronage and Practice*, p.10.
8. ditto, p.88.
9. See *Art in a City*, John Willett, Methuen 1967, p.90 for an illustration of the removal of the Disraeli statue from the front of St George's Hall.
10. *Patronage and Practice*, p.87.
11. ditto, p.89.
12. Neville Bertram with the author, summer 1990.
13. 'The figure behind the statues'. 16.7.69.
14. Neville Bertram with the author.
15. Letter to F. Radcliffe dated 8.1.31. See *Patronage and Practice*, p.94.
16. *Patronage and Practice*, p.10.
17. ditto.

I am grateful to Julia Carter Preston and Neville and Danae Bertram for patiently answering my questions for this chapter.

A Merseyside middle generation

The purpose of this chapter is to look at a number of artists who came to local prominence in the 1950s and 1960s, and who form a kind of 'middle generation' between the earlier artists who had exhibited with the Sandon Society or the Liverpool Academy, and the younger generation of the 1960s and thereafter. Most of the artists looked at here were born and trained in the Liverpool area, but there are others, like Nicholas Horsfield and George Mayer-Marton, who became Liverpudlian artists by adoption. Non-figurative painters like John Edkins and Robin Rae slot into a transient category. The artists all gave flavour to a notable period of expansion and experimentation, and in addition they all entered into various forms of dialogue with the abstract or avant garde mainstream. From today's pluralistic position their forms of abstraction may now seem quite familiar and unshocking, continuing the tradition of easel painting. But at the time their work departed dramatically from the academic conventions of figurative painting, which was structured by classical drawing and where paint was but a mere contrivance, expressing the appearance of things. It should not surprise us, therefore, that accompanying a more vigorous, autonomous approach to paint, came a new and sometimes aggressive Bohemianism that broke down gentlemanly behaviour codes and challenged art's traditional role within local life.

One of the most influential painters in Liverpool from the mid-1950s onwards was not a local at all, but an artist from the South, who came to Liverpool after a spell working for the Arts Council in Manchester. Nicholas Horsfield (born 1917) has been a stalwart of the Liverpool art scene from the 1950s through to the present time of writing. With his earlier spell in the Manchester of Margot Ingham, Crane Kalman and Lowry, Horsfield probably had a knowledge of post-war art in the North-west that was second to none. Horsfield's talent has never been fully acknowledged, though I have yet to meet a painter who does not have a good word to say about his art. One critic always ready to lead the chorus of approval is his lifelong friend John Willett, who has long championed and collected his work. Willett's large house at Le Thil outside Dieppe has provided a gathering point for Horsfield, as for many other artists and writers. Horsfield made it an almost annual retreat, leading to his long association with the northern French landscape. This has been a more common feature in his work than the dune-lined coastal landscape (with the

Irish sea and large skies) on the doorstep of his home in the northern Liverpool suburbs. Willett referred to Horsfield's "sensuous feeling for pigment and colour," which he speculated "perhaps now strikes the British as 'elitist'."[1]

To the more naturally visual French eye such a lush handling of paint and skill of drawing with the brush have never been seen as exclusive but simply as beautiful. The ethos of *la belle peinture* has roots in the tradition and history of French painting. It entered the work of artists like de Stael, Sickert and Bonnard, who have meant more than most to Horsfield. Willett used the occasion of Horsfield's large 1984 retrospective in Dieppe — appropriately held in France before his own country — to develop his argument about the beauty in Horsfield's painting. Such *belle peinture* is hard won, the outcome of a high concentration struggle with risk, gesture, spontaneous impulse, physical wrestling with the material and so on. If Horsfield can be seen as a painter who matured in the 1950s — the decade of Abstract Expressionism and kitchen sink realism — then he adopted the gesturalism and abstract composition of that period to his own figurative ends. Sickert is obviously an influence, and not just because of Dieppe or of dingy self-portraits in smoky pub mirrors or attics. The construction of image with controlled, gestural brushwork, the perfect absorption of drawing into the painting process, the sensitivity to tone (the fundamental balance of light and dark) and the masterful game-playing with focus (requiring distant viewing for coherent reading of the overall image) are all formal qualities that owe a greater or lesser debt to Sickert.

Horsfield rarely painted Merseyside subjects, though a number of large works and related studies concentrate on the characteristic large sky and dunes of the coastline between Southport and Crosby. A spate of *pochade* studies was produced at Hightown, Blundellsands and Crosby in the early 1980s, culminating in *The Large Sky* (1982), illustrated in *A Northern School* (1989). The painting *Mount Street* (1957), owned by the Walker Art Gallery, was described by the artist as "the only sustained Liverpool picture I have ever done."[2] The picture was built up with rectangles of thick paint applied with a palette knife. Although depicting the rows of Georgian buildings gradually sloping downwards from the high vantage point of Hope Street, the picture used a degree of abstract simplification that made it typical of this de Stael-influenced period. The picture was bought by John Moores from the Liverpool Academy and later presented to the Walker. The Walker's other Horsfield, *Le Pollet Cliffs* (1954), was painted while the artist was on sabbatical from Manchester Arts Council at his mother's home in Rochester, Kent. The picture was exhibited with the Manchester Group at the City Art Gallery in Manchester, before it went on display as the artist's first contribution to the Liverpool Academy exhibition. Horsfield spent six months of the 1953–54 sabbatical at the Willett's house in Dieppe

Nicholas Horsfield Le Pollet,
the swingbridge, *1959. Oil.*

Nicholas Horsfield River
Epte (1), *1974. Oil on
canvas.*

Nicholas Horsfield Self Portrait, *1980. Oil.*

Nicholas Horsfield Life drawing, *1979. Pencil.*

88

before visiting Venice, where a few pictures with Venetian themes resulted.

By the end of the 1950s Horsfield was showing a high degree of abstraction and palette knifed stylisation in works like *Le Pollet Swingbridge* (1959). Any coherent reading of the image is only possible by stepping back and allowing the chaos of lights and darks, of lines and knifed slabs slowly to unravel itself into a swingbridge. The same is true of *River Epte* (1974), now in the Atkinson Art Gallery, and the grand self-portrait of 1980. Horsfield is a deceptively clever master of scale, focus, tone and line. The linear brushwork seems close to Frank Auerbach, who was also influenced by Sickert. Drawing has always been for Horsfield a distinctive feature within its own right. He was an art history lecturer at Liverpool College of Art from 1956 and in 1977 he went into partial retirement, teaching life drawing, "something I loved",[3] on a part-time basis until his total retirement in 1982. His nude sketches are heaped with linear pentimenti; the gradual process of mark-making, crosshatching, readjusting and so on is left visible. The figures have a voluptuous monumentality, the outlines and anatomical recesses allowing for dense webs of markings that are balanced, in other parts of the body, with much lighter linear treatment. Horsfield's life drawings are confident, active, open-ended exercises in the use of pencil. An exquisite touch is never allowed to become precious, or to prevent movement.

The artist's ability to create harmony and formal poise out of risky, spontaneous procedure was what time and again allowed him to 'deliver the goods'. Horsfield produced his first etching in 1972. In 1970 the Sandon Society had sold their etching press, and an etching room had been set up in the Bluecoat Chambers. In 1972 Horsfield attended an etching class run by George Drought at no. 9 Bluecoat Chambers. He was also encouraged by the late Brendan McDermott, who ran an etching room at the art college. By the mid-1980s, inspired by the Degas print exhibition at the Hayward, he began to produce etchings in greater numbers. In 1987 Horsfield started an etching press at home, allowing him more frequent use of the medium to produce French coastal subjects, self-portraits, Christmas cards, and the occasional reworking of old master themes.

Another principle he seems to have adopted from French art in general, but in particular from very early modernist masters, is the development of a theme using a single motif. He made many studies of a motif that caught his attention. Since the late 1980s Horsfield has reacted with the intelligence and vigour of an artist who realises that the fine art of painting, with its ongoing value, has to take unpredictable, mysterious courses. The onslaught of television and other mass media, the attack on the art schools and so on have required painting to adopt a wholesome, protective posture, and for that reason Horsfield describes a new look at the old masters as "a

valid field of exploration.''[4] Committed to the European painting tradition since Giotto, Horsfield has begun looking at fragments of old masters, and in his pastel sketches based on Tintoretto's *St George and the Dragon* in the National Gallery he manages to invest an old master theme with his own style and language of mark-making as it has evolved over many decades. Here the old and new synthesise in the way that we first saw in his early Liverpool years when he used de Stael's palette knife architectonics alongside the realism of everyday life.

George Mayer-Marton, the Hungarian émigré, also became Liverpudlian by adoption, and his last years teaching at Liverpool Art College overlapped with Horsfield's first few years teaching there. In their differing ways each brought a wide knowledge of European painting into the college. Mayer-Marton was born in 1897 and served in the Austro-Hungarian army during the Great War. He was thus 20 years older than Horsfield, and had direct insight into the early phases of modern art. Indeed, he came into contact with cubism early, while studying at art academies in Vienna and Munich. In Vienna he was secretary of Hagenbund, the most progressive art society that was later banned by the Nazis. The rise of Hitler compelled Mayer-Marton to seek refuge in London in 1938. He was able to obtain a teaching job at a school in St Johns Wood. From 1940 to 1952 his output of work was held back, first by the destruction of his studio and its contents during the war, then by a demanding job lecturing for C.E.M.A. (later the Arts Council) that involved much travel. During these years he lived in a flat in Belsize Park. He was friendly with Martin Bell and after losing his lecturing job was encouraged to apply to Liverpool Art College, which accepted him in 1952. In 1960 his friend Hugh Scrutton wrote that ''he gave great devotion to his students — it was his special belief that every student had some special talent.''[5] He introduced the craft of fresco and mosaic into the college, and encouraged the students to learn age-old techniques and paint chemistry that had long fallen out of fashion. Mayer-Marton also taught aesthetics and art history. He lived in a flat at Professor Fröhlich's house near the University and he kept a studio at the Bluecoat where, improvising with visual memory and modern ideas, he produced up to two hundred oils during his eight years on Merseyside. In 1960 he bought a house and started living with Wendy Moran, wife of the editor of a local newspaper. Mayer-Marton's first wife, an Austrian pianist, had died in 1952.

Mayer-Marton enjoyed Liverpool to the full, and took maximum advantage of this final phase of his life. In particular, he enjoyed the accessibility to spectacular landscapes in Wales, the Lake District and Derbyshire, where he made many sketches that were used in the studio as starting points for elaborate oil and watercolour paintings. These finished works were seldom tamely topographical, however, for in them he imposed his own compositional order that emphasised, indeed exaggerated, linear force, perspectives

and hidden parallels. While remaining recognisable, his landscapes, still lifes and interiors carried an independence of pattern, colour and design that gave them abstract significance as well as figurative and naturalistic association. He utilised aerial perspective on landscape and emphasised the linear furrows of ploughed fields, undulating hills, or meandering hedgerows. The interest in pure pattern, together with an earlier period in Ravenna, led him to start a school of mural decoration at the college in 1955. He had coloured glass imported from Italy. The mosaic course thrived until his early death from leukaemia in 1960. He was helped by Robin Riley, Gordon Millar and Eric Woodward in his mosaic enterprises. He also gained several commissions to decorate churches throughout the north-west. One commission for a Catholic church came from Walter Pater, a Polish architect. In 1988, Robin Riley had the painstaking job of removing the large mosaic of the Pentecost (1957) from the wall of the Church of the Holy Ghost at Netherton, Bootle, which was due for demolition. The impressive mosaic was transferred in May 1989 to the Roman Catholic Cathedral where, along with John Piper's stained glass patterns, it introduces a high note of modernism into a religious setting.

Richard Young has made a valuable, if quiet contribution to post-war art on Merseyside, using themes suggested to him by his immediate environment. Even his overall project as a painter has had a provisional, self-questioning and open-ended character about it, almost as if the need to paint is a transitory grace that comes and goes. His works, in the grubby domestic genre of interior still life painting, hark back through Bratby and the kitchen sink artists to Sickert's North London bedsit realism. A touch of Bonnard's and even Vuillard's intimacy occurs, while the exquisite formal colour harmonies of Matisse also make themselves felt across the surfaces of Young's occasionally masterful paintings.

Young was born in the north Liverpool suburb of Walton in 1921, though he spent the first ten years of his life in Deptford, London, not returning to Liverpool until the depression of the 1930s. He began work as a labourer, aged only 14, in a small Liverpool engineering company, but spent most of the remaining pre-war years working as an electrician in a Newcastle shipyard. In 1943 he went to sea as a radio operator in the navy, and travelled widely. After the war he returned to Tyneside, but when his father died he went back to Liverpool with his mother, who subsequently ran a chandler's shop in Bootle. The drawing shown here was based on the kitchen of the Bootle premises and signifies both the artist's facility with the pencil — the exquisite balance between the need to relay enough detail while retaining a broad, wholesome, plastic vigour — and his natural ability to create a sense of beauty and grace out of apparently unpromising, poverty-stricken scenes. Another interior from this period was his *Morning Interior* (1957), depicting the artist in striped red trousers next to a table

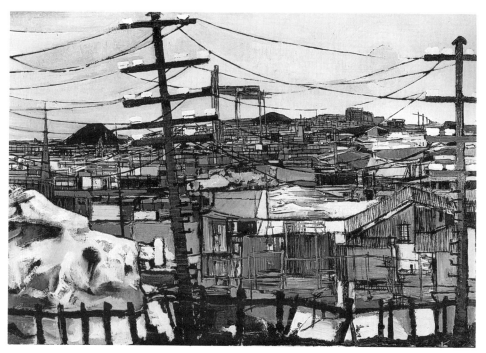

John Heritage Landscape No.2. *Coll: Walker Gallery, Liverpool.*

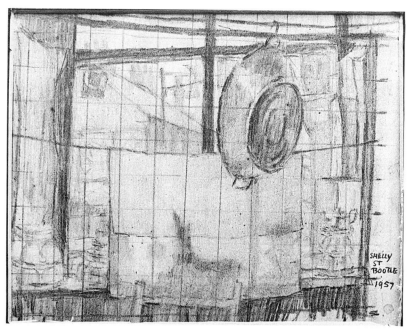

Richard Young Bootle drawing, *1957.*

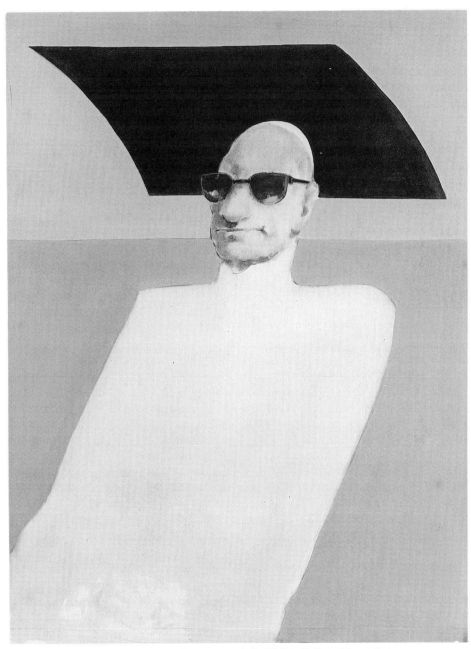

John Heritage Pope in a car. *Coll: Walker Gallery, Liverpool.*

laden with breakfast items. Charles Sewter wrote that the picture was indebted to Bratby, a fact that illustrates, not Young's derivativeness, but rather his unpretentiousness in feeling free to borrow at will from other artists' work. It was bought by the University in 1989.

Throughout his working career, Young treated art as an essential activity, but not one by which he sought to live. This fact should not cast the artist in the role of amateur, but rather should illustrate the fact that his ordinary working class background never allowed art to gain unrealistic proportions, which is why Young's work succeeds while the work of career art teachers so often fails. He began working as a freelance electrician in Liverpool, and was invited by Nicholas Horsfield to join the Liverpool Academy in 1958. He exhibited works every year after that, and John Moores acquired a kitchen interior from Young. The Academy gave Young "a sort of impetus that gave you a reason to continue"[6], and a number of sales were generated throughout the years of his membership. Margo Ingham, the energetic Manchester entrepreneur who in later years lived in Southport, acquired a dark Young still life painting. She also reviewed his exhibition in the 1970s at the Academy's Renshaw Street Gallery.

Young joined life drawing classes held by George Mayer-Marton, Arthur Ballard and Austin Davies at the art college. Never too proud to learn from these professionals, Young was enough of an artist to follow his own nose in the personal matter of choosing a genre and style, and after the kitchen sink phase he pursued an interest in Bomberg. Young became fascinated after seeing some articles on Bomberg, and for a time he reduced his palette to black, yellow and white. The still lifes or self-portraits acquired a rough and pronounced impasto, a kind of painterly monumentality given a dramatic edge through crude yet powerful tonal treatment. As with the delicate pastel shades and subtly tinted greys of the monochromatic interior pictures, Young could release extremely powerful colouristic or tonal effects through the simplest and most understated of means. The key to reading many of Young's best pictures lies in walking away from them. At an adequate distance the subtle shifts and spatial interplay between forms and tones come into focus, throwing light on the artist's exceptional ability to conjure coherence and harmony out of apparent chaos.

Dick Young's subjects are conditioned by the reality of painting at home. His home provided the ambiance that seemed to suit him best. He acquired a Bridewell studio in 1980, but it was used more as a store room while his sparsely furnished front room at home remained his main place of work. On the occasions when Young departed from views of modest rooms, images of self in a mirror, or of laden tables, it was only to paint views through his own windows. The quest to say the most by the most restricted means is a hallmark of the work of many significant artists. It is a foil that releases in the artist the fullest plastic rigours and strongest formal energy. The

window, as an object that links the outside world of the street with the inside world of the room, has also intrigued Young as a potentially significant pictorial symbol. Ever the interpreter of the psychology of the domestic inhabitant, Young is interested in the window as an object that is sometimes looked at, or at other times looked through. The window, while providing formal visual interest with its simplified lines of composition (window frames, curtains and architecture sketched outside), also acts as a metaphor for the sitter. The consciousness of the sitter is perched, like the window itself, at the junction between the interior (subjective inner life) and the objective outside world.

For all his down-to-earth honesty, Young has always resisted any pressure to conform to a specific Liverpool 'group', 'style' or 'theme'. He has always steered his own course, able on occasion to feed off the inspiration of major artists like Sickert, Bomberg, and more recently Matisse and the American Milton Avery. The interest in Matisse evolves from preoccupation with the interior, a subject that encourages association between interior design and pictorial art. Young in terms of both style and theme, could never relate to the flat, photo-based pictures of Walsh, Henri, Baum or Cockrill. Instead he comes closest to Nicholas Horsfield, who although more interested in the outside world of the Normandy landscape with its impressionist colour, does share with Young a Sickertian manner of paint handling and an earthy range of subject matter. Young admired Milton Avery's relaxed attitude to painting that sometimes allowed considerable areas of canvas to remain untouched. It links in with an interest in the canvas as an object that we first saw when Young's painted view of a window doubled up as the actual window itself.

Young showed work in the large Hayward Gallery drawing exhibition in 1982. *Interior L8* depicted a solitary chair in an empty room. Young has always drawn, delighting in a relaxed graphic style that is very linear in its structural approach (always searching for a compositional harmony). Whether drawing or painting, he has always seemed to be feeling for the actual physical space of the flat sheet of paper, canvas or board he is working with. This is a sure symptom of a formally strong artist, and Young is one of the most powerful yet underrated artists dealt with in this book. The line in Young's drawings has a somewhat wobbly, febrile quality about it, emphasising the hand-made and therefore personal and expressive intentions behind the work. The naive and childlike can even on occasion be alluded to, though Young's position as a painter is as premeditated as it is natural to him. He once said that he could never paint a picture with political or philosophical significance — however much he might have wanted to — a fact that leaves him "with a small aesthetic feeling" deriving from a simple love of the paint medium. Philosophically Young shares Gombrich's ideas about art as an illusionist device — as we have seen the

artist exploits *trompe l'oeil* effects. For all his interest in surrealist art, Young took an entirely different path, his imagination subsumed within the mundane compositional confines around him.

Young has exhibited frequently. In the early 1970s he had a moderately successful solo show at the Bluecoat, while he sold three oils hung at the 1986 Royal Academy exhibition. A willing exhibitor in less salubrious local settings, he enjoyed meeting artists from other milieux. During a 'members' choice' exhibition held in the Liverpool Academy Gallery in Pilgrim Street (that included Uglow and Kossoff), Young met Alan Lowndes, an artist with whom he had some sympathy though not on account of Lowndes' fairly ambitious careerism and commercial association with a leading London gallery.

Donald McKinlay was one of Arthur Ballard's protégés during the 1950s, painting in an impastoed, rectilinear style demanded by the de Stael cult. Yet McKinlay was never a convincing abstractionist in spite of possessing a natural inventiveness with his hands. For a time this enabled him to produce wood reliefs and free-standing wooden constructions that proved popular items in Liverpool Academy exhibitions during the 1950s. But his most usual Sickertian style of painting is a latter day variation of drab working class streets and bedsits. Apart from the two Arthurs, Dooley and Ballard, it is hard to imagine a more typical Liverpudlian — direct, occasionally abusive, naturally talented in the basics of his chosen craft, and uncompromising. His qualities as a teacher took him over to Manchester where from the mid-1960s on he taught, living in a house on the moor above Bury.

McKinlay was born in Bootle in 1929. His father was a feature writer on the *Liverpool Daily Post*, specialising in crime stories. McKinlay entered Liverpool's Art School in 1949, an experience that gave him vivid appreciation both of the privilege of art school and of the importance of art. The lesson was not lost on McKinlay, for he was to spend much of his working life in the art school situation, to the extent that it prevented him ever becoming professionally ambitious as an artist. The desirability of having a relaxed attitude to one's paintings is a matter open to debate. McKinlay's regard for Sickert began in earnest at the art college and was due to the influence of Martin Bell, who for McKinlay represented the chief source of inspiration. Bell was a very precise teacher who imparted set procedures and technical basics to the art of painting. He even led the students, McKinlay among them, to paint murals on dry plaster walls, using blotting paper to dry out the oil. Bell loved Sickert's work and not surprisingly, most revered the chalky, dry, matt pictures of the late 1930s — the artist's last. The photographic source material also provided echoes of a modernism not so much based on formalist practice as on a quirky approach to subject matter, visual tricks and so on. Bell also accepted Braque and Picasso —

though not the post-war American iconoclasts — and declared a Soutine painting of a piece of meat to be as good, in its different way, as a Rembrandt. Other teachers who had an effect were Coburn Witherop (McKinlay attended his drawing classes), Stan English (who taught him ceramics which led to his interest in plaster and built-up sculpture) and George Jardine (who taught him lino printing). The whole atmosphere was stimulating with ex-servicemen like John Hart and Clifford Fishwick importing a peculiarly post-war worldliness to student life.

In 1951 McKinlay went into the army for two years on National Service. There followed two years on Social Security, a period that at least allowed him to develop his painting on Bedford Street. He produced a painting — no doubt inspired by Gauguin — in oil and wax on a Tahiti subject which entered the Liverpool Academy and won attention from *Guardian* critic Charles Sewter. He unsuccessfully tried to open his own commercial silk screen business and fell back on a job as a stage painter for the Liverpool Playhouse. The job was full-time for four years and it effectively stopped his own painting. McKinlay disliked the job, for in the days shortly before the advent of kitchen sink drama and angry young men, the theatre still had a middle-class ambiance. For three years after 1956 McKinlay taught art at a boys' school in Netherton. He started exhibiting annually at the Liverpool Academy, and his contributions were noted in the press. Participation in an exhibition of five painters followed at the Bluecoat Gallery. Like so many others at this time, McKinlay was heavily influenced by the charismatic Arthur Ballard. His work became non-figurative for a time, made up of great slabs of thick paint. A series of monumental figures in dark spaces was produced. In the late 1950s McKinlay followed the advice of Ballard and visited Paris, where he saw the work of Appel and Tapies. Their full commitment to paint, materials and texture had a pronounced effect, and Tapies, in particular, influenced McKinlay to make reliefs in wax, wood and oil paint for a couple of years. These works won acclaim when shown on Merseyside and struck the contemporary chord of tachiste and tactile construction.

McKinlay made several important friendships during these years. Austin Davies, a painting tutor at the art school, became especially friendly, helping McKinlay get work into local exhibitions. Davies' father was Hinchcliffe Davies, the renowned local architect who built the Corn Exchange. Ballard was another important friend. McKinlay visited Cornwall with Ballard in the late 1950s where they met Frost, Wynter and Lanyon. The whole ambiance was impressive, and the Cornish artists appreciated Ballard for the tough commitment of his work which at the time seemed a northern variance on (particularly) Lanyon's work. But to McKinlay's eyes, St Ives art looked too American and he did not wish to identify with the abstract expressionists so much as with the European abstract artists. He seemed to

97

be echoing his former teacher Martin Bell's dislike of post-war American art.

Gradually McKinlay built up a teaching career. He spent two years at the small art school in St Helens and through Adrian Henri began part-time teaching on the Foundation Course in Manchester. This later became full-time and he remained a forceful teacher in Manchester until his retirement in 1990. In the mid-1960s McKinlay went to live in a house on the moors above Bury. He disliked the complacent tenor of the Manchester Academy and only exhibited with the Liverpool Academy when he moved across to Bury. McKinlay had for a number of years been making wood assemblages and constructions, some of them abstract, others of animals or mysterious figures. But he was by nature a figurative painter whose work benefitted most from his natural draughtsmanship and subtle, if grubby, handling of tone. He began venting his political anger by using protest imagery derived from photo-journalistic sources. At the end of the 1960s he had a sabbatical year in India where he taught and became very involved with Indian culture. The next few years saw a lull in his professional life as an artist, and he painted mainly private autobiographical themes. The painting of his friend and colleague Sam Walsh leaving the Walker with a rejected painting under his arm was exhibited at the entrance to the large Sam Walsh retrospective at the same gallery in the early months of 1991. McKinlay is a wry observer of his own or his friends' faces. The figurative drawing, kitchen sink subjects and, latterly, photo-journalistically-derived imagery set this artist within the post-Sickert orbit that is a still under-appreciated aspect of British realist painting.

Another local artist, and contemporary of McKinlay's, John Heritage, was also helped by Arthur Ballard. Heritage studied at Liverpool Art School in the late 1940s and did his national service at Blackpool in 1954. Ballard persuaded Heritage to enter the art school as a junior. He studied sculpture for two years under Charles Gardiner, and such was his talent that he entered the Slade for a year in 1955. Gardiner had taught clay modelling and Heritage made modelled heads at the Slade. Reg Butler taught Heritage and gave him advice about breaking out of the academic mould. Money was scarce and Heritage was only able to last a year by virtue of living with a relative in Harrow. He returned to Merseyside and began teaching in schools. In 1961 Heritage spent a year at the British School in Rome, where he began drawing and painting. The architectural studies of Roman streets were exhibited in the mid-1960s at Frost and Reed in London. At this time he became a secretary of the Liverpool Academy, seeing the presidency change from Horsfield to Ballard.

After returning from Rome Heritage began teaching at a school in Anfield. His paintings showed sculptural influences. The large emulsion

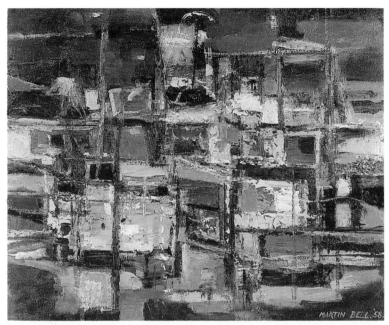

W. Martin Bell Seaside fairground, *1958. Oil. Coll: Walker Gallery, Liverpool.*

William Stevenson Milan. *Oil.*

99

Anthony Butler New Brighton Pier, *1956.*

Anthony Butler Cab wheels, *1955.*

paintings of iconic beauty queens or of popes in irreverent sporty gestures, showed the artist breaking down monumentality with a breezy humour. Pop art had its effect as on so many of his contemporaries, and the early work of Patrick Caulfield (also in flatly painted emulsion) had an important influence, both for its spare formal characteristics and for the irony of the imagery. Heritage found oil paint too versatile at the time and preferred emulsion because "being drier, leaves no illusion". From 1972 to 1979 Heritage was Head of Wallasey School of Art and then Vice-Principal of Wirral College of Art. He built up Wallasey, opening the college to the public for pottery and jewellery classes. Wallasey soon after merged with Harry Hoodless' Birkenhead Art School to become the Wirral College of Art. Arguments in local government about who would run the new college led to Tony Helliwell's appointment. In 1979 Heritage moved over to Wrexham as Dean of Clwyd College of Art, but continued to live in Wallasey. Throughout the 1960s Heritage had a Bluecoat studio.

Heritage's experiences in educational administration inspired — if inspired is the apt word to describe committee men — a series of cartoon-like skits on people in boardrooms or on coaches. He followed Sickert's dictum that caricature must be a blatant and cogent form of communication. His first teaching job at a school in Heywood meant railway travel every day and his visual memory of lines, cables and telegraph poles led to the successful rectilinear composition, acquired by Walker director Hugh Scrutton for his gallery from the Liverpool Academy exhibition.

Another local artist who was acquired for the Walker collection, George Kennerley, came into art from an entirely different direction. He only began painting in 1950. Kennerley was for many years a managing director of Vernons Pools. He was a friend of John Moores and built up a formidable collection of pictures that included de Staels, Bombergs, Scotts and many others. A naturally gifted figurative painter, he often painted copies of famous paintings he owned, and upon the suggestion of Martin Bell, sent in work to the Royal Academy. He showed a still life at the well known 'Artists of Fame and Promise' exhibition at the Leicester Galleries in 1953. Much of his knowledge and practice came about through collecting. At various times this wealthy man owned Vuillards, Bonnards and Augustus Johns and he used these as models to copy. Kennerley was given a one man show by Andras Kalman at the Crane Gallery in Manchester, from where the Walker purchased its own painting by the local self-taught derivative. Kennerley knew William Brooker who took him down to Corsham Art School outside Bath. Here he met some of the St Ives artists and befriended the Corsham head, William Scott, from whom he learnt much about painting.

Anthony Butler (born 1927) came out of Liverpool College of Art at the end of the 1940s. Henry Huggill saw the drawings that Butler produced at

school and duly accepted him into the art college. Butler found the art college before bureaucratisation an "exceedingly happy place",[7] in which he could pursue drawing and illustration under the able guidance of Wiffen, Wedgewood and Tankard. He went on to spend a year under Martin Bell in the painting school. Bell's cautious approach — a product of what the critic Basil Taylor referred to as his "seriousness, intelligence and integrity"[8] — was complemented by the dynamism of Arthur Ballard. Butler's studies were interrupted by R.A.F. duties. During most of the 1950s he taught at Eric Gill's St Helens Art School, where he was influenced by the elder man's interest in pottery. After St Helens Butler taught at Birkenhead School until his retirement in the late 1980s. Teaching meant he never had to earn a living solely from his painting, which was just as well for the artist's output was high in quality but poor in quantity. Butler's work never lost its link with natural form though a linear rhythm of independent force pervaded such pictures as the Walker's *Web* (1953) — based on seeing a spider in a dark storeroom at St Helens — and *Cab Wheels*. As with a number of Butler themes, *Cab Wheels* was inspired by nostalgia. He remembered seeing horse-drawn carriages on Lime Street as a youth and he used an old carriage yard in Southport to make many preparatory drawings. The artist's *Fish on the Shore*, also belonging to the Walker, was inspired by a flat fish washed up on the shore near his home at Caldy. Similarly, the Walker's *Landscape* was based on a Welsh view, though what he referred to as the "contagious" effect of de Stael led to the use of a palette knife to construct a picture with fat slabs of paint. Butler saw de Stael's work in London, though on trips to Paris he had also been affected by Feininger and Viera da Silva, whose own abstractions involved a use of linear labyrinth in a forceful spatial setting. Closer to home and a little more down to earth was the influence of the Scottish painter Joan Eardley, whose late seascapes provided an example of what outdoor painting could be.

Butler showed work in some important exhibitions throughout the region. One was the Agnews exhibition that displayed the Walker's acquisitions in the aftermath decade of 1945–55. In the autumn of 1955 he showed in an exhibition of northern artists at the Manchester City Art Gallery, which bought one of his exhibits titled *Flamingoes*. In 1956 he participated in a four man show 'Young Northern Painters' at the Crane Gallery in Manchester. At this important commercial gallery, Butler sold two pictures based on New Brighton Pier. He was drawn by the pier's linear structure and shafts of light. From drawings made under the pier he worked up oils at his West Kirby home. Further success came when in 1958 Granada bought *Low Tide* from the Liverpool Academy.

None of the Liverpool-born artists featured in this chapter relied for a living solely on their work. The failure of Liverpool artists to do themselves

justice by breaking into the all-important London gallery world seems as much to do with the frequency with which they became involved, 'bogged down' even, in full-time teaching careers, as with the dearth of effective commercial and promotional outlets on Merseyside itself. Liverpool artists have long had a problematical relationship with the London gallery establishment, the Merseyside area being seen as distant and provincial. Successful forays, such as Arthur Ballard at Delbancos in the 1950s, George Jardine and Sam Walsh at the Portal in the 1960s, or Arthur Dooley at the St Martin's Gallery, prove the exception rather than the rule. Indeed, one of the area's brightest lights in recent years, Maurice Cockrill, only established himself at the prestigious Bernard Jacobson Gallery after leaving Liverpool for the metropolis in the early 1980s. Peter MacKarell, born in the north Liverpool area of Fazakerley in 1933, also moved south to London, but in his case it was to pursue a career in art education (he was at Goldsmith's from 1971 to 1987), rather than to throw caution to the winds and set up as a full-time painter as Cockrill was so successfully to do.

MacKarell's father, a shipwright based at the docks, encouraged Peter's flair for literature and drawing. Peter was at Allsop's Grammar School at Anfield, before entering Liverpool College of Art in 1950. He started in graphics under George Jardine but moved into the painting school under Arthur Ballard. After national service in Singapore between 1955 and 1957, he qualified as a teacher and taught on Hope Street during the 1960s. He married one of his students, the Irish-born Joan Rosser. During the late 1950s MacKarell lived in Huskisson Street and his imagination was drawn to the docks, where he painted dock scenes and he also produced portraits. He was a playful, imaginative artist and for seven years after 1965 he invented characters and produced illustrations for the *Times Educational Supplement*. In the early 1960s he produced a series of paintings, influenced by Larry Rivers's *The Next to Last Confederate Soldier* (an important transitional painting between Abstract Expressionism and Pop Art), based on American Civil War and Napoleonic themes. Although MacKarell declared that "descriptive graphic drawings" was the key to his work, John Willett found that his paintings — particularly of romantic 19th century battle scenes — were much freer and more spontaneous. Liverpool University owns a particularly energetic confederate picture, *The Charge of the Texas Dragoons*.[9]

John Edkins was two years older than MacKarell and came from London. He was a very talented painter whose career was cruelly cut short by an early death in 1966, as a result of complications after a series of operations for a replacement heart valve. He studied at Ealing School of Art after the war, then following a spell as a gardener, entered the Royal College. In 1957 he went to Mykonos on a travelling scholarship and in the late 1950s began a teaching career at Bideford School of Art. In 1961 after

John Edkins Nomex. *Coll: Walker Gallery, Liverpool.*

three years teaching in North Devon, he joined the staff at Liverpool College of Art, thereby beginning the association with Liverpool that lasted the remainder of his short life. He lived in the Liverpool 8 area and in 1963 wrote that "although I have painted continuously I have been constantly dissatisfied with what has happened."[10] This early statement suggested a restless, searching artist who had not yet reached his target. Nicholas Horsfield suggested this when writing many years later that "he was a very sick man for his last year or so. He was a very good painter, who could have gone a long way."[11] What he did achieve always went on public display. In January 1966 he had an exhibition of ten paintings and three constructions at the Bluecoat, a pleasing enough acknowledgement of his progress even if he declared that he preferred his work to be "exhibited in a more comfortable place than the Bluecoat."[12] The scale and broad spatial statement that formed the essential components of his art demanded a large, uncluttered hall, and if the Walker provided this during Academy group shows then the cramped hanging with many other, very different, kinds of art nearby spoilt the effect and worked against the Walker's spaciousness. Possibly this was one factor behind his declaration of being "lazy about exhibiting my work, not really thinking that it was worth the trouble."[13] It was a sad irony that Edkins's one man exhibition in the Walker was a posthumous one put on in memory of his life and work on Merseyside.

In the artist's 1966 Bluecoat exhibition two paintings were included that went into important collections. They were *Nomex*, acquired by the Walker and *We Love the Beatles* which went to Granada. *Nomex* was described at the time as possessing a serenity "achieved partly through the large areas of distinct colours, and partly through the delicate balance of the clean cut geometrical forms on the canvas." Thus colour and form acted on the surface as balancing elements. Yet Edkins's work contained more than mere surface qualities. It was never absolutely concrete and tied to a rigid minimal or neo-plastic surface. Rather it contained playful, lyrical, and even romantic characteristics. The dynamics of colour were one obvious way to elicit more subjective, emotional responses, but Edkins's use of geometrical form also contributed towards a playful or lighthearted mood by functioning as unpredictable, rhythmically inconsistent elements in disjointed perspectival arrangements. Therefore both colour and form acted in their differing ways to break down the static effect of flat surface pattern. Furthermore, Edkins's geometric box of tricks was akin to the kinds of emblematic images that abound in the urban environment. Thus flags, symbols, transport signs, signals and so on seemed to be alluded to, although Edkins's images were set in a distinct non-functional, that is to say non-communicative, context.

If the images were shorn of informative significance, then Keith Arnatt

105

explained in the Bluecoat catalogue that "they do affect us psychologically".[14] That psychological effect was part the mystery of colour association, part the innuendo of enigmatic formal relationships on the surface. But above all it was the result of what Arnatt described as "the use of parallel perspective which creates ambiguity of reading, and distortion . . . forms appear to lie parallel to the picture plane, and then to recede obliquely into the picture plane." In other words, like Robin Rae, Edkins reached the classic modern synthesis between surface flatness and illusionary depth. Also in tune with Modernism since Matisse, Edkins constructed with colour. In spite of being "entirely subjective", colour also operated on a formal level, constructing a composition on the flat surface of the canvas, and highlighting through contrast where one form gave way to another. Drawing was thus sublimated to the level of colour contrast. He never pre-designed a composition, but used masking tape for the final hard-edged images. Remixing and overpainting was often necessary when process failed to produce a desired outcome. Many of Edkins's pictures, like the Walker's symmetrical *Seven Answers*, operated along conventional figure/ground lines. The consequential "growing preoccupation with the expression of the third dimension", that the plastic reality of the picture plane determined was not actually physically there, found its logical conclusion with the reliefs and constructions that Edkins started to make before his death.

Edkins's life on Merseyside was spent quietly. He and Ballard got on well though Edkins's health problems prevented him participating in pub life. He had a large flat and studio in Princes Road, where he absorbed himself in his work. A small group of friends included Keith Arnatt, Neville Weston, Roger Smith and Robin Rae. Edkins was interested in the Bauhaus, but being a pragmatic rather than theoretical artist he seldom followed other people's systems. Interests outside art had their due influence. He used photography to gather information, sometimes using a camera like a microscope and homing in on an object in order to rid it of familiarity and render it as a geometrical shape. Edkins's other interests were cars, toys and hot air balloons, the spatial movements of which inspired pictorial ideas. Constant ill health had prevented him enjoying a normal childhood and for this reason he probably continued childhood interests into adult life. He maintained an optimistic, fighting attitude to health problems, and often painted throughout the night to classical music. Like Stuart Sutcliffe in Hamburg, Edkins painted away as if there were no tomorrow. In the final year of his life he married Andrea Longsbottom (a student whom he had met in 1961) and lived in Formby.

Edkins liked the intimate and whimsical world of Klee, was impressed with the spatial sensations conveyed so simply yet clearly by Albers in the *Homage to the square* series, and admired Schwitters. He visited Schwitters' Merz barn in Ambleside. In his last works Edkins reached a more serene

harmony and balance with his geometric forms. He scoured *Scientific American* magazine, finding visual rather than scientific interest in molecular and microbiological articles. He also found interest in the visual patterns of everyday objects displayed in shop windows. Similarly he liked colourful objects in the new Rymans stationery chainshops. Edkins took such interests into the personal domain of his life, wearing clean, colourful clothes and painting alternate rooms in his Formby house in red and brown schemes. The push and pull factor of colour dynamics greatly interested him and he spent hours staring at a picture surface in order to judge the effect he was after. He was interested in Op Art and went to see a Bridget Riley exhibition, but generally his concern was with a more static 'gestalt', one that did not explode into shifting optical movements and vibrating interactive colour. Rather, the artist's purely plastic interests took him into the third dimension of wall-bound reliefs, which were adorned, or rather constructed, with similar colour quality to the paintings. In his works Edkins used emulsion on canvas because emulsion conformed to his interest in industrial products. The medium also lent a surface anonymity, allowing the spectator to experience the colour rather than the surface. Edkins often used unbleached calico (of the kind used for tents and sails) as his chosen support. It was painted over after tight stretching.

Robin Rae, who was born in London in 1928, knew John Edkins as a fellow art student at Ealing after the war. Each went on to the Royal College before eventually ending up as tutors at Liverpool College of Art in the 1960s. Rae entered the Royal College on a scholarship, and during his three years there in the early 1950s was impressed by Bacon and Moynihan. He was clearly quick to mature, for in 1946, aged just 18, he had a work exhibited at the Royal Academy, and before the decade was out had enjoyed two commercially successful shows in London, one of which gained a complimentary review from Eric Newton. Rae's work had a simple, poetic quality bordering on the visionary. Nothing could be more appropriate, for instance, for the R.A.'s first post-war exhibition than an unassuming picture of a group of figures planting a tree. So promising were his natural gifts that he was advised not to over-educate himself by going to the Royal College. But go he did, and he found there a renewed innocence through dabbling in current kitchen sink styles. He befriended Jack Smith during his time on Exhibition Road. Thereafter, Rae always questioned the values and pitfalls of education and after ten years of teaching — four in Edinburgh then six in Liverpool — he finally dropped out of his profession. This was an irony because Rae gained a wide reputation for the forceful yet sympathetic nature of his dealings with younger artists.

Rae found in Edinburgh an art scene too established and complacent for his own taste and so was pleased when, through John Edkins, he met Arthur Ballard in a Hoylake pub. Ballard helped him obtain a position at

Robin Rae Caradoc. *Coll: Walker Gallery, Liverpool.*

108

Liverpool in 1963 and he taught full-time until 1970. Rae fell into a ready-made slot in Liverpool, where not only Edkins but also Roger Smith had been fellow students at Ealing. An experimental fervour, precipitated by Thubron and Pasmore, fired Edkins, Smith and also Keith Arnatt in Liverpool at this time. Rae moved with his wife out of Liverpool and lived close to his colleagues in Formby. Most of his teaching was in the foundation department, allowing him and colleagues like Henri and Walsh to indulge in a wide-ranging, liberal approach. Rae started to make shaped paintings, generally cut with a saw from chipboard. Where figures or other forms were silhouetted against striped backgrounds the artist stuck down jigsaws of cut chipboard onto plywood backing planes. In the more abstract pieces Rae called into play his interest in parallel perspective, and by so doing touched on a common interest among non-figurative artists during the 1960s. The colour was generally typical of the period in being assertive and bright. Unfortunately, many of the Liverpool 'jigsaw' works were destroyed, though one of the best, *Caradoc*, was acquired by the Walker Art Gallery. Hugh Scrutton, the Director at the time, disliked Rae's work, but gave John Jacob, the Deputy Keeper, the choice of making an acquisition as a leaving present when he went to London. Jacob knew Rae and was interested in local artists. He chose *Caradoc*.

Although *Caradoc* seems an abstract picture shaped from a number of interlocking, geometrical components, the painted image within the compositional shape itself contained organic, landscape references. Indeed, the interplay between the mechanical composition and the organic references was a conscious ploy, a metaphor for the interaction between the intellectual construction of a picture (colour and form) and the emotional content of the image. Seurat was an artist Rae admired for these reasons and the dull purple, olive and grey metallic hues of the picture were conveyed with many dabs of paint in an almost pointilliste manner. The colours were in fact those of a hill of the same near Church Stretton. The artist achieved a particularly smooth surface by rubbing down the chipboard and sealing it with cellulose prior to painting it. The smooth, almost manufactured quality that resulted seemed to contradict the organic naturalism of the painted image. The picture was bought by Jacob from a Liverpool Academy exhibition where it was hung with several other Rae abstracts, and the gallery later acquired from the artist all the working drawings. Rae pursued personal interests in this and other similar works. In his etchings he pursued an interest in mechanical pattern not by imposing a purely abstract design but rather by abstracting and simplifying a mechanical subject such as a factory. In his shaped pictures, Rae continually challenged the artificial boundaries between abstract and figurative form. He did not feel part of an international, or even a local, group style. Although he shared some concerns with his friend John Edkins,

Ray Fields Birkenhead Docks, *mid 1950s.*

William Turner Ellesmere Port. *Oil. Turner, a Manchester painter, has painted Merseyside subjects. His penchant for depicting dramatic tonal effects and strangely lit industrial panoramas contributes a vein of topographical landscape to a Liverpool art scene that has seldom chosen to represent such forms of urban realism.*

Rae's work was more romantic, open-ended and playfully experimental than Edkins's which was more purist in intention. In 1970 Rae followed a number of people associated with the Liverpool art scene down to Dorset, where he set up a silkscreen fabric business with his second wife. His own painting retreated from the formalism of the 1960s and became more referential and poetic, in response to the Dorset landscape.

John Edkins's general curiosity about formal spatial division and proportional systems was such that he made regular visits to the graphic department of the art college. Within this department, his friend Roger Smith ran a topographical printing course and Reg Cox taught photography, an interest which engaged Edkins. An artist who came into the graphic department in 1965, Ray Fields, introduced significant innovations such as film animation and audiovisual studies.

Fields, who came from a working-class Birkenhead background, was only a year older than Edkins. He came to art through the advertising world. Having left school at 14, he produced posters for the Coal Board, Littlewoods and Lewis's. After national service he went freelance and concentrated on packaging design. Fields also taught himself to paint, although from 1946 to 1948 he attended life drawing classes most evenings at the Laird School of Art, under the guidance of Charles Sharpe. He lived in Bebington and married in 1952. The following year he went on his first holiday to Cornwall with Eddie Forrest, another commercial artist from Birkenhead with whom Fields used to paint in the docks area of Birkenhead. The view of a large ship at the quay in Birkenhead shows how Fields painted during this time. It has a strong design and a rigorous, knifed handling.

In Cornwall Fields and Forrest met Marcella Smith and Dorothea Sharpe, two important post-impressionist painters of holidaymakers and their children on the beach. They ran Lanhams Gallery in St Ives and sold Fields's *plein air* landscape paintings in the gallery. Fields was taken with Cornwall and he made annual visits thereafter. He was impressed not only by the natural surroundings, but also by the art atmosphere which allowed for chance meetings with Barbara Hepworth and Sydney Graham. Cornwall was indeed an integral part of Fields' education. At the suggestion of Alfred Wiffen he began exhibiting his landscape paintings at the Liverpool Academy, and Will Penn likewise encouraged him to show with the Wirral Society of Artists. Indeed, in the mid-1950s Penn opened a two man show of work by Forrest and Fields at a small gallery in Islington, Liverpool. The friendship extended to Fields visiting Penn's Caroline Place house in Birkenhead for dinner. In spite of family problems and his dislike of much post-war modern art, Penn enjoyed the company of younger people and was a good host. During the first half of the 1960s Fields's design bias led to his teaching in the graphic design department at Chester. About this time

111

the St Ives connection came home to roost when he met Terry Frost and then Harry Thubron at the Barry Summer School. As a result he experimented with mobiles and metal structures while teaching at Chester. But the real breakthrough for him at this time was film animation. Fields was a full-timer in graphics at Liverpool from 1965 to 1988, where he developed first-year graphics studies, introduced animation and audiovisual studies, and even took students to Germany to see Max Bill's design course. One essential point about animation and movement studies that Fields developed was that they needed the fundamental, formal disciplines such as drawing and use of colour. As well as exhibiting with the Royal Cambrian Academy (he became President in the mid-1980s) Fields had an exhibiting career with the Liverpool Academy and the Wirral Society during the 1950s and 1960s.

NOTES

1. John Willett, introduction to catalogue for the Nicholas Horsfield retrospective exhibition, Camden Arts Centre, October 1984.
2. Conversation with the author, Liverpool, 21.6.91.
3. ditto.
4. ditto.
5. *The Times* Obituary by Hugh Scrutton, August 1960.
6. Conversation with the author, Liverpool, 1990.
7. ditto, Wallasey, June 1990.
8. Basil Taylor, letter to Anthony Butler, 31.8.55.
9. John Willett, *Art in a City*, p.186, Methuen, 1967.
10. John Edkins, letter to Mary Bennett, 26.8.63.
11. Nicholas Horsfield, letter to the author, 7.5.91.
12. John Edkins, 12.2.66.
13. John Edkins, letter to Hugh Scrutton, 12.2.66.
14. Keith Arnatt, introduction to John Edkins exhibition, Bluecoat Gallery, January 1966.

Sculpture and the art college

Once established, the sculpture department at Liverpool College of Art created a network of sculptors among the staff and the students, which went on to distinguish itself in many different ways. The man responsible for building up the sculpture department on Merseyside was George MacPherson, whose own modest sculpture career was secondary to his career as a forceful and dynamic teacher of sculpture from 1954 to 1971. Born in Hackney, London, in 1910, 'Mac' studied painting at Liverpool College of Art between 1927 and 1932, under the guidance of Penn and Huggill. He continued his studies at the Central School in London under William Roberts and Alfred Turner. His notable teaching career began at the small art school in Wallasey, but personality clashes with the school's head led to an early move. In those early days before the war, MacPherson frequently painted outdoors, specialising in rural Wirral (flat) and Welsh (hilly) landscape subjects. Around this time the young artist was married in Wallasey.

MacPherson's eventful war service is worthy of brief note for it involved much foreign travel. His wife Hilda returned from London to Wallasey (she had her first child in 1941 and a second in 1946). MacPherson joined the coastal naval forces and moved to Sheerness, Hastings, then Swansea. Eventually he was posted to the Far East and spent three years in the navy in Ceylon. Just as the war was ending, and with clearing-up duties off the Belgian coast, MacPherson lost a leg in a dreadful accident during a mine-clearing operation in the North Sea. He spent nine months recovering in hospital, before returning to Liverpool. It was at this moment, still suffering from an arduous war experience and a traumatic injury, that he discovered sculpture. A family contact led to his making clay models for the shop windows of a fashion house in Birkenhead. Immediately, he found an affinity with the medium.

In 1954 MacPherson replaced Charles Gardiner as sculpture master at Liverpool Art College, and thereafter he assembled a worthy team of sculptors and technicians. In Neville Bertram he had a traditional craftsman and architectural carver of considerable skill and experience gained from an ongoing apprenticeship with his father-in-law Herbert Tyson Smith. In addition, Mac recruited Sean Rice and Philip Hartas, followed later by Roger Dean, Ian Carrick, Rod Murray, David Morris and Mike Yeomans. These later sculptors all took their sculpture practice into an experimental area. Roger Dean later became head of sculpture at Exeter and produced

113

a West Country style that imbued abstract monoliths with organic suggestions. Ian Carrick, a keen sailor, introduced poles as balanced units in his work. David Morris made maze-like, perspex constructions, exploiting to the full the rainbow effects of light refracted through the perspex. Mike Yeomans made polychromatic chessboard models in card and wood, while Rod Murray, a former painting student on Hope Street, experimented with laser light effects. He was brought in to teach kinetic sculpture, using his knowledge of electronic visual effects. From having to share a single room with ceramics in the overcrowded main building on Hope Street, the sculpture department by 1960 had grown to the extent that it had to move into the more spacious premises of a former Dr Barnardo's Home on Myrtle Street. This move allowed many more sculptural techniques to be practised. Sean Rice was brought in to teach welding and metalwork, and Philip Hartas to teach foundation sculpture.

The practical spur to MacPherson's adoption of sculpture may have come from commercial clay modelling jobs, but before the war he had enjoyed the privilege of staying with Jacob Epstein. The experience was surely inspirational if not directly formative for his future vocation. Mac's girlfriend, Isobel, was working as a model for Epstein. Mac was immediately moved by the series of portrait busts of young children. He may not have received any direct tuition, but it is not hard to imagine the value of witnessing works in progress. Later MacPherson made sensitive studies of children, family and friends, though the main thrust of his work was towards refined, finished surfaces. His portrait heads were first cast in plaster, then in metal resins. A group exhibition of such work was held at the R.W.S. galleries in May 1954, and prompted Neville Wallis to write a review in the *Observer*.[1] MacPherson's portrait of his son, Stuart (whom he later taught at Liverpool Art School), was illustrated in the paper together with Willi Soukop's *Anita* and David Evans's *Harry*. He also carved in wood and through a friend, Liverpool timber merchant Vincent Murphy, obtained for the students rare woods which encouraged direct carving in the college. He carved himself in high quality African woods, and in the 1960s and 1970s began making abstract wood carvings, lacquered and coloured in a way consistent with his desire for smooth surface and formal order. MacPherson was never able to equal the breadth and confidence of Epstein's sculpture. He liked a tight, self-contained and often abstract design, and he executed a number of abstract pieces in stainless steel which were shown in Liverpool Academy and Bluecoat exhibitions. MacPherson had a studio at the Bluecoat throughout the years he taught at the art college.

MacPherson never gained the regular commissions enjoyed by his more professional and productive colleagues like Sean Rice or Neville Bertram, but he did execute some work for churches in Preston, Congleton, Oswaldtwistle and Birmingham. Timothy Stevens, Director of the Walker

114

Art Gallery, asked MacPherson to design vandal-proof fountains for a shopping precinct in Liverpool, and although the sculpture never went up due to lack of funds MacPherson did produce a number of excellent designs for it. These were Gaboesque in feeling, displaying a genuine exploration of three-dimensional design in which open space played an equal part with rotating or interlocking architectural arches or spans. His first fountain commission, produced for a disabled children's school, used water as a kinetic element and showed imaginative vigour. In his final retirement years MacPherson worked in a converted studio in North Wales (he moved from Birkenhead in 1973 soon after retiring), where he produced a number of kinetic pieces, beautifully finished with coloured planes. The influence was Calder, whose work he had seen and admired in the early 1970s at the Maeght Foundation in Provence, visited while on holiday with Gordon Green, a renowned Liverpool pianist who lived opposite the art school. MacPherson died in 1984.

Philip Hartas, one of MacPherson's earliest recruits, taught at Liverpool from 1957 to 1961. He was put in charge of foundation sculpture. Born in Yorkshire, Hartas had lived much of his life in the South. He studied at the Slade in the early 1950s, where he was instructed by Reg Butler and Henry Moore, and won two scholarships. His first teaching post was at Derby, whence he came to Liverpool. He lived in Liverpool 8, was able to witness the completion of the R.C. Cathedral, and obtained a number of commissions during his short spell on Merseyside. One was a thirteen-foot relief in plaster for the hairdressing room at Lewis's, an instance of Lewis's commissioning of modern sculpture shortly after the unveiling of the huge Epstein figure *Resurgent* on the outside of the building. The theme of Hartas's relief was the pastoral and romantic interpretation of hairdressing in the form of girls washing their hair in a stream. The other commission was a black ciment fondu madonna and child, in the elongated and spiky idiom of the day, for a modern Catholic church in Bootle. The image was modelled in Hartas's art school office subsequent to its casting in cement. Another notable piece, *Crying Child*, reminiscent of Epstein's moving portraits of children, was exhibited in a Liverpool Academy exhibition in 1958. It was certainly more expressive than MacPherson's rather stiff renditions of the same subject. Hartas modelled his child in Petronella Robinson's Falkner Street basement. He also produced a larger than life portrait bust, cast in resin, of George Mayer Marton. Hartas never satisfactorily fitted into the Liverpool art scene, finding it too insular and macho, and he moved on to teach sculpture at Bournemouth with Paul Fletcher. After a spell at Leicester, Hartas ended up in the art department of Brighton Polytechnic where he continued to teach throughout the 1980s.

Among MacPherson's staff in the sculpture department at Liverpool was Neville Bertram, an important figure on Merseyside who linked the

Philip Hartas Crying child, *exhibited Liverpool Academy c. 1958.*

traditional and modern generations of sculptors. In Mary Bennett's catalogue for the 150th anniversary exhibition of the Liverpool Academy (1960) Bertram had reproduced a carefully carved abstract sculpture in wood that not only echoed the current work of Barbara Hepworth and her followers in Cornwall, but also showed a fully integrated and pure approach to abstract form. Hewn from a single block of rosewood or lignum vitae, such pieces as the upright sculpture for Padgate College, Warrington (1960) or *Pierced Forms* shown in Bennett's anniversary exhibition, saw the artist exploring both the interior and exterior dimensions of a monumental form via the fashionable process of directly opening up the overall form by cutting through the entire block at strategic points. The Warrington piece, smoothly finished in a way that revealed his own refined, classical training, contained three such cavities, one near the base to suggest a gap between legs, another half-way up with the inference of spaces between arms, and a third near the top 'head' area. The vague relationship to an upright figure is unmistakable, though the sculpture always retains its own architectonic rhythms, balances and intervals, in a way that does not compromise the fundamentally abstract though never sterile formalism of the piece. Indeed the cavities are imperfect and irregular, and differ from the equally organic but generally more circular or oval holes of Hepworth.

These forays into a fully modern style represent a late departure for an artist who was originally trained in the craft of orthodox modelling and carving for plaques, architectural reliefs and so on. The change in emphasis shows Bertram as a flexible, enquiring and open-minded craftsman able to turn his hand to all varieties of material and more importantly to both traditional and abstract styles. It is a pity that Bertram is not better known outside Merseyside.

Bertram's first abstract carving came at the beginning of the 1950s, a response as he called it to the "mood of the day" when sculptors such as Moore and Hepworth were establishing international reputations at the Venice Biennale or the Festival of Britain. Bertram's conversion to purely abstract form was likened to a mental as well as an artistic change, implying that Bertram's was a cerebral approach, a logical finding when we consider his architectural and craft background. Although Bertram's work lacks the exuberance of a more sensual or expressive approach, it reveals beyond the precision and refinement of his formal realisation an admirable and coherent liaison between eye and hand. Yet Bertram never produced his sculpture to a pre-designed plan — probably a case of the emancipated artist reacting against the tight rigours of commissioned, decorative or architectural embellishments for public spaces. Instead he carved wood in a spontaneous manner allowing the shapes to suggest themselves through an intuitive but physical accord of truth with the material. The grain and composition of the material helped 'mould' the eventual statement; in his

lignum vitae pieces an internal pattern was consciously exploited between the lighter grains of the wood at the surface and the darker seams at greater depth. The pattern — though an ancillary, visual phenomenon incidental to the tactile reality of the form itself — added to the overall appearance. In such instances, it becomes possible to accept the artist's own dictum that the abstract wood carving phase — lasting until 1965 — was "quite devoid of any attachment to any known object".

The attribution of a craftsmanlike finish to the surface of Bertram's sculpture should not lead us to suppose that he merely reimposed the lessons of his father-in-law Tyson Smith — who opted for the refined, even sleek, naturalism of neo-classical and art deco styles — to create a similar tenor in the realm of non-figurative form. In fact, even while working for his father-in-law, Bertram recognised in himself a dislike for such refinement derived from Greek ideals of quintessential naturalism. Bertram was imbued with the spirit of sculptural modernism, by-passing stodgy, neo-classical contrivances. In 1962 he visited Crete on a nine-month sabbatical from the Liverpool College of Art. Always recognising an attraction to the Greek Archaic period — when sculpture, with its robust, column-like semi-figuration was at a half-way stage between Ancient Egyptian and Classical Greek — Bertram immersed himself in ancient Cretan sculpture, architecture and landscape. He visited many museums on the island and spent much time sketching on hillsides. The outcome was that, upon his return home, he produced a number of ciment fondu reliefs, celebrating in architectonic terms the textual and linear features of Cretan geology and topography. One is reminded in such instances of John Milne's contemporaneous sculpture, in both relief and free-standing form, that was inspired by Ancient Egyptian and Middle Eastern archaeology and architecture.

Most of Bertram's work was produced in Tyson Smith's studio yard at the back of the Bluecoat Chambers. Living at Eastham on the Wirral, Bertram joined the Liverpool Academy not long after the war and exhibited both watercolours and sculptures (wood and alabaster carvings) at the Academy every year. He had an excellent rapport with Henry Huggill who at that time was both head of the art college and in a pre-eminent position in the Academy. Stylistically, Bertram's watercolours, tightly composed and detailed topographical views, are similar to the work produced by Huggill, Tankard, Wedgwood and Sharpe in Liverpool. These are essentially graphic renditions of landscape or buildings, drawn with a felicitous ink line and mechanically inlaid with tonally exact washes. They are slightly caricatural in flavour, every inch a part of the rich, illustrational vein that runs strongly in the work of a significant number of Merseyside artists and students.

By the late 1960s Bertram was approaching retirement age and slowed down on sculpture production. He was still working for Tyson Smith, and

Neville Bertram Red/white alabaster,
1955 and, right,
Rosewood, *1960.*

was engaged on designing and executing reliefs for churches. A number of these were shallow, painted wood reliefs on crucifix themes for Wirral churches. One especially bold piece was a suspended wood carving of Christ standing on an anchor form which is now situated inside St Nicholas's Church on the Mersey Quay. Bertram retired from teaching in 1973, though he continued to do small lettering commissions, the occasional wood engravings, and landscape sketches.

Three sculptors made notable reputations after early studies in Liverpool. One of them, Ted Atkinson, was born in 1929 in Liverpool, the son of impoverished parents (his father was out of work during the depression and took window cleaning jobs). He had talent for art and gained entry to the art school, studying for the drawing certificate under Alfred Wiffen. Alan Tankard taught antique drawing and Robert Timmis took classes in anatomy and perspective, all traditional approaches to the articulation of form that gave Atkinson a sound basis for his eventual vocation of sculpture. He began sculpture in his third year with Charles Gardiner in charge of a threadbare department, though Neville Bertram and the Czech refugee Karl Vogel were beginning to teach there after the war. Vogel had a liberating influence, modelling heads in clay but with a handling that was clearly expressive and romantic in the typical East European way. The college library was still orientated towards the nineteenth century, though books on Henry Moore and other leading lights of the modern movement were beginning to be added to the collection courtesy of the Penguin Modern Series. The tenor of the college was therefore tradition-bound (Wiffen told the students to disregard Van Gogh because his paintings were raw and unfinished, not an attribution that could be made of Wiffen's own war painting in the Walker, *Jet of Iada*). Yet modern influences were beginning to creep in. Martin Bell, one of the more progressive of the painting tutors, gave sympathetic lectures on Picasso. A noticeable jolt forward came with the influx of demob students after the war.

Atkinson's sculpture year at Liverpool introduced him to clay modelling, of which the principles were imparted by Vogel. Vogel encouraged an interest in Rodin and the interesting English variant on Maillol's neo-classicism, Frank Dobson. Local sculptors like Tyson Smith and Carter Preston were not held in high esteem, being considered commercial craftsmen at the service of architectural relief commissions. Atkinson was ambitious and took drawings to the Slade. Between Liverpool and his entry into the Slade, where he studied under McWilliam from 1950 to 1954, Atkinson spent two years in Germany on National Service. He taught art in Düsseldorf for a spell and after the Slade launched himself vigorously into teaching. Following his Liverpool contemporary Clifford Fishwick to Exeter, he taught during the second half of the 1950s in the growing Devon art school.

120

At the Slade Atkinson was forced to work in a meticulously measured way from the model, using a plumb line in the customary way. But in common with the mid-fifties style that employed pronounced surface handling and a spiky, threatening angularity, Atkinson made bronze resin figures based on the examples of Richier, Giacometti and Armitage, and in the painting field Fishwick and Vaughan. Marino Marini was perhaps the principal influence at the time. Valuable and direct experience was gained through working with Henry Moore on the Time Life Building reliefs in 1953. Moore chose Atkinson from a number of Slade students. For three months Atkinson helped Moore with stone carving work. He had first been introduced to stone carving in Liverpool by Charles Gardiner and then at the Slade by Reg Butler.

During the 1960s Atkinson's work underwent significant changes; many lumpy torsos in cast concrete were produced in all sizes. In the early 1960s Atkinson joined the teaching staff at Leeds, where the chief influences were Harry Thubron and Hubert Dalwood, each instilling completely new approaches into the teaching and practice of art. Still using cast concrete, but soon introducing fibreglass, Atkinson shook out references to the figure, which he felt had become obsolete, and gradually veered towards the abstract and architectural. He started making reliefs, enjoying the imposed rectangular framework, and he won a number of notable commissions for Coventry, Düsseldorf, Hamburg and Birmingham University. These fibreglass pieces were frequently sprayed with grey paint to obtain a metallic effect. The influence of Indian wall reliefs seemed to go hand-in-hand with an interest in cinema decor and modern architectural effects. He exploited the effect of swelling, organic, even figurative, shapes competing with the rigid, rectangular frame. The relief illustrated here was bought by an Australian University after Atkinson had been chosen to represent Britain along with Moore, Frink, Chadwick and Armitage at the Brisbane Expo '88. The pipe shapes and rectilinear organisation of the surface are thrown into relief by soft, bulbous areas that mitigate the imposed flat design at the source of the composition.

These successes did not prevent Atkinson maintaining links with his native Liverpool. While at Leeds in the early 1960s he visited his family in Liverpool almost every weekend and he fraternised with Sam Walsh, Arthur Dooley and Arthur Ballard. He showed work in two of the early John Moores exhibitions.

Roger Leigh was not a native Liverpudlian, and his notable sculpture career did not begin at art school in Liverpool, but rather through his training at Liverpool University School of Architecture. The son of a Gloucestershire farmer, he was able to further an interest in art during war service thanks to life drawing classes at Oxford's Ruskin School. But after the war Leigh succumbed to family pressure and appeased his vocation-minded

Ted Atkinson Untitled. *8' × 10'. Installed: Science Faculty, University of Queensland.*

father by undertaking architecture studies on Merseyside. A training in architecture could well be of the utmost value not only for a young man seeking a job, but more relevantly for a budding artist later intent on making sculpture. The case of Reg Butler highlights this, where architecture studies provided a liberating advantage, a foil with which to approach sculptural form. Indeed, later on in St Ives Leigh was recruited by Barbara Hepworth as a part-time assistant precisely because she considered his architecture background an advantage for the kind of constructive/abstract sculpture she was making.

Leigh began his studies in 1947 and lived near the college in Percy Street. The course was rigorous, the students being given regular exercises in designing buildings for specific sites around Merseyside. The students reacted to the rigours of the course and gave vent to freer, expressive emotions that led to experimental mobiles influenced by Calder. Leigh was only able to make carvings in the holidays, when he returned to Gloucestershire. He made stylised figures from local cherry woods. On the course at Liverpool Leigh studied some landscape design and pursued his interest in relating buildings to specific landscape settings. In 1948 he visited Venice with other Liverpool students and started to take a serious interest in modern British sculpture of the kind soon to be shown in the open air at Battersea. Yet his first encounter with a Hepworth sculpture was not in London but in Liverpool. The occasion was Eric Cole's retirement from the architecture school. Cole taught acoustics and colour theory and was given a late 1930s Hepworth marble carving of simple ovoids and upright pebble shapes as a retirement gift. It did not make much of an impression on Leigh at the time, though the student would have sat up if he had realised that he would work for several key years in Hepworth's famous Cornish atelier.

Leigh gained his first exposure to other painters in Liverpool, visiting many exhibitions at the Bluecoat where the work of Alan Tankard and George Jardine made a particular impression. He also epitomised a healthy overlap between the architecture and art students when he attended lively Sandon parties at the Bluecoat, drank at the Cracke with students like Don McKinlay, saw the work of contemporary art students on Hope Street, and indeed attended Saturday morning life classes there under the excellent tutelage of Arthur Ballard. These valuable exercises so useful to all within the visual arts as a whole, furthered the lessons that Leigh had learnt in Oxford. The model was, inevitably, June Furlong. Leigh also learnt to throw pots under Stan English at the art college, relevant because forty years later Leigh would be making abstract, ceramic sculptures based on letter shapes that functioned on the level of their abstract rather than associative form. These objects were part aesthetic sculpture and part receptacles for plants.

Michael Kenny has probably gone further than any other Liverpool-born sculptor. He was born in 1941, the son of an engineer, and educated in a local Catholic school, where he was encouraged to paint. Early readings of Zola promoted the romantic ideal of the artist's life. However he left school early to appease vocation-minded parents, and worked in blood transfusion laboratories in the Whitechapel area of Liverpool. He was encouraged by a friend to approach the art school with his drawings. He was accepted by Martin Bell and John Keates and entered the art school despite his parents' reluctance. Kenny studied at Liverpool from 1959 to 1961. He shared accommodation in Canning Street with Henry Graham and Don McKinlay, and became a part of the remarkable Bohemian group in the Liverpool 8 area. Kenny got to know Stuart Sutcliffe, John Lennon, Rod Murray, Adrian Henri and Margaret Duxbury among others.

Kenny first entered art school as a painter. His tutor was Austin Davies, who encouraged a subjective, realist approach taking in contemporary or local subjects. Kenny was sent off to draw at the ballet school or, at the other extreme, the docks. He bent the rules and began pursuing an interest in texture and impasto. He was a self-willed student who even before entering the college knew de Kooning's work (from reproduction). He was impressed with a large Alan Davie show at the Walker and also had taken to the work of Jack Smith and Sheila Fell seen at the first John Moores exhibition in 1957. Smith's prizewinning painting of a drab fifties interior seems a logical candidate for influencing Kenny's developing interest in creating sculptural environments, extended into surrounding space. A number of Kenny's contemporaries — Chris Davidson, Frank Wilson, Ray Walker among them — went on to the Royal College in London. It has been written how "Peter Blake recalled a hard-nosed crowd of students from Liverpool who graduated to London's Royal College of Art in the early 1960s. He called them 'the Liverpool toughies'".[2] In contrast, Kenny was encouraged by his tutor Philip Hartas to try for the Slade, which he entered on a three year postgraduate course in 1961. Hartas could see the energy of Kenny's expressionist handling which was achieved by using a broken stick and other makeshift implements to apply wet clay or plaster. The clay figures produced were sculpturally compelling compositions with pronounced textural handling, a generous helping of material and social-realist subject matter. A man in a cloth cap was a particularly successful figure and another, *Mein Kampf*, was exhibited at the Liverpool Academy in June 1961 where it was referred to as "large scale, human but lively sculpture."[3]

At the Slade Gerard, Coldstream, McWilliam and a visiting Paolozzi each exerted some influence though Reg Butler became Kenny's greatest supporter. In fact Butler was alone in his support for Kenny's rough, realist style, which seemed a conscious reaction to the traditional 'caliper

Michael Kenny Woman in an evening dress, *1963–4. 48" high, plaster (destroyed). Courtesy. Annely Juda Fine Art.*

Michael Kenny Water and Wine, *1990–91. Portland and Hornton Stone. Coll: The artist. Courtesy: Annely Juda Fine Art.*

measurement school' that was so prevalent in the Slade. Butler triggered in Kenny an interest in early Giacometti, before the modern Swiss master substituted a primarily imaginative, and indeed surreal approach, with a more direct response to the motif before his eyes. Indeed, the ritual and theatre of the life model became source material for both. Kenny also made frequent lunchtime visits to the nearby British Museum and spent much time in the life drawing rooms, an experience that gave him a pronounced feeling for the upright or reclining posture within a room or across a section of floor. This feeling was reflected in the sculpture that he later made. In addition, Kenny took what he felt was useful in the Slade's preoccupation with measurement and structure. This would not be used for conventional anatomical or figurative ends, but rather to impose on his increasingly abstract sculpture an architectural order. "Essentially I'm an expressionist but through the Slade training, the expressionism became controlled."[4]

Kenny showed work at the Young Contemporaries exhibitions in 1963 and '64 and had his first one man show at Oxford's Bear Lane Gallery at the end of 1964. The exhibition of small lead and bronze figures was a great success and most items sold. By 1964 Kenny's tall, plaster torsos or figures were sufficiently simplified as to be almost abstract. They had a certain mysterious presence, incorporating an architectural as well as a human presence. "I use the situation of an isolated figure in a room as a paradigm of the essential aloneness of any individual in this secular century."[5] Alan Bowness wrote the introductory note for Kenny's Oxford show. He detected this very problem of the ambiguity between abstraction and figuration by writing that "however non-figurative a work of sculpture may be in intention, if its dimensions are like ours, we still incline to regard it as a human-type object . . . if not the abstract equivalent of a figure, then some sort of idol or totem." Bowness went on to cite monumentalism as a way of breaking out of the figurative trap, and for many artists open steel sculpture was a way of doing this.

Bowness applauded Kenny's achievement in confronting "this particular man-monument problem" which he claimed gave the work "a sharp relevance for our time." That sharp relevance addressed the human condition in a scientific century and emphasised the upright posture as a metaphor for the enduring presence of human values.

Such praise from an establishment figure encouraged Kenny in his professional endeavour. In spite of addressing the corporeal "man-monument problem" Kenny's sculpture, with its horizontal as well as vertical features and with the act of placing dispersed elements lending the work what one critic described as "the emotional trappings of separation, fragmentation and loss of individuation,"[6] seemed to be motivated by pictorial as well as by purely sculptural motives. Certainly the work became more abstract, and within a few years of his professional christening at the Bear Lane he was

taking on board the influence of Japanese gardens, with their flat ground planes giving rise to isolated figures, rhythmic stones and a general dispersal of elements. The interest in the ground plane had started, of course, in Slade life rooms, but by the 1970s Kenny's sculptures used as their bases slightly elevated wooden platforms whose parallel lines gave pattern and structure while echoing the floorboards of the real room. In spite of using aluminium and prefabricated metal in his 1960s work he had by the 1970s settled for wood and carved stone for the symmetry and directness of statement he sought. In 1974 Hubert 'Nibs' Dalwood — whom Kenny had previously encountered on part-time teaching spells — moved into the same Stepney studio complex. Before Dalwood's death a little over two years later, the pair struck up a useful partnership and shared the interest in oriental gardens and other outdoor influences that sought to link sculpture with a wider landscape or cultural setting.

Kenny's rising success was of such magnitude that during the 1970s he was a much sought after teacher and visited the Slade on part-time teaching outings. His interest in stone carving led to involvement in the 1983 Portland Tout Quarry summer project. Many sculptors and students were involved and his efforts on the project led in 1986 to a one man show of large carvings in Portland stone at the Royal Academy's Diploma Galleries. That year marked the start of a series of painted wood reliefs with the artist tilting up his wooden ground bases and painting geometric shapes. The end product was a wall-bound relief, part sculpture and part painting. During his rise (he became an R.A. in 1986) he made few visits to his native Liverpool, for his parents had moved out to Blackburn. During the early 1980s, however, he visited Liverpool Art College as an external assessor. In 1981 Brian Biggs invited him to have an exhibition at the Bluecoat Gallery.

NOTES

1. *The Observer*, Neville Wallis, 23.5.54.
2. *The Lennon Companion*, p.14. Mike Evans, 'The arty Teddy boy.'
3. *The Guardian*, June 1961, Anthony Tucker.
4. Interview with Adrian Lewis, *Aspects* no. 19, 1982.
5. ditto.
6. *Art Monthly*, March 1981, Jon Thompson, 'Sculpture as Picturing'.

Sean Rice and Arthur Dooley

Two modern sculptors who have excelled in their respective struggles to master and give expressive resonance to form in metal are Arthur Dooley and Sean Rice. Dooley was born in Liverpool in 1929, Rice two years later in London. Dooley has a following as a well-known, local media personality and creator of rather beautiful religious figures in polished bronze, Rice has a wider reputation in London through regular exhibitions at the Alwin, the West End sculpture gallery. They warrant being looked at together, not for any great similarities in their formal and technical approaches (which in any case are outweighed by dissimilarities), but rather for their consistent and single-minded presence in Merseyside art since the 1960s. In contrast to Liverpool sculptors like Ted Atkinson and Michael Kenny, Dooley and Rice have spent their professional lives on Merseyside. Since each has produced some work for Merseyside churches it becomes possible to see them, with their unorthodox techniques and independent interpretations of traditional themes, as significant sculptors of post-war, ecclesiastical modernism. In their smaller ways they belong to the tradition of Epstein, Piper and Sutherland, whose sculptural, stained glass, or pictorial embellishments to modern churches introduced a figurative boldness and imaginative colour to the often uniform architectural facades. Both have therefore trodden individual paths, wary of passing fad or fashion, and if they have relished the challenge of a commission or the chance of a sell-out exhibition, then it has always been on their own terms. This is no mean feat when we consider the kinds of pressure that Sean Rice faced when, having given up his comfortable if distracting position as head of sculpture at Liverpool, he began depending for a living on exhibiting regularly at the ultra-commercial Alwin Gallery. Whereas Dooley, both personally and artistically, proudly proclaims his Irish Liverpudlian roots and links with the Catholic Church, Sean Rice is a Southerner by background and training. Furthermore, when occasionally inspired by specifically religious themes, Rice finds greater interest in Old Testament symbols and characters.

Sean Rice moved to Brighton with his family in 1940, and as an adolescent on the south coast, enjoyed what he described as a "quiet, gentle upbringing". He developed an early interest in archaeology and natural history. Bones, sea urchins, fossils and other odds and ends were collected and gave him an early appreciation for the 'found' object as a ready-made aesthetic entity full of the mysteries of the past. Shortly after the war Rice

128

entered the Brighton College of Art where he studied painting for two years, an experience valuable if for no other reason than that it allowed him to discover his real vocation as a sculptor. He was fortunate in having a Royal Academy sculptor, James Woodford, tell him that sculpture was what he should be doing. It is likely that the kind of work Woodford produced professionally had some kind of formative influence on Rice. Later on, Rice's larger than life mythical or symbolic figures perhaps hark back to the large Robin Hood bronze in Nottingham that Woodford produced. Woodford's heraldic images, lions, unicorns and the Queen's Beasts produced for the Coronation may also have alerted Rice to the power of hybrid or mythical forms. Whatever the case, Woodford was an excellent craftsman of the old order, highly adept at modelling, and most important of all for Sean Rice, "a generous man with his time".[1]

Sean Rice turned to sculpture during the final two of the four years spent at Brighton. He described the training there as being "orientated towards symbolism at the time". Exercises towards potential church or hospital commissions often called for a dramatic narrative content, though the contextual nature of these set pieces would not allow for imaginatively wild or purely expressive distortions. In the same way, disciplines such as relief carving and lettering also needed to be learnt. The reward for Rice's hard application at Brighton was a place at the Royal Academy Schools, where the celebrated sculptor Maurice Lambert had recently begun teaching. Lambert's work was already known to Rice, through magazine reproductions but more importantly as a result of early visits to the Tate Gallery. As early as 1932 the Tate Gallery had acquired an alabaster carving by Lambert, *The Swan*, and by the late 1940s he had produced one of his most memorable works, *Pegasus and Bellerophan*, a version of which Rice saw at the Festival of Britain's open air sculpture exhibition at Battersea Park in 1951. Lambert's *Pegasus* was typical for its adoption of Greek mythical themes by the Art Deco-inspired sculptor. The *Pegasus*, pre-cast versions of which were also shown at the R.A., inspired in Rice a feeling for extravagant imagery (in his case themes would be derived from the Old Testament rather than Greek mythology) and overflowing symbolic detail. Both the *Pegasus* and the pre-war *Shoal of Fish* surely testify to the fact that Lambert had looked at a reproduction of Gaston Lachaise's well-known dolphin fountain in the Whitney Museum. Possessing a tireless will to experiment with new materials and working methods, Lambert produced daring compositions of baroque complexity and symbolic fantasy that effectively broke away from the more academic, figurative bronze statuary of Francis Derwent Wood, for whom he had worked at the outset of his sculpture career, and who had contributed the Cotton Exchange Memorial in Liverpool.

The early influence of Lambert on Sean Rice cannot be in doubt. The older artist frequently worked on his own sculptures at the Royal Academy

Schools. Rice saw him carve and also watched the Degas-influenced Margot Fonteyn plasticine head taking shape. Another distinctive Lambert, *Aengus and the Birds*, drew on Irish legend, for Aengus was the Irish God of Love. Lambert's Aengus, a tall, narrow bronze figure, acts as a column around which flutter a number of birds. Intended as a tribute to his friend Yeats, the Lambert is echoed very closely by Sean Rice's seventeen-foot fountain commissioned for the Atlantic Tower Hotel near Liverpool's seafront. Rice's stacked, totemic aviary of a rapidly ascending flurry of birds, a cogent rhythm of flapping wings and extending beaks, itself looks out fittingly towards the Irish Sea. Seldom can a work be so derivative in content and theme, yet so individual and powerful in terms of its own formal resolution.

A fellow student of Rice's at the Academy Schools was Anthony Caro. While Rice furthered his Academy studies by going to Italy for two years on scholarship, Caro went on to work as an assistant to Henry Moore. As early as 1952, Anthony Caro showed his preference for a pared down vocabulary of form by criticising the complex figurative forms and mythological themes discernible in Rice's student work. Caro, while eventually eschewing figurative form for a plainer language of steel plate, tubing and industrial offcuts, nonetheless later became, in the words of his critical mentor, Clement Greenberg, an ''incurably addictive'' artist, a kind of abstract, baroque sculptor intent on complex additions built around a steel 'table', 'armature' or axis. For all their difference of intention — the one referential, the other resolutely architectonic — if we compare Rice's Boccioni-like motorcycle rider (produced from a complicated array of stainless steel planes and tubes) with Caro's own mature steel constructions, then we are not witnessing artists who are speaking in altogether different tongues.

Motorcycles had always interested Rice and he used one to travel around Italy during the two years of his Italian scholarship from 1953 to 1955. Rome opened his eyes to a richer vein of archaeology than had been available in Sussex, and he found Etruscan art particularly exciting. A Picasso exhibition at the Academia, near the British School, had a great effect. Rice, who has confessed to an interest in ''all sorts of extremes of expression'', was turned on by the brutal symbolism in Picasso, not only in terms of imagery, but also in terms of the vivid and untrammelled style. Rice has borrowed from Picasso as we can witness in his bronzes of animals and goats, in his constructed metal animal skulls, or again in his series of wash drawings depicting peasants carrying goats across their shoulders.

Already a picture may be emerging of an eclectic artist, geared by personal taste (however eccentric or unlikely) rather than by desire to follow any dogmatic, fashionable stylistic imperatives. In Italy Rice responded to Italian mannerist sculpture, particularly to that of Gian Bologna. He was

moved by the incorporation of turkeys, horses and other animal imagery into the Italian's bronze sculpture. He was likewise intrigued by the technical aspects thrown up by mannerist sculpture's predilection for detail and surface flourish. This interest highlights the fact that the technical process of making a sculpture remains in Rice's mind indivisible from the work's thematic meaning and expressive energy.

One process that Rice began in Rome was that of lead casting in his studio using elementary equipment such as pans and a single studio stove. He visited several foundries around Rome, and made use of another great Italian tradition, marble carving. He carved an Adam and Eve, then a Pieta, in travertine marble. He also did a great deal of small-scale, outdoor landscape painting, a factor that sharpened his vision for the Italian landscape. Rice also visited a number of contemporary Italian sculptors (like Emilio Greco and Fazzini). Italy with its consummate feeling for design and the outer appearance of things, has produced an interesting, if not major, school of modern sculptors. He met one of the most famous, Manzu, at an exhibition in Rome, and also visited the romantic-cum-realist painter Renatso Guttuso in the same city. Manzu, however, with his work for the Vatican, would seem a sculptor of more direct relevance to Arthur Dooley than to Rice. We can conclude the importance of the Italian scholarship to Rice by identifying the fact that he has visited Italy almost every year since the mid 1950s.

Upon returning to England in 1955, Rice set up studio in an old Sussex forge. There he produced some large works including an early mechanistic piece in reinforced concrete showing the influence of Epstein's rock drill. He started a coke-fired foundry, and learnt much from a literally painful process of trial and error. Before the end of 1955 he became the modelling and carving tutor at the art college in Chichester, where he taught for three years. The works from that time were again mechanistic pieces, reflecting his interest in motorcycles, though he also produced works in concrete and wood using Lambert-inspired themes like submarine figures, mythical sea forms or Italian swordfish fishermen.

During the early 1960s Rice taught sculpture at the art college in Nottingham. He produced sculptures in steel and concrete, and also started to use other ferrous metals. Some bronze casting realised small, surrealistic compositions of biomorphic figures, part human, part plant, or centaur-like figures. His welded metal 'skull' piece was shown in the Liverpool Academy exhibition in the mid-1960s and was illustrated in John Willett's book *Art in a City* (1967). The piece, an enlarged version of a rook skull, was produced in Nottingham shortly before the artist's move to Liverpool. He also made some curvilinear steel structures, using section tube that would move in the wind. These mobiles expressed the artist's interest in movement, a feature that had remained dormant in the inert, mechanistic structures.

131

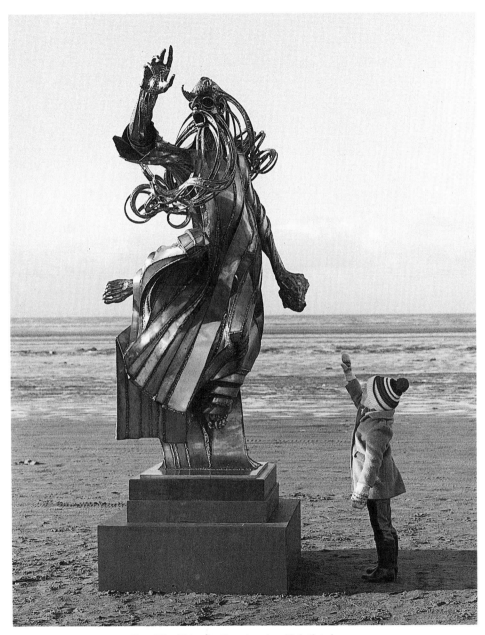

Sean Rice Shimei. *Forged and welded plate bronze.*

Sean Rice finally came to Liverpool in 1963, a young sculptor still only in his early 30s. The new materials that were available to architects and sculptors at this time — resins, latex rubber, reinforced glass — gave further encouragement to experiment. George MacPherson appointed Rice in his sculpture department as lecturer in metal sculpture. Rice set up a home and studio in Southport, and began winning commissions for metal sculptures, the first being a large steel crucifix for St Paul's Litherland (1964) and a twelve-foot steel crucifix for St Margaret's, a new church at Anfield. Soon afterwards in 1969, Rice produced a slightly larger than life bronze figure of Ezekiel for a private Texan collector. Rice was formally recognised on Merseyside with a successful exhibition at the Bluecoat Gallery of mixed media metal sculptures ranging from the abstract to the more familiarly figurative. The exhibition, from which many pieces sold, went on to the Midland Group Gallery. Rice also gained the distinction of entering his first public collection in the Liverpool area when the indefatigable Harry Ratcliffe, curator of Southport's Atkinson Museum, bought a large piece of fabricated steel from an exhibition Rice held at the Lord Street Museum in 1967. At the time Ratcliffe was engaged in upgrading the Atkinson's sculpture collection, to keep up with an adventurous and up-to-the-minute collection of twentieth century British paintings. The Rice acquisition contributed, along with a strange, figure-within-architecture bronze piece by Arthur Dooley and Henry Moore's important *Three Points*, to the Ratcliffe sculpture initiative. Rice's Southport piece was called *Winnower* and was, like the rook skull piece, based on a large skeletal animal form.

Rice's teaching at Liverpool benefitted from the thriving team that George MacPherson had assembled at the art college. A healthy mixture of craft-based sculptors and iconoclasts gave the department a suitable tenor for the empirically-minded 1960s. Neville Bertram, Roger Dean and Ian Carrick (who later became heads of sculpture at Exeter and Falmouth respectively), Mike Yeomans, Rod Murray, David Morris, as well as MacPherson himself were a few who taught there during the 1960s and 70s. For ten years after 1967 Rice was a senior lecturer on Hope Street, and was then Principal Lecturer until 1980, when he made the error of leaving the post to concentrate solely on the hazardous business of creating a body of sculpture to satisfy the fluctuating demands of clients of his London dealer's gallery.

The connection was first made with the Alwin Gallery after a successful exhibition at Geoffrey Green's Tib Lane Gallery in 1967. A short feature programme was made by the BBC at the time of the Manchester exhibition. The year after Rice's Southport and Tib Lane shows the artist held the first of many exhibitions at the Alwin Gallery. These continued every two years during the 1970s and early 1980s, and many sales to and commissions for

foreign as well as British clients resulted. Rice moved to a terraced house in Walton in the early 1970s, and with continuing sales through the Alwin was able to build a large studio and foundry at the back. One sizeable commission originated in 1972 when Rice won the competition to design and produce a fountain sculpture for London Zoo. Practical difficulties prevented the project materialising but a few years later C. Mottershead, founder of Chester Zoo, and a collector of ivories, saw Rice's original design and made a site available. The large figure, *Noah and the Four Winds*, was produced at Walton and installed in 1977.

Rice's large figure for Chester Zoo is a typical example of the way his liking for exuberance, for internally eccentric conglomerates of detail and form went hand in hand with an open-ended and almost malleable process of assembling a number of metals in the same piece. Richard Walker summed this up well while reviewing Rice's third exhibition at the Alwin. "Rice brings off a genuine restatement of Gothic expressionism while constantly reminding one of his constructional methods — straps and rods bunching, binding, to give a feeling of 20th century truth to materials and an objet trouvé — like interplay between the image and its implementation."[2] On occasion Rice seemed able artistically to manipulate metals to formal ends by exploiting their differing colours, textures and melting points. A fluid and direct method of construction with several types of metals within the same sculpture lent the work an organic, malleable quality, almost as if the artist had formed the shapes by hand as would have been the case with wet plaster or clay. In his Chester sculpture and others of the same period Rice indulged in mythical or biblical figures with extruding hair,cloaks or other paraphernalia. A bronze-cast figure might be fabricated in boilerplate and sections of plate offcut to give the piece roughened texture and extra variety of surface imagery. Strips of copper or brass could be forged to create strands of hair or clothing. Such work was clearly symptomatic of an interest in the colourful imagery and symbolism of the Old Testament. As early as 1967, at the Tib Lane Gallery, Rice had sold a prophet figure and was giving full vent to disestablishment sentiments with a series of brutalised, ecclesiastic images of screaming nuns. An interest in civil disturbance and urban warfare — a side of the 1960s that we often overlook when looking back with nostalgia — also informed imagery that in extreme cases included figurative mutations. Perhaps in his own way Rice here came closest to the spirit, if not the form, of the 'geometry of fear' sculptors. Though he never took an abstract or architectonic direction, Rice felt greatest sympathy with the early Chadwick constructions of the inner eye and fish eater, and with the menacing crabs of early Meadows.

Perhaps the only real correspondence that exists between Sean Rice and Arthur Dooley is their commitment to metals and to a generally figurative

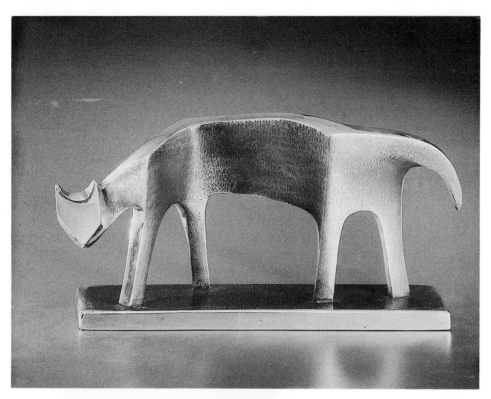

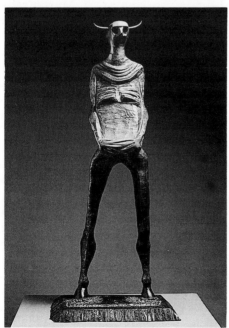

Arthur Dooley Cat. *Bronze.*
Left, Satan.

approach to conveying mythical or religious form. Whereas Rice came from a middle-class background with a conventional artistic training under a prominent Royal Academy sculptor, Dooley has made a virtue out of his tough, Scouse, working-class background and the fact of his being self-taught. But while Dooley never had the breadth of Rice's training, many will feel that the Liverpudlian rawness, directness, naivety even, has been a powerful advantage, enabling the artist to fall back on his own creative instincts. But in spite of his supposed solidarity with the urban proletariat and the 'macho' cult of engineering, he has produced bronze religious figures of considerable refinement and elegance.

Appropriately enough for a modern sculptor affected by the angst of the atomic age, Dooley's first sculpture was made in an army prison in Egypt. That early effort was a four-foot sphinx modelled in sand and water from memory. Upon his return to England, Dooley joined a drawing class at the Whitechapel Gallery in London. One of his teachers helped him obtain a job as a janitor at St Martin's School of Art, where he worked for a year in the early 1950s. He continued to live in Whitechapel, commuting to Charing Cross Road daily. He cleared up after sculptors, helped set up materials and began to make his own pieces in the college using scraps of metal left over on the studio floor. Dooley produced his first cast lead piece, a crucified Jesus figure, which received a good response when it was shown around the college.

During the period when Dooley was working at St Martin's, Anthony Caro was embarking on a legendary stint of teaching there that led to a so-called 'St Martin's School of Sculpture' boom phenomenon. It saw a generation of students (among them Annesley, Bolus, Scott, Tucker and King) pursue Caro's mode of structural constructivism which made use of industrial steel and the welding techniques of the shipyard or construction industry. Yet it was not Caro who influenced Dooley most during the 1950s but Reg Butler, whose thin, linear metal sculpture won the competition for the Unknown Political Prisoner. It is sometimes forgotten that Caro did not initiate direct construction and welding, even though he later came to embody it in not only British, but indeed transatlantic post-Smith sculpture. In addition to Butler, Lynn Chadwick, Robert Adams and even Brian Wall had begun using welding techniques some time in advance of Caro's sudden conversion to abstract steel sculpture in 1959–60. Dooley was eventually to meet Butler in Liverpool, when Butler visited the University to deliver a lecture. They had a stimulating discussion after the talk, during which Dooley took the opportunity to acknowledge his debt to Butler. He spoke of the tower concept (employing open space as a part of a 'displaced volume'), the linear structure as if conducting a latent power, and the symbolism of dwarfed figures at the mercy of imposing and impersonal structures, as being the qualities that most impressed him. These qualities

were derived from the alienated and pent-up figures of Giacometti, forever fragile and vulnerable to the enormity of surrounding space.

All of this becomes even more relevant when we consider that Dooley first left school at 14 and worked for a year at the shipyards in Birkenhead. He worked on the Ark Royal, welding brackets on bulkheads. The "shipyard was really my art school",[3] Dooley recalled, and in associating industrial labour with heroic proletarian effort we see the roots of his communist beliefs prior to his adoption of a fully-fledged Catholicism. Also in the shipyard experience Dooley found the courage to announce, "I have been privileged in missing the art schools."[4] Further opportunities to inflict his anti-intellectualism on the art world's status quo came about. One occasion led Dooley to meet the American critic Clement Greenberg who was in Liverpool to select the John Moores exhibition. Greenberg received a tirade — a little less eloquent but every bit as vitriolic as the attacks he would later receive from Patrick Heron — against the kind of hard-edged or post-painterly abstraction he was promulgating. Another opportunity presented itself in the form of disrupting a meeting in the basement bar of the Everyman Theatre at which Arthur Ballard was holding court with a group of his students and followers. Dooley also wrote a *Daily Post* review of the John Moores selections, an early example of his penchant for courting media attention. Ballard's vitriolic reaction to Dooley's interruptions in the Everyman led to a fist fight, abated only by the restraining arms of responsibly-minded onlookers.

The Everyman was a regular drinking haunt for Dooley. In 1961 he met several architecture students there who were campaigning, like himself, against Graham Shankland's controversial 'City Centre Plan'. The students offered Dooley an exhibition at the University Students' Union, a useful exercise that besides all else put him in touch with Polish architecture teachers at the University who knew George Fazinski, the Polish architect who was designing the Church of St Mary's at Leyland, near Preston, on behalf of his firm Wakeman and Bullen. Henry Moore had been approached about producing some figures for the Stations of the Cross but was over-worked and turned down the commission. The Benedictine Community of Ampleforth Monastery agreed to Dooley having the commission instead. Most of the next two years were taken up with completing the series of bronze figures. Indeed, the company involved in the castings offered him accommodation in the Kirkby area while he was on hand to work on the final figures. These remarkable figures are perhaps the high point in Dooley's career. A consideration of Dooley's technique for the commission is useful at this point to see the kind of material and aesthetic imperatives that, literally as well as metaphorically, moulded the character of his work.

The figures were built up in wax of the kind produced by melting down pieces of wax chalk. After returning to Liverpool at the end of his St Martin's job, Dooley spent a couple of years working in Speke for the

Dunlop rubber company. It was here that wax chalk occurred to him as a potential modelling material. The wax models were then put into a two-piece sand box where molten bronze could be poured into the sand-embedded image. The final castings for the Leyland sculptures were made at the George Bagnall foundry in Kirkby, the new town situated between the north end of Liverpool and Skelmersdale. The whole experience of watching the casting processes at Bagnall's was formative in the sense that Dooley retained the two-piece sand box method for the casting of his bronzes. Indeed the method, which produced solid, and therefore heavy, bronze figures became an important determining ingredient in his work. For one thing, this cheaper process demanded a simplification of the statues he was making in order to achieve satisfactory casting. That simplification was one of Dooley's central principles as an artist, though it was achieved through technical, rather than deliberately aesthetic, decision-making. The works are finished off by filing and polishing either with hand instruments or else high-speed dye grinders and angle grinders. A simplified surface texture is preferred, though the artist has on occasion patinated the figures, as with the crisp, bony and strident Satan now in the Williamson collection in Birkenhead, where Dooley once had an exhibition.

The time spent at Dunlop's in Speke during the middle 1950s was the prelude to Dooley's decision to become a full-time sculptor. Dooley's realisation — which came to him early one morning waiting for a bus to take him to work — that he wanted to be a sculptor had the suddenness and dramatic fatalism of a religious conviction. It was also tempered by a solid disillusionment with the often soulless and meaningless hack work required on the factory floor. His first studio was at Slater Street, and the artist's maiden exhibition took place at the legendary Blue Angel Club. The club was run by Alan Williams, the Beatles' first manager, who arranged their Hamburg stints. The works were deliberately, flagrantly brutish in their uncompromisingly raw physicality. Obtaining material from a dockside steel company, Dooley produced a number of abstract steel constructions. These were executed in a style that suited his notion, as a 'card-carrying' member of the Communist party, of art being closely bound up not only with the ethos of manufactured labour (as opposed to the more rarefied and effeminate ethos of pure craft) but also with the positive and physical reality of the materials themselves. One of the early pieces which was bought by a professor from the University was a Picasso-influenced assemblage, made by welding steel pipes on each corner of a metal milk crate. A bicycle seat was added for the imaginary goat's head.

A more significant exhibition came after the Blue Angel. It took place in early 1962 at the well-known St Martin's Gallery off the Charing Cross Road and not far from its art school namesake where Dooley himself had worked almost ten years earlier. From the successful exhibition, the

Liverpool-born jazz singer and journalist George Melly bought two pieces, while Dooley made the first of his many television appearances on Cliff Michelmore's 'Tonight' programme. Television did the trick as far as the exhibition was concerned and visitors to the show, together with sales increased. The flirtation with television led in the late 1970s to London Weekend commissioning Dooley to produce a bull in bronze for its South Bank building. Dooley had an exhibition in the foyer. Elena Geputyte, a young artist who had opened a worthwhile gallery showing the leading lights of the Cornish art colony of St Ives, visited the exhibition and subsequently showed some of Dooley's works in her gallery near the picturesque St Ives harbour.

Arthur Dooley's work sits comfortably within the modern tradition of humanism as monuments of hope or solace in a frequently troubled and fast-changing world. With their Catholic symbolism and their modern figurative style, they belong best of all in the company of Epstein (particularly the Cavendish Square Madonna), Frink (the thinly robed Madonna figures), Giacometti and Richier. He has used the theme of the Crucifixion and of the Madonna to a remarkable extent, but always keeping his work within a fine art, sculptural context and slightly beyond the reach of the more commonplace and commercial Christian images that adorn churches throughout the world. Many artists have flirted with identifying their work, or themes within their work, with excessively popular and banal folkish or functional imagery. In extreme cases banality itself has become an art historical virtue as we see in Jasper Johns' bronze light bulbs or in Andy Warhol's silkscreens. But they have never themselves succumbed to monotony, thanks to a powerful expressiveness in terms of formal realisation, ironic intent and technical accomplishment. While the catalogue to Dooley's St Martin's exhibition spoke of the artist who "feels deeply about the social problems of our day", it soon concluded that the work which "has no literary content whatsoever" was in the mainstream of formalism of the kind advocated by Fry and Bell. By describing the creative act as "letting the materials themselves take over" the St Martin's catalogue described the artist engaged on an adventure with unforeseen and fortuitous plastic problems to solve on the way, however perennial or limited the themes actively pursued may on the face of things appear.

NOTES

1. Sean Rice in conversation with the author, September 1990.
2. *Arts Review*, 6.5.72.
3. Conversation with the author, September 1990.
4. ditto.

Surrealist impulses

The seaside is perhaps the most surreal of all locations, a compellingly evocative junction point between earth and water. Nowhere is the mystery of natural form more keenly felt than in maritime places. The sea covers two-thirds of the globe's surface and was the source of life. Britain, as a small, offshore island, built her imperial past on an enterprising seaworthiness. With the decline of traditional maritime industries like fishing and shipbuilding, it is nowadays easier to overlook the importance of the sea to Britain.

Harry Hoodless has spent most of his professional life close to the sea on the Wirral peninsular. Whilst never being a direct painter of the sea, Hoodless has always depicted a more or less marine context. The seascape or landscape elements in his elaborate quayside compositions are frequently diminished to a thin strip of topographical backdrop. The majority of the picture plane is taken up with a quayside still life of items of marine engineering. The artist is at his best when choosing a group of heavy metal objects and displaying them across the cobbled top of a pier or quay with the discretion of the most sensitive still life painter. However small or distant the landscape element may be it is painted with the same degree of specificity given to looming foreground machinery. Precision is the key to Hoodless's pictures, but it is never a cold precision, rather one pregnant with a sense of mystery and atmosphere. His topographical ability shows when he paints a distant headland or port and identifies it as Birkenhead, Bootle, Liverpool, or any other stretch of coastline.

Hoodless was born in Leeds in 1913 though his family originated from Cumbria. His father, who came from Maryport, certainly had seafaring roots, and it is likely that Henry Hoodless, a nineteenth century Cumbrian landscape painter, was a distant relation. Harry attended art school in Leeds from 1929 to 1933, during which time he studied pictorial design and some etching (rather surprisingly, Hoodless never pursued print-making thereafter). The Principal, Douglas Andrews, presided over a quiet period in the college's important history. In 1933 Hoodless's abilities won him a scholarship to the Royal College. Here he specialised in mural painting for the final two years under the guidance of E.W. Tristram, who also taught George Jardine at the college a few years later. William Rothenstein and Percy Jowett had overall control of teaching at the college (Nicholas Horsfield and Harry Ratcliffe entered at the same time that Jowett took

140

over from Rothenstein). By specialising in mural decoration Hoodless came into contact with Edward Bawden and Eric Ravilious, two of the most influential artists during the 1930s. Hoodless was particularly fortunate in having Bawden come round the college and discuss with the students work in progress. Bawden noticed a picture that Hoodless had made based on a London dry dock, liking the pronounced textural effects used to capture elusive surface detail. Hoodless was much moved by the Italian Primitives, particularly Piero. Partially forgotten old master techniques like lime-based fresco painting were another motivating interest under Tristram. But Hoodless also admired the moderns, like Edward Wadsworth (whose work his own most resembles), Tristram Hillier, Stanley Spencer and the American Ben Shahn.

After completing his studies, Hoodless travelled around Spain during the summer of 1936. He was part of a group of students who were caught up in the Civil War, and were evacuated by British battleships to France. The opportunity to visit Paris was then taken, where a generous helping of painting culture was provided by the museums and the Latin Quarter. Upon returning to England Hoodless spent two years teaching at Norwich Art School, a valuable apprenticeship for his arrival in Birkenhead in 1939. Birkenhead had a small but useful art school, run by the proficient water-colour painter Charles Sharpe, a member of the traditional group of topographical Merseyside artists like Tankard, Wedgwood and Grosvenor. Henry Mundy, who in the early 1960s became a leading member of the vanguard Situation Group in London (and also the John Moores prize-winner in 1961), had studied at this local art school shortly before the arrival of Hoodless. Apart from the interruption of war service in the Navy between 1941 and 1946, Hoodless remained at Birkenhead's art school for the remainder of his teaching career. Luckily, he avoided naval battles and did much valuable travelling, notably in the Caribbean and Mediterranean. During these times he observed the complex curves of boats, and made drawings and took photographs of moored vessels, material that was later worked up into more lavish compositions. His interest in boats often took him to local marine yards where he spent much time sketching. Never a *plein air* painter, his entire outdoor work consisted of preparatory sketches for architecturally rigorous, meticulously detailed and painstakingly painted studio pictures in egg tempera.

In 1946, Hoodless became Principal at Birkenhead, from which position he slowly built up the college. Charles Oliver was brought in to teach life drawing, Raymond Hawthorne to teach wood engraving, Joan Taylor textile design, while part-timers like ex-pupil David Hillhouse and Edna Rose were brought in to help out with painting and sculpture respectively. Maurice Cockrill's exact topographical and photo-realist style of that time was favoured and he made part-time appearances. The school had suffered

Harry Hoodless Quayside composition (Birkenhead).

David Hillhouse Pigeon feed.

during the war, being located in a vulnerable dock area. Its regeneration was a challenging task that for a number of years effectively reduced Hoodless's annual output to only two or three major pictures. His style embraced large scale, fine detail and elaborate composition, factors that explain his slow output. Nonetheless, he was invariably keen to exhibit, showing fifteen paintings in nine separate Royal Academy summer exhibitions. One of them, *Evening on the Solway*, was bought by John Moores, who subsequently donated it to the Walker. Hoodless was no less enthusiastic when contributing to the local Academy, and Charles Sharpe put him forward for the Liverpool Academy, where he exhibited most years. The Walker acquired their second picture from the Academy. The University followed suit and the Blue Funnel shipping firm bought another picture.

It was not always plain sailing, however, as Nicholas Horsfield — indefatigable canvasser for the cause of local art — found out when encouraging a sometimes disheartened Hoodless to keep painting. This he managed more successfully during vacations and particularly once he had retired from the arduous task of running the local authority art school. Holiday visits to West Wales, East Anglia, Whitby, Cumbria or to the South Coast resulted in sketches that back home on the Wirral were worked up into full-scale compositions. By no means have his quayside pictures been confined to Merseyside, and a delightful keynote throughout his work is the expression of differing parts of the British coastline through a varied palette, tonal register and changing visual dialect.

David Hillhouse (born 1945) studied at Hoodless's Laird School of Art in Birkenhead in 1963 before entering the graphics department at Liverpool College of Art (1964–7). For all his later professional association with Hoodless, Hillhouse found the older artist only "a distant administrator"[1] at the Laird. He later spoke to Hoodless about the technique of mutually favoured tempera painting. In general Hillhouse extended relations with former tutors, and indeed sometimes thanked them by giving one man exhibitions in his capacity as curator of the Williamson Art Gallery. Charles Oliver, who had taught Hillhouse life drawing, and Ray Hawthorne, described by Hillhouse as a "superb craftsman printmaker", were treated in this way. Hillhouse had a less happy time as a student on Mount Street. After a good start, benefitting in the first year from Ray Fields's disciplined illustration and print-making course, he grew unhappy with the local art scene within and outside the college. He disliked the trendiness of the Liverpool scene at the time, preferring the quieter, more academic approach that was instilled by Hawthorne, Sharpe, Oliver and Fields. He was encouraged in the more permanent values of art by Nicholas Horsfield in the art history department. Hillhouse's problems at the time were certainly compounded by a philistine family who were hostile to art studies and sceptical about vocational prospects. It is ironic therefore that such studies led to Hillhouse

becoming head of one of Merseyside's largest museums. He graduated with a teaching qualification and taught for several years in secondary schools in Birkenhead. There followed a period of odd-jobbing, making furniture, even playing in pop groups (on his own terms rather than as a part of the Liverpool scene). In 1976 he became technician at the Williamson where, as they say, he never looked back.

The first contemporary painting to move Hillhouse was Peter Blake's self-portrait in badge-covered denims. The work, which he saw at a John Moores exhibition, had an autobiographical honesty that appealed, and Hillhouse looked to old family albums with their "naive unstudied charm" as source material for his own work. The mystery of one's own background, seen with hindsight, spurred Hillhouse to self-expression. Later on, influenced by Ray Fields, he made hard-edged, abstract paintings, but then returned to meticulously detailed watercolour and ink studies, depicting local views and familiar back gardens. Hoodless encouraged him to paint and exhibit locally, though administrative responsibilities have restricted the annual output to half a dozen highly detailed pictures.

Timothy Stevens's decision to replace the Liverpool Academy annual with a broader Merseyside exhibitions scheme led to Hillhouse running a feasibility study on behalf of Merseyside Arts to determine whether the visual arts could helpfully be exhibited in non-gallery public spaces such as hospitals, schools, factories and libraries. Hillhouse gave much support to the idea and he played a leading role in mounting the first of an ongoing series of exhibitions of Merseyside artists at the Walker in 1982. This exhibition featured Horsfield, Hoodless, Henri, Christine Leadbetter, Kowal Post and Sam Walsh. The well-known Liverpool solicitor and art collector John Entwistle became chairman of the organising committee that included Horsfield and Hillhouse.

George Jardine is perhaps the most distinctive and popular of all Wirral-based artists. His work is a remarkable amalgam of surreal and conventional landscape sources. He has also always had an informed audience of admirers in London. A whole range of influences, embracing Max Ernst, Lewis Carroll, the Italian Primitives, Pre-Raphaelitism and the Victorian fantasy illustrators, gives his work its unique, if at times eclectic, flavour. Certainly he does not belong to the English surrealist group. What he once termed the "variable and elusive atmospheric hills"[2] of the Lake District and Wales have constantly entered his art, anchoring it in the realm of the familiar and reassuring, a factor at odds with the time warps and mythology of his foreground dramas. Jardine's roots lie in pre-war illustration and design, giving his work its tight, neat composition. What truly brings the pictures to life are the endless poetic narrative of the bizarre subjects and a frequent employment of surrealist or post-surrealist techniques such as frottage, grattage, decalcomania and tachisme. Jardine is always very

145

interested in landscape texture and these techniques give his work the power to 'fix' elusive detail without recourse to pedantic copying. He put this very clearly when writing that "a mossy texture pressed on à la Max Ernst gives a better basis for a natural observed landscape than laborious detail faithfully rendered by brush that the Pre-Raphaelites suffered from."[3] Twenty-nine years earlier, in the spring of 1962, Jardine had written very similar words when declaring that Victorian painters "were too laborious" and that much eluded them because "they failed to comprehend the vitality of accidental effects and textures."[4] In the same article, written for Patrick Hayman's influential magazine *Painter and Sculptor*, Jardine declared that good draughtsmanship is essential to convey meaning in art, a view that was once again echoed those twenty-nine years later when he wrote that the "basis of life drawing and the long forgotten plant drawing which used to prevail in all art education was really a scientific approach in relation to the scientific age we are living in."[5]

As a young man Jardine was liberated by artists like Max Ernst, though he drew as much from the world of ideas beyond art itself. Jardine's fearless embrace of the full world of the imagination was therefore dressed up in the conventional garb of good academic drawing and illustration. He was conscious of this and wrote in 1962 about how Lewis Carroll had employed "an extremely matter-of-fact illustrator, Tenniel, to illustrate his most imaginative dream fantasy."[6] Indeed he pinpointed that it was precisely this "see-saw between imagination and stark materialism that intrigues me in Art."[7] On a more formal, technical level, Surrealism was important for the way it liberated him "from the hog's hair brush and conventionally proportioned canvas." He was free to introduce extraneous collage elements on to the painted surfaces of his imagery, to use many tools and techniques for enhancing textural richness, and to turn the conventional easel painting into a box or environment all its own, rather like a doll's house. Openness could be cited as one of Jardine's central tenets; impatient of theory, particularly of the dialectical kind that progressively streamlined art from observation to the non-figurative, he has always resisted what he emotively called "kow-towing to the Philosophy of Modernism, and its co-partner the destruction of the Natural Environment."[8] What he especially liked in Surrealism was the "unbridled use of observation and of abstraction occuring side by side."[9]

George Wallace Jardine was born in Liverpool in 1920. He began studying in 1936 at the Wallasey School of Art, a small college where one of Jardine's few fellow students was Albert Richards, that highly talented painter best remembered today for his compelling wartime paintings of parachuting soldiers. The Imperial War Museum has most of Richards's works as he became an Official War Artist. Both Richards and Jardine went on to the Royal College in London, Jardine gaining a scholarship based on

George Jardine Strange flying machine. *Oil.*

147

George Jardine Imperial elephant. *Watercolour and collage.*

George Jardine Balloon fantasy.

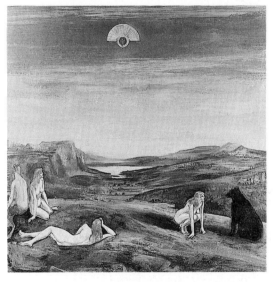

George Jardine Daedalus. *Oil. Coll: Graham Gallery*
(Tunbridge Wells)

outstanding design work. In his short life, tragically terminated when his Jeep ran over a German mine when crossing the Rhine at the end of the war, Richards developed an association with Paul Nash in London and thereby found himself on the fringes of the International Surrealist Movement. Jardine recalled that he "would be one of the leading artists had he lived."[10] Jardine saw the large exhibition of International Surrealism at the Walker Art Gallery in 1936. This event certainly inspired in him the beginnings of a visionary quest to paint the marvellous. The exhibition carried with it the same kind of formative significance for a young, conventionally trained student looking for something extra in the disquieting 1930s aura of precarious calm as the exhibitions of Jackson Pollock and the new American painting were to provide for a younger generation in the 1950s.

War interrupted Jardine's studies on Exhibition Road, but the result was a delightful sojourn (despite wartime privations) in the Lake District, where the college had been evacuated. Ambleside was where the renowned collagist and Merz-creator Kurt Schwitters spent his last days and Jardine met him before he died. Indeed, Percy Jowett used Schwitters to teach sculpture to his Ambleside students. Apart from offering benefits in the form of hiking, climbing, and skating on Lake Windermere which froze very hard in the cold winter of 1940, the wonderful landscape encouraged outdoor painting above all else. While Jardine's class pursued mural decoration under the unmistakable guidance of Professor Tristram, the lessons provided by the haunting scenery were a spur to *plein air* sketching.

An important point therefore about Jardine's work is that the mythological or fantastic content of the foreground is set against landscape backdrops that are either straight transcriptions of accurate, topographical, watercolour studies the artist made in his favoured locations, or else composite views. The bizarre elements are not always the impossible metamorphs they appear to be, but are plausible images taken from a prehistoric past. Jardine's break with the conventions of the present takes the form of illustrating the strange creatures of weird, primaeval landscapes of long before *Homo sapiens* walked the planet. His imagination also projects into the astral plane and he has painted pictures of interplanetary space. He found equal enjoyment in visits to natural history museums as in visits to Jodrell Bank or the Planetarium. Never are the space paintings vulgar or set in the impersonal format of science fiction. Science fiction often alludes to a dehumanised universe where machines dominate and such visions could not be further away from the deeply human nature of Jardine's universe.

Two artists who influenced Jardine early on were Ernst and Klee. Jardine scoured old junk shops and second-hand book shops for nineteenth century engravings to use in elaborate collages much as Ernst had done. The technique of collage resulted in hybrid black and white imagery of Edwardian ladies, fish, trees, clocks, or other stock surrealist objects. Collage also found

150

its way into Jardine's earlier paintings. These incorporated actual objects into the predominantly painted composition, or else the pictorial surface was subdivided into several extruding box compartments, each one becoming a painting within a painting. Two of the Jardines owned by the Walker are good examples, the one an elaborate head made up of collaged shells, the other a complex painting subdivided into many separate picto-images.

In post-war art schools promising young artists could respond to their places of study either by rejecting much on offer in a quest to reach an abrasive contemporary idiom uncaring of the past or future, or by passively absorbing the current lessons of a group of tutors who used the colleges to promote their own modes of practice. Jardine avoided both extremes; instead he blossomed in a sympathetic ambiance that encouraged gentle experiment while insisting on mastery of the craft-based traditions. In his only conversation with Stanley Spencer, Jardine declared that he wished to do a Turner or a Klee painting. Spencer advised the young artist to do both, a gesture in keeping with his own eccentric project to marry realism with biblical fantasy. In many respects Jardine has held true to his dictum, for he has married Turner's glowing naturalism and mythology with Klee's private whimsy and closeted, ideographic dream world. Another helpful contemporary was his tutor Percy Jowett, who enforced the suggestion of museum director Gavin de Beer that the Royal College students make use of the nearby Natural History Museum in order to draw the wide variety of specimens. Jardine was subsequently to draw regularly at the museum, precipitating a life-long preoccupation with natural forms and rare creatures, which afterwards found their way into his vivid and richly imaginative paintings.

In 1943 Jardine completed his R.C.A. studies at Ambleside, and for a term taught in a grammar school. In the same year Alan Tankard, who lived opposite the Jardine family on Barmouth Road near the Wallasey seafront, took George in to meet Henry Huggill, the sympathetic Principal of Liverpool Art School. This led to Jardine's appointment as a tutor in the graphics department, a position he held for nearly forty years. Between 1950 and 1975 Jardine kept a studio at the Bluecoat at a favourable rent. This enabled a ready supply of influential clients to come to the studio and buy work. Jardine always put accessible prices on his work and has been one of the most widely collected and popular of all Merseyside artists. The Bluecoat milieu was therefore an important one both for social as well as for artistic reasons. Jardine was an active member of the Sandon Studios Society, which included Bisson, Tankard, Wedgwood, Bell, Coburn Witherop, Edgar Grosvenor and Stanley Reed. They were a mixed assortment of artists, generally on the traditional rather than the avant garde side, who dabbled in activities ranging from art restoration (Witherop) to astronomy (Reed). Reed was an academic portrait painter who relished

painting fellow artists and members of the Liverpool art scene generally. His life drawings of Jardine's friend June Furlong, the seemingly timeless model on Mount Street, now belong to the Williamson Art Gallery. Bisson's noteworthy extra-mural activity was art criticism for the *Liverpool Post*. For many years Bisson, under the name 'Z', brought an unusual degree of perception and professionalism to the reviewing of local art exhibitions.

Jardine's popularity across the area has been aided and abetted by June Furlong's tireless energy as a freelance exhibition organiser. Jardines have sold from many of her exhibitions, recalling the good old days of the 1960s when many Jardines were bought from the Portal Gallery in London. Jardine rarely participated in the annual Liverpool Academy shows, which seemed on the whole to relay an ethos of self-conscious modernism and art-historical topicality that would have always been anathema to an artist of Jardine's highly individualistic temperament.

George Jardine has been a prolific painter of astonishingly varied and beautiful pictures. His works seldom fail to lift the spirits with their magical alchemy of imagery. The unusual juxtaposition of disparate imagery is not a crude attempt to emulate an academic surrealist device, but an implicit language, originally derived from playing around with scissors and off-cuts of old engravings, which are used to reinvent reality. In Jardine's case it is always a reality suggesting the totality of naturalistic possibilities. On occasion he invests his pictures with a theatrical or circus-like ambiance, suggesting a peep show into another lighter and more fanciful reality. In *Strange Flying Machine* all the key Jardine elements are present — a naturalistically rendered sea, cliff face and cirrus sky, a psychosexual confrontation of the gentlest kind between a slim female figure and a bear who appear as stage performers behind a partially drawn set of curtains. A sense of historical discontinuity can be created through any simple device such as pasting together units extracted from differing cultural or historical sources. In this painting Jardine has an eighteenth century clipper sailing beneath a Max Ernst air balloon and a larger flying machine of dubious patent. In *Imperial Elephant*, this time a consummate watercolour, Jardine takes a circus elephant and makes it carry a totemic stack of mandala boxes, horns, butterflies, clocks, cages and flags (of Islamic and Latin American countries). The elephant is engaged in an acrobatic balancing act of great precision, beauty and precariousness. The animal is set back in its natural environment on a flat, arid plain with hills nearby.

A Jardine picture always leaves a little message, reminding us that the harsh materialism and social conditioning of modern life are themselves illusions shrouding the deeper range of possibilities that lie dormant in more expansive and coherent levels of consciousness. To some this seems to belong to the romantic world of make-believe, but even the most advanced

frontiers of science would find common ground with it, and Jardine is an artist who, in his own inimitable way, is as mindful of science as any.

Jardine is also a good example of how far a person's mind can travel in a life spent predominantly in his native city. John Willett noticed in the 1960s that of all Liverpool painters "he seems the least restless, though he says he lives here primarily because he has a job at the College . . . he says he'd sooner work anywhere than where he was born and bred."[11] The imagination can fathom limitless depths in the present time and place. The landscape of the Wirral, and more particularly of North Wales and the Lakes, triggers off a sense of the wonder and mystery of nature. He summarised his feelings when declaring that "I don't think I would have gained much by going to live in an art centre like Paris. Too much like 'taking coal to Newcastle'. I like more the wilderness . . . I could have been happy if I had lived in the Victorian era, exploring remote parts of the world collecting plants."[12] Similarly, he found that the flatness of London gave him a feeling of claustrophobia when be lived there as a student.

Josh Kirby is one of the most notable graduates of Liverpool's art school in the late 1940s. Kirby's career as a painter of science fiction and ultra-fantastic scenes logically stemmed from George Jardine's influence in the graphics department on Hope Street. He pursued a highly unusual course leading Adrian Henri to open his review on Kirby's 1988 exhibition at the Albert Dock (organised by June Furlong) by speculating that he "may well be Liverpool's best known but least exhibited artist." The opening of this long overdue exhibition bears this out for according to George Jardine the artist "could not get into his own exhibition for the crowd when he arrived."[13] The paradox of being well known but under-exhibited is the result of Kirby's general unwillingness to sell the originals of his detailed fantasies that were commissioned for reproduction on science fiction book-jackets, commercial posters and prints. He has earned a living through reproduction rights rather than by selling the original pictures, which at any rate are painfully slow to emerge from the easel.

Kirby was born in the Waterloo district of Liverpool in 1928. Henry Huggill could see his graphic brilliance and accepted him into the junior art college, where he began studying under Charles Gardiner. Even then he was making copies from contemporary cartoons. He studied there for six years, finally leaving Merseyside for London in 1950. Kirby gained a thorough grounding in the traditional crafts that go to make up a complete visual education. Tankard taught lettering, Timmis antique drawing, Wiffen life drawing and so on. Yet the painter Martin Bell made the biggest impression, encouraging Kirby in everything he attempted. Jardine, a recent addition to the staff, also made an impact, not only instilling the principles of nature observation and neat transcription of minute detail but also encouraging variations of Surrealism. The world of fantasy was what

Josh Kirby The Life of Brian. *Courtesy: Monty Python.*

mattered most and in Kirby Jardine found one of his earliest kindred spirits. But Kirby also found himself in a sympathetic, if not yet consciously avant garde, milieu. Don McKinlay was in the same year and friendships were also formed with other students like John Mundy (later to teach in the junior art school) and Ken Woodward.

Kirby's student course demanded an academic approach, and it was felt that he would graduate to be a portrait painter. Through Walker director Frank Lambert, Kirby painted a portrait of Liverpool's Lord Mayor in 1951. In London he joined a commercial studio and set to work designing film posters in gouache. After a year in France he went freelance and during the later 1950s designed jackets for science fiction stories and also made some romantic and cowboy covers for Panther books. His private easel painting was still on conventional lines, though it gradually converged with the fantasy illustration. Kirby married and moved to Norfolk. There he later produced two of his most famous works, the film posters for *Life of Brian* and *Return of the Jedi*. Basing his idea on the Tower of Babel, Kirby's painting for the former is a high point in his career. Kirby employs all the high standards of academic art to perfect the complex imagery, wild frenzy and teeming detail of his phantasmagorical scenes. The virtuosity is akin to that shown by Ernst in his shrubberies in *Nature at Dawn* and *Europe After the Rain*. A Christian theme underlies what at first sight seem to be Kirby's grotesque, futuristic visions. But the motive is likely to be classical rather than religious. In such visions there is a marriage between the perfect machines of futurama — metallic monsters, glittering flying saucers and so on — and soft, pastoral landscape tinged with the lushness of a primaeval past. Similarly, the human creatures are at once flesh and blood, and Krishna-like beings materialised from the astral plane. It is a question of classicism and tradition dressed up in the decadent garb of the space age. The decadent garb is not to everyone's taste and one suspects that catering to the world of science fiction novels and films may have had the same effect on Kirby's work that a Hollywood film commission had on Ernst's *Temptation of St Anthony* (1945). Overloaded with detail its vulgarity was rebuked by George Melly who said it was where "Bosch meets Walt Disney".[14]

Kirby is however well able to handle large-scale formats and when doing so frequently emphasises the gentle curvature of the horizon that a broad, long-distant view of topography gives. Brueghel, Bosch and Dali are obvious influences, though a still greater one is Frank Brangwyn. Indeed Adrian Henri described Kirby's picture as being like "Frank Brangwyn on an L.S.D. trip." Brangwyn's naval battle scenes, a richly painted primaeval soup of wreckage and torn rigging, conveys a sense of disorder and of vulnerability to violence and piracy. A similar mood conducts itself through Kirby's space-age fantasies. He has also used Dali's device of 'paranoia

criticism', in which the disquieting metamorphic character of a face or object is composed to represent two different things at one and the same time. Thus in a series of compelling portraits of Alfred Hitchcock, produced for Pan Books in the early 1970s, Kirby has birds or animals emerging from Hitchcock's flesh. Perhaps when all the complexity and eccentricity of surface vernacular is stripped away, Kirby is seen to emulate the great age of mythological neo-classical painting exemplified by Poussin or Rubens. If so, it proves what Kirby claims has been his desire to react against the trendiness and suaveness of modern art. Disliking the materialistic values of modern society he has followed the surrealist maxim that decrees the primacy of the unfettered imagination, as shown by Dali and Ernst, and back through the mythological splendours of seventeenth century painting to Brueghel.

Ken Woodward was a student with Kirby, and their careers followed similar courses. Woodward entered Liverpool Art College in 1942, aged 14, and spent most of his time in both the junior and senior schools under Martin Bell. The war was on and provided a strange kind of excitement for an adolescent who lived in Maghull away from the vulnerable parts of the city. He was taught figure drawing by Alfred Wiffen and architectural drawing by Geoffrey Wedgwood and Alan Tankard. He was interested in Surrealism and was drawn to the work by George Jardine. He completed the course in 1948 and went to Cookham where he worked on animated designs for Gaumont British Animation. In the following year he moved to Granada in London where he worked on interior decoration for cinemas. Privately he was painting easel pictures of elephants in various metamorphic guises, though these he never exhibited. In 1956 he worked for Disney as a designer of merchandise, later worked in films and finally illustrated children's books. In the 1980s he began making collage boxes. Woodward takes his place alongside Josh Kirby and the cartoonist Norman Thelwell as Liverpool art students who made a name in the realm of the commercial or fictional arts.

Max Blond is an artist who uses fantasy and symbolic narrative in his work. He was born in Liverpool in 1943 and has spent most of his life on Merseyside. In the first half of the 1960s he had spells studying at Corsham and the Slade. He has had numerous exhibitions since and exhibited in his brother Jonathan's galleries in Liverpool (the Allerton) and later in London (the Blond Fine Art). His work slots into a general surrealist category, though more specifically his work belongs to the wild, distorted, figurative style of the 1980s. In this supposedly post-modern climate a new pluralism seemed to break away from the accepted 'isms' and stylistic conventions of the past, and it is not possible to attach Blond to any one coherent lineage. But his work has general links with recent artists like Paula Rego, Wyn Jones, Tricia Gilman, Amanda Faulkner, Eileen Cooper, Ken Kiff and

Ken Woodward Don't forget the diver, *1990. Assemblage, exhibited Tokyo.*

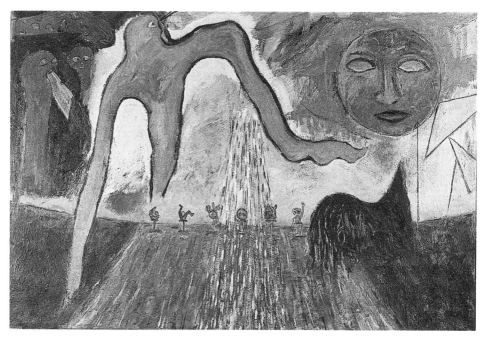

Max Blond A dream of longing, *1985. Oil on canvas. Below,* Voices from the past, *1985. Oil on canvas.*

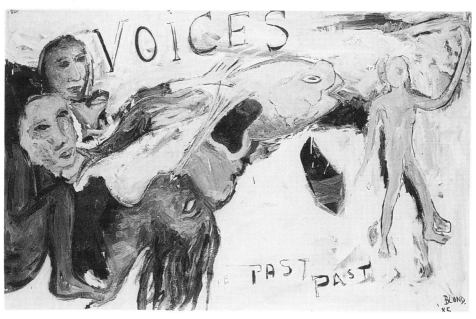

Arthur Boyd, as well as relating back to the late work of Philip Guston, or to Nolde, Ensor and the Expressionists in their most exuberant, symbolist moods. What characterises the work of Blond and a number of his contemporaries is their apocalyptic vision, the sense of chaos, impending catastrophe, or violence. The symbolism tends to use the nude or the elements of nature in their most turbulent or sublime moods. The handling of paint is crude and urgent, allowing for drips or other expressionist bi-products. Phantoms or other strange biomorphs jump out of the microcosm and become fully-fledged creatures, looming large over a landscape. A frenetic energy alludes to the age of anxiety. Traces of German Expressionism are clear in the woodcuts that most of these artists produce along with their paintings. The making of images by cutting away wood creates a simple but powerful dialogue between positive and negative space, between light and dark and so on. In Blond the forms are similarly robust and set in a plastic equilibrium with the background space surrounding the form itself.

In his *Voices from the Past* Blond wishes to evoke the positive but also harmful ancestral influences that mould a person's nature. The image is a kind of intergenerational procession. The large fish symbolises fertility and birth. The canvas is typically large, suggesting Blond's need for freedom of handling and also his desire for monumentality. The second picture, *A Dream of Longing*, depicts the soul searching for spiritual contact with a higher force. Blond chooses the unappealing form of an amorphous, amoeba-like figure to symbolise the soul rising upwards in its search. The sun face symbolises the sought-after spiritual power. The small, totem-like sculptural figures on the horizon "show stages in the struggle for progress" according to the artist. To the left and right of the picture snake-like phantoms and a woman's downturned head — both depicted in dark, shadowy tones — warn of the forces of evil and of the possibility of failure. Like the previous picture this is a large-scale work dating from 1985. It is a courageous and deceptively simple portrayal of aspects of the human condition.

These pictures provide clear examples of the fluent way Blond paints his imagery in a quest to convey important meanings. They are highly individual works reflecting the ethos of an artist who left the Slade School in 1965 "with the outlook and philosophy that contemporary painting was going in the wrong direction."[15] Such a sentiment echoes perfectly the views of George Jardine and many other Merseyside artists. Modern painting's impasse was due to its hermetic formalism that had become sterile and lacking in genuine association with life and experience. Since 1965 Blond has used the figure in a robust and evocative form of expressive dialogue with the spiritual meaning and insight that are the *raison d'être* of his art.

NOTES

1. David Hillhouse in conversation with the author, March 1991, Birkenhead.
2. 'Another World', by George Jardine in *Painter and Sculptor*, 1962.
3. Letter to the author, spring 1991.
4. *Painter and Sculptor*, 1962, p.22.
5. Letter to the author, March 1991.
6. *Painter and Sculptor*, 1962, p.19.
7. ditto.
8. Letter to the author, 1991.
9. *Painter and Sculptor*, 1962, p.22.
10. Letter to the author via Pelter Sands Gallery, August 1989.
11. *Art in a City*, John Willett, p.188, Methuen, 1967.
12. Letter to the author, spring 1991.
13. Letter to the author, August 1989.
14. George Melly on cassette guide to Max Ernst exhibition, Tate Gallery, April 1991.
15. Notes written to the author by Max Blond, May 1991.

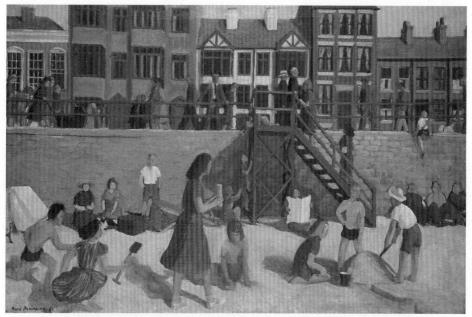

Mavis Blackburn Rhyl Beach, *1951. Oil. Collection: Graham Gallery (Tunbridge Wells).*

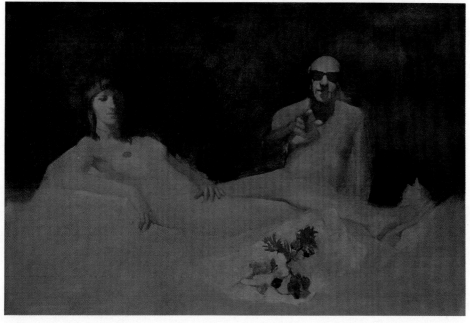

Arthur Ballard Punch and his Judy, *1973. Oil. Collection: Atkinson Museum, Southport.*

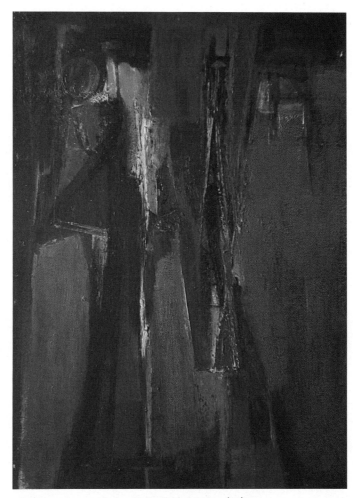

Arthur Ballard Abstract painting.

Nicholas Horsfield French Landscape, *1955. Oil. Collection: Graham Gallery (Tunbridge Wells).*

George Jardine Fantasy
Landscape. *Oil.*

George Jardine Procession of the Druids. *Oil. Collection: Graham Gallery (Tunbridge Wells).*

Maurice Cockrill Two
Windows, *1973. Acrylic.*

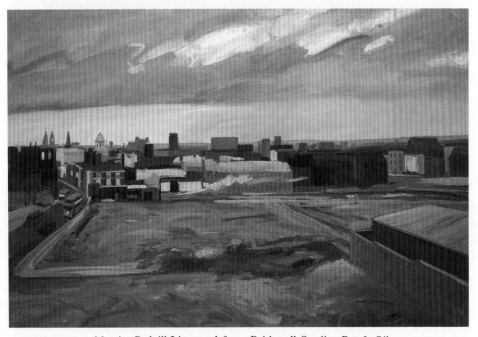

Maurice Cockrill Liverpool from Bridewell Studios Roof. *Oil.*

Maurice Cockrill Summer, *from* Four Seasons, *1991. Oil on canvas. Collection: Bernard Jacobson Gallery.*

Stuart Sutcliffe Hamburg painting. *Oil on paper.*

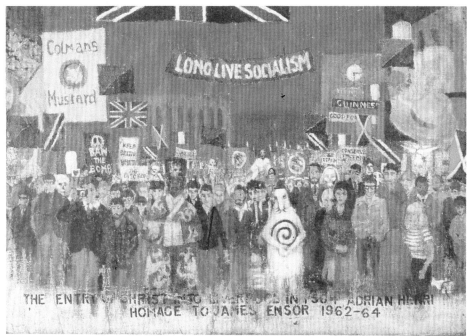

Adrian Henri The Entry of Christ
into Liverpool, *1964. Oil on
hessian. Collection: Graham Gallery
(Tunbridge Wells).*

Adrian Henri Interior, *1961.*

Maurice Cockrill

Maurice Cockrill's work has undergone great changes down the years. So much so that the early and mature phases may look to the superficial eye to be the work of two entirely different artists. But there are underlying qualities common to all phases of this searching artist's *oeuvre*. At the time of writing he is in his mid-fifties, at the height of his artistic powers and with an ascending reputation. Thus if we look back from the vantage point of the early 1990s we can see two broad phases in his work. The earlier Liverpool period that began in 1964 was characterised by a number of 'pop', then so-called 'super-' or 'photo-realist' styles. The work was carefully composed, often tightly drawn, and usually broadly autobiographical in the sense that imagery was taken from his personal experience and immediate surroundings. Towards the close of the artist's eighteen-year period on Merseyside he experimented with fragmented imagery, collage, oblique social symbolism and even billboard art. Throughout such experiments the imagery remained concrete and the scale large. In marked contrast the work since the 1970s, particularly after his move to London, has become much looser and more expressionistic. His painting gradually became an arena giving full vent to dreams, fantasy, and both collective and personal mythology. Professionally, he has never looked back and the move south paid rich dividends, particularly after he graduated from the Edward Totah Gallery to the high-powered, internationally-oriented Bernard Jacobson Gallery in the West End. Any full retrospective of his career (such as the one scheduled at the Walker Art Gallery for 1995), needs to look closely at both contrasting sides of his work and to discover threads consistent throughout the apparent stylistic diversity.

Cockrill was born in 1936 in Hartlepool but spent his early boyhood in Aberdare. The spectacle of heavy industry set among dramatic Welsh hills, the menacing ambiance of the war, exerted a lasting impression on him. Until the age of twenty-four he had a variety of jobs, the most sustained of which was three years at de Haviland's aircraft factory in Chester. He went to evening classes at Wrexham, subsequently enrolling full time, and later went to the University of Reading, where he encountered the charismatic Claude Rogers. In the early 1960s Cockrill painted in Reading a large oil, *Blue Dancer* (1963), which with echoes of Adler, Armitage and particularly Scott, presented a monumental though simplified blue figure

with angular body and crescent head. It was a raw image, much of its time though tending to look back rather than forwards. In 1964 Cockrill moved north again when he managed to obtain his first teaching job at the small art school in St Helens, run by the talented, though autocratic, Eric Gill. Gill's approach was incompatible with Cockrill's liberal-mindedness and he was eventually forced out by Gill's inflexibility. Cockrill, by now married and with a family, was living in Liverpool.

Another Reading work, *Late Shake* (1964), was shown at the Bradford Spring Show in 1965, with works by Hockney and Boshier. Despite its unmistakable sixties theme of disco dancing, the work again looked back. With its gestural paint lines and moving energy the picture belonged more to Rivers and Diebenkorn than to the concrete, often inert imagery of Pop. One of Cockrill's early successes was a huge, lozenge-shaped relief painted on wood, *Round We Go*, which was exhibited at the Walker with five other Cockrills in the Liverpool Academy exhibition of 1966. It was described by Robert Waterhouse of the *Guardian* as "the most exciting exhibit in the show." The artist has described how the picture was made for the John Moores entry earlier that year "but rejected because it projected too far from the wall, and was not entirely characteristic of my work at that time."[1] The work's prominent lozenge shape was offset by an internal circular composition divided into four units. Whirls of hard-edged colour, a cross between Arp's biomorphism and sixties psychedelia, focussed, upon closer examination, into amplified segments of human faces. The work sat tantalisingly on the fence between abstract significance and figurative association.

During the late sixties Cockrill had taken on board glamorous and provocative pop imagery and often relayed it with the deadpan sensuality (if that does not seem a contradiction in terms) of photo-realism. Naturalistic detail, most often depicting blades of grass, hedgerows, gardens, or architectural facades, was painstakingly painted. Virtuosity in the breathtaking depiction of detail was held in check by the sheer earnestness of the image construction. *Clean Tasting Mouth* of 1970, typical of the period for being painted with fast-drying acrylics and divided up into several distinct zonal images — a spray-gunned sky, a road truncating the middle of the picture and a coffin-shaped inserted canvas conveying the mouth of a girl sensually licking a lollipop. Taken from a Pirelli calendar, the image was a lingering piece of sixties hedonism, relayed in hard, linear detail. Stylistically and emotionally this work was far removed from what Cockrill would be doing twenty years later. The work was displayed at the artist's Serpentine exhibition in the summer of 1971. With its mixture of overt sixties sexuality and the metaphysical elements of early seventies post-psychedelic youth culture, the painting resembled the imagery found on contemporary Pink Floyd, Led Zeppelin or Blind Faith album covers.

But the artist was dissatisfied with the effect that pop culture was having
on his work. Cockrill used that quintessential sixties event — a house party
on Huskisson Street — as the occasion to burn many early pictures, and
most student work, in an iconoclastic gesture that signalled the desire to
make a completely fresh start. The marked contrast that was later apparent
between the artist's Liverpool and London work was therefore predicted by
this startling event. Cockrill moved into a Canning Street house where a
number of Liverpool scene characters, including Adrian Henri, had been or
were living. Disliking the distracting and chaotic ambiance, he moved out
to the more tranquil location of Roger McGough's 'Windermere House'
near Sefton Park. The smart house was painted by Cockrill's friend John
Baum, and the picture is now in the Walker Art Gallery. Baum's tightly
detailed, full-frontal style echoed Cockrill's own contemporary work. A
certain quality of stillness accompanied the imagery that seemed frozen in
time. For all the surface verisimilitude, nothing very dynamic or interesting
appeared to be happening. The stillness and melancholy of the early 1970s
works, though a passing style, undoubtedly reflect most authentically
Cockrill's own sensibilities at that time.

Four of Cockrill's pictures from the 1973–4 period found their way into
museum collections on Merseyside. The well known *Two Windows/Two
People* (1973) and *Sudley* (1974) belong to the Walker, while *Scillonian Pumps*
(1974) was acquired by the Atkinson in Southport. The first of the three is
a huge, horizontal picture in three sections. It was exhibited at the Walker
in 'Communication'. This exhibition was sponsored by the *Liverpool Post*
who bought the Cockrill and presented it to the Walker. The painting
clearly made an impression at the exhibition, where Adrian Henri described
it as the best picture created in Liverpool for a decade. After the private
view Nicholas Horsfield advised Cockrill to find a London gallery before the
age of forty. It was sound advice from a stalwart, though Cockrill was to
be in his mid-forties before fulfilling Horsfield's prescription for success.
The picture of two windows cannot safely be categorised as photo-realist,
because the source material for the diverse imagery comes from a large
number of different photographs, drawings and even memories. The artist
has located the picture as a piece of "synthetic realism" which neither
mimics photographs nor other art styles, past or present. As so often with
Cockrill, the picture's content was in part motivated by psychological
experiences. The artist, together with a woman with whom he had been
living, are portrayed standing, facing front, one behind each of the two
windows. The idea behind the complex image is the possibility of living
together while inhabiting two entirely separate mental or spiritual worlds.
Once again Cockrill's work, even when at its most tangible and real,
searches for a suggestion of the other 'reality' lying dormant beyond surface
appearances. The idea of alienation, often touched on in Cockrill's images,

is also present. Alienation is in essence a spiritual malaise. The figures are rigidly set behind their separate window frame grids unable to communicate or interact.

The handling of paint is rigidly controlled, impersonal and precise in an effort to compensate for the chaotic, unresolved state of his emotional life at the time. In looking for stability Cockrill created "a subjugation of style" in which painting became meditation. At the time Cockrill had been through a divorce, had been drinking heavily and was promiscuous. The artist increasingly came to the view that both his lifestyle and work of the late 1960s was directionless and wasteful. The death of his parents in the late 1960s contributed to this re-evaluation. He described the will to order in the pictures as being "like building a sanctuary for myself where everything balanced." In the two 1974 pictures, *Sudley* and *Scillonian Pumps*, Cockrill delights in vast scale, frontality, exactness of detail and the 'stitching together' of architecture (man-made elements) with grass or trees (nature). The petrol pumps picture took the artist five months to complete, painting in the early morning light prior to a day's teaching at the art college. The Sudley picture, depicting one of the well known satellites of the Merseyside museum's complex (set in a park), relates to his equally frontal and detailed painting of the steps, column and facade of the Walker Gallery's entrance. Both Sudley and Walker pictures were commissioned by Timothy Stevens.

In its more English way *Scillonian Pumps* presented an image that recalled one of Edward Hopper's best known subjects. The silent play of light across building facades that we see in Cockrill's *Sudley* also reminds one of Hopper. The treatment is not all that different either, though with *Entrance* (1975) Cockrill establishes a new connection with another American artist whose involvement with the American scene is imbued with the starkness and brashness of up-to-date urban technology and advertising. Richard Estes is an uncompromising urban realist whose compelling, photographic images of New York shop fronts, neon advertisement displays and urban transport are stamped with American culture in its most commercially brash guise. In *Entrance* (1975) Cockrill uses the same frontal view of an entrance to a modern building, though the style has evolved from the Sudley and Walker facades rather than from a wilful adoption of Estes's manner. Balancing the large area of reflecting glass, metal hinging and concrete a young woman (Cockrill's future partner Helen) stands in *contrapposto* outside the doorway. The picture has a greater degree of contrivance than an Estes, suggesting a softer, more romantic and poetic kind of pictoriality. The artist also expresses an interest in peripheral vision by painting looser, more diffused forms towards the edges of a detailed focal centre. Nevertheless, with *Entrance* Cockrill comes closest to a virtuoso photo-realist style, one which shows off a superb technical mastery over architectural symmetry, pictorial

Maurice Cockrill Shadow, *c.1970*.

Maurice Cockrill's Bridewell studio, Liverpool in the late 1970s with paintings for Lime Street Station project in progress.

Maurice Cockrill The Lyceum. Liverpool. *Charcoal and pastel.*

Maurice Cockrill Nocturne to the city, *1979.*

Maurice Cockrill Still life – red and blue axes, *1979. Oil on canvas.*

167

Maurice Cockrill: Bluecoat Gallery, Liverpool, 1982.

Maurice Cockrill Beneath the wheel, *1981*.

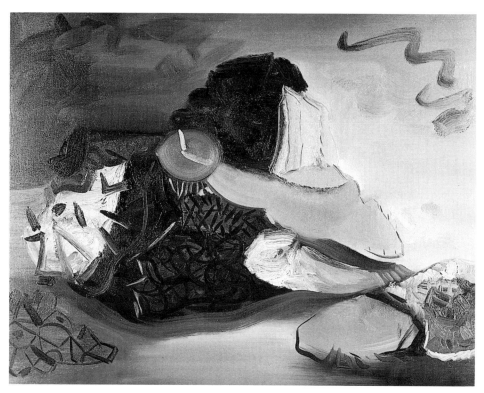

Maurice Cockrill Landscape at 4.00 a.m. *Oil.*

Maurice Cockrill Woman in landscape – No.3. *Oil.*

170

composition, tonal credence and complex drawing. *Entrance* was commissioned by the University of Liverpool, and now hangs in the Mathematics Building.

Another painting of the same year, *Sailing On* has affinities with the work of another American artist, the English-born Malcolm Morley. Morley had also evolved through a super-realist style, his series of ocean liners from the mid-1960s striking a high pitch of verisilimitude while at the same time making no bones about the postcard source material. Gradually, Morley began to subvert the safe super-realism of the recurring liner subjects, either with wilful, painterly interruptions and defacements, or else by drawing attention to the postcard sources by tearing them up and painting the resulting fragments. In *Sailing On*, the Liverpool artist chooses to paint a ripped postcard of a nineteenth century painting, a graffiti-covered wall symbolising a declining port, and one of his own plastic lids that had served as a palette. In a series suitably called *Untitled* in 1976, the artist takes his interest in the recycled imagery of torn-up postcards to quite abstract proportions. He simply paints fragments of paintings belonging to the Walker that have been torn and collaged together in a new and arbitrary, but consciously artful, way. They are not high points in Cockrill's work though their scale and boldness represent a decisive conclusion to this particular line of formal enquiry in his work. There is something Johnsian in the painted image of a painted image, one that has been disrupted and reassembled in a new way. Cockrill also follows the later phases of Cubist still life painting by depicting the shadows supposedly cast by collaged fragments loosely stuck across a flat background. The *Untitled* series was scaled and shaped for installation on the walls of the Walker Art Gallery.

Discussion of Cockrill's links with contemporary American painting is valid only if kept as a secondary consideration. In *New York/Liverpool/San Francisco* (1978) Cockrill may well allude to the special relationship and transatlantic feeling linking the great English port with two American ones. He also uses the Morleyesque disruption of second-hand postcard source material by crisply and faithfully painting still partially recognisable images of the three cities conveyed in crumpled postcards. Yet his most ambitious, and certainly largest, work from the period, *North West Passage*, utilises not only symbols and imagery specific to Liverpool's situation at a given historical moment but also the artist's own responses to that situation. Talk of formal links with other artists here becomes insignificant as Cockrill attempts a *magnum opus* that expresses the paradox, even pathos, of a declining port. Nevertheless, Cockrill's style at this time related to American 'New Image Painting'. This presented socially or psychologically significant subject matter using the contemporary rhetorical poses of conceptual art.

The massive seven-panel painting *North West Passage* was started in 1975 for the 'Face of Merseyside' exhibition the following year. The picture had

also developed after the rejection of *Transplant*, a scheme in which Cockrill would produce two hoarding-sized paintings, one for installation in a poor area and the other in a wealthy part of the city. The intention was to place a large image of comfortable Allerton on the rough Scotland Road and vice versa. The public implication of this ambitious outdoor scheme impressed Adrian Henri who, as President of the Academy, discussed the idea with the *Post* and *Echo*. The advertising firm of Arthur Maiden was approached for the provision of hoardings, but typically the firm declined due to the expense and controversial nature of the scheme. The artist wished to confront two realities, one "with evidence of dereliction, neglect, disorder" the other with "signs of growth, prosperity, comfort, balance."[2]

In *North West Passage* Cockrill was able to present the two sides of social reality that he sought to portray in *Transplant*. The image of an ocean liner symbolised Liverpool's great past as a shipping port. The yellow area of graffiti below was taken from an underpass near his Aigburth home, and symbolised the boredom and disaffection of the unemployed and socially deprived in current day Liverpool. Furthermore, the pronounced fissure between the liner and the graffiti represented the junction point of a torn postcard fragment. The notion of an official Merseyside tourist postcard being torn promoted the idea of the dismemberment of local economic and social life.

In early 1979 Cockrill's attempts to take his painting into the real world at last came to fruition with the series of large portrait heads for *Seven in Two*, his much publicised Lime Street Project commissioned by the Arts Council. The paintings were billboard-sized canvases each ten feet high, conforming to the 'sixteen-sheet' size characteristic of hoardings. The seven paintings were hung high above the concourse at Lime Street Station (out of reach of vandals). The works were placed in the sequence of the colour spectrum as well as in the age order of the subjects. During the previous winter Cockrill had candidly used a camera to record passers-by, the best images resulting from spontaneous encounters with unsuspecting subjects. The artist wrote that he was simply seeking "representatives of each age group, and eventually found 'ordinariness' a more appropriate factor for development in paint than eccentricity of appearance." In common with the American billboard artist Alex Katz, therefore, Cockrill was aiming to level out facial characteristics, romantic distractions and so on. He was looking for a uniformity within the diversity of his subjects. Simplification and stylisation were reached through a long process of preparatory drawing to ensure "the legibility of such images in the context of a busy and unglamorous provincial station already overspread with tawdry advertising." The working drawings were displayed concurrently at the Bluecoat Gallery.

A year previously, Cockrill had aired another long-standing preoccupation at an exhibition of works illustrating his use of the postcard from 1964

onwards. His early use of collage and fragmented imagery had been in the 'conventional' surrealist manner that sought to combine, as he put it, "incongruous images with a shade of black humour or eroticism."[3] By the 1970s the idea of a picture containing sudden compositional fractures or disruption of straightforward narrative imagery had led the artist to illustrate disparate collaged material rather than incorporate it into the picture surface. He was always a painter before a collagist and if collage interested him then it was for conceptual rather than stylistic reasons. Cockrill's contribution to the Walker Gallery's Centenary in 1977 also involved the use of postcard sources. He made twenty large studies on paper, each variously relating to a postcard reproduction of Turner's *Linlithgow Palace* in the Walker collection, and also to an 1877 newspaper cutting on the Walker's opening celebrations. Also in 1977 Cockrill won Alexander Howdon's sponsorship prize to produce a picture on the theme of great British achievements for the Silver Jubilee. Cockrill was invited to make an image of the Beatles. Merseyside Tourist Board commissioned a second painting, from which they made a print. Cockrill did not consider the works important in his development as a painter though the money was welcome at the time and the two pictures do, with their use of well-known photographic and postcard imagery, slot into a significant theme within the artist's *oeuvre*.

The neatly delineated and flatly painted style, and the coherent imagery of the Lime Street portraits were features echoed in other smaller canvases of 1979. In *Red and Blue Axes* Cockrill paints a pair of axes, one red, the other blue (political symbolism?), laid across a stool in the blue and brown corner of a room. Formal interest in the axes as sculpture-like objects or surrogate human figures seems to be thrown into relief. Also, the unusual juxtaposition of a standing blue axe and a red telephone in *Axe and Receiver* begs the question of surrealist enigma. The still life series, in general, "hint at unseen protagonists, at stories about to unfold, and — in the pictures of axes and other potentially dangerous implements — at dramatic and violent confrontations." Clear in Marco Livingstone's comments was a feeling that figures were about to emerge in Cockrill's art, for the artist's "growing concern with the workings of the mind, particularly in a state of anxiety or stress, was unmistakable."[4] The first canvases to incorporate monumental figures were produced in London and exhibited at the Edward Totah Gallery in 1983. Resolutely figurative, the human form occupies most of the surface. The life-size axe pictures of 1979 anticipate the Totah canvases as the axes were considered to be "like human protagonists, stand-ins for figures."[5] In its concrete and figurative way, Cockrill's series of a dozen axe and tool pictures shares something with Neil Jenney's post modern chainsaw and sawn log paintings. There are echoes too of William Scott's identification with kitchen utensils.

A large picture depicting Liverpool at night, together with a number of

other cityscapes, "partake of the compression and economy of the still lifes." A number of compact, archetypal architectural objects loom against a dark blue background (the sky at night) from a flat foreground area (a roadway network). Formally the picture successfully tackles the problem of "activating areas that would otherwise be lacking in interest." The painting is full of atmosphere, and presents a mixture of fading natural light with a network of artificial light. It is a well drawn composition, conveying across its surface powerful geometric perspectives and what Joni Mitchell described in one of her contemporary songs as "the mathematic circuits of the modern night."[6] On the horizon, placed two-thirds up, are distant but unmistakable features of the Liverpool skyline. The nocturne series resulted from many pencil studies made at night from the rooftop of the Bridewell Studio. In another depersonalised urban night view, *Hotel Alicia*, the artist uses the predominance of dark recession as a foil to artificially lit railings, pavement and windows. Such forms gain in mystery from the absence of a context. According to Marco Livingstone there was not as yet any need for expressive handling because the "atmospheric night scenes and images of objects with disturbingly violent connotations are in themselves rich in emotional content."[7]

The early 1980s were a watershed in Cockrill's career and the new decade ushered in entirely new technical, formal and thematic approaches. The night pictures seemed to signal the artist's desire to dissolve concrete form and the tangible content of surface consciousness in a darker, enshrouding atmosphere. The artist's journey within had started, and soon the whole or fragmented images would be invested with the enigma of the dream state. Such changes were reflected in the artist's own life, for in 1980 he resigned from his teaching position at Liverpool Art College. He had been full-time there since 1969, but decided that he wanted to devote his energies exclusively to painting. A disillusionment with the college had set in, and Arthur Ballard's retirement seemed in a way to signal the end of art's vital role in the city. Cockrill got on well with the older man, the two resembling one another to the extent of sometimes being taken for brothers. Ballard, always a good judge of an artist, had by now come to consider Cockrill the "premier" artist on Merseyside, and advised him to head for London, the real centre of the art world. Cockrill had first met Ballard as a young man in the late 1950s. They were introduced by Cockrill's friend, Judith Dunn, who was at the time studying under Ballard. He had also seen Ballard's painting *Farm* in the Walker, a formative experience for a young man who was working in a Chester factory, and who was already seeking views of North Wales with Cézannean motifs for sketching.

It may seem to some, in view of past events, that Cockrill's decision to work in a more fashionable, expressionistic style in the 1980s and beyond was opportunistic. But as we have seen the change had already been

anticipated by themes implicit within the more detailed, concrete imagery of the 1970s. Cockrill felt he had earned the freedom to express himself in a more direct and sensual way. He had mastered detail and structure to such an extent that a new freedom of handling could conjure up the most elusive of dream or psychic imagery. In many ways the great changes in Cockrill's art at this time reflect the growth of Abstract Expressionism, with its gestural automatism, out of European Surrealism. The Surrealists tended to favour detail, poetic metaphor and legibility, while the Abstract Expressionists gave 'form' to more direct psycho-automatic impulses. The gestural arena of Abstract Expressionism and the conventions of monumental scale later became an avant garde academia. What makes Cockrill so relevant an artist in the post-modern 1980s is the way he transmutes the gestural approaches of the New York School into an entirely new cultural reference point for a renewal of figurative expressionism and mythical symbolism. As if to squash any stuffy academic habits the artist has always considered his style at a given time to be based on his own needs and priorities. Painting was nothing if not an expression of lived experience.

By the time he left Liverpool for London in 1982, Cockrill had been living in his Bridewell studio for four years. Times were bad, as his work was not selling well. This had something to do with the recession and also with changes in his style. The Toxteth riots of 1981 represented the city at a very low ebb. The riots awakened Cockrill to the plight of others, and it was because of a desire to introduce a sense of turmoil into his work that he began to use urgent gesture, impastoed paint and agitated handling. It is a measure of the versatility and facility of this artist, of his formal power and imagination, that in works like *Mardi Gras* or *Beneath the Wheel* could be seen a new symbolic expressionism so different from the work of a few years before. He used a wide dragnet of art historical references borrowed from whatever source took his fancy. Thus could be seen hints of Christopher Wood at his wildest, Poussin and the Old Masters, or Bacon and Bomberg.

The move to London was not without its problems though Marco Livingstone introduced Cockrill to Edward Totah, one of a new breed of enterprising and energetic art dealers specialising in high-powered new painting. Cockrill obtained a studio in the communal Berry Street complex (shared with other rising artists like Paula Rego and her husband Victor Willing) and after visiting him here, Totah included him in a mixed show in 1983 and gave him a one man show in 1984. In order to keep the wolf from the door, Cockrill did some part-time teaching at Winchester, Portsmouth and Nottingham art schools. Livingstone, formerly a keeper at the Walker and by then an assistant director at the Museum of Modern Art, Oxford, continued to lend critical support to Cockrill's project throughout the period of his transition from north to south, from objective to expressive. Working at the Walker meant that Livingstone was close at

hand to see the changes that were taking place in Cockrill's art during the late 1970s and early 1980s. He cited the event of Cockrill's move into the Bridewell Studios in 1978 as marking a shift away from the use of second-hand sources, like postcards and photography, and the embrace of real-life objects in his immediate environment. The critic detected in 1980 that making "the pictures look modern is no longer a prime concern. What matters is that they transmit experience." This desire to invest his pictures with direct experience is the key to understanding the changes that occurred in the artist's work during the next few years.

One gauge of the giant swing-about is a comparison of his one man exhibition at the Bluecoat in 1980 (the axe series, the cityscapes and the nocturnes) with the one he had at the same gallery two years later. The second display included all the new works with symbolic shapes, gestural impasto and rich colouration. The huge contrast between the two Bluecoat exhibitions prompted Adrian Lewis to refer to the "courageous plunge into more automatist procedure, after an earlier phase of processing imagery from photographs and postcards."[8] Lewis, who had once been on the staff of the Walker, chose to review the Bluecoat show of a Liverpool artist on the very threshold of moving to London. His review hinged on Robert Motherwell's distinction between 'psychic' and 'plastic' automatism. Motherwell also regarded good painting as existing somewhere between masturbation and engineering. Psychic automatism was a less respectable category, intellectually, in that subjective or visionary outpourings were not necessarily truly automatic or independent of preconceived cultural and psychological conditioning. Plastic automatism, a more appropriate category in which to discuss the recent Cockrills, could be physically gauged in terms of technical process, handling of material and formal construction of imagery. The works on paper presented imagery built up by using pastel over tempera. The medium allowed "rapid procedure" denied to the more ponderous medium of oil paint. Nevertheless, the critic finished by citing as his favourites a group of oils "sunk in the brooding atmosphere of woods, mountain streams and livid skies, which suggest possible symbolic readings by including a drowned bird, axe stuck into a truncated tree, but which avoid straining the factual plausibility of these invented scenes."[9] These landscapes, teeming with mixed naturalistic and symbolic information, pointed the way to Cockrill's future use of landscape as the metaphor in which to locate his dreams and fantasies, as well as more collective kinds of subconscious or mythological material.

The two years that followed the Bluecoat exhibition — coinciding with the artist's first phase of living in London — led to a body of work that concentrated on the human figure as never before. The series was exhibited at the Totah Gallery in 1984. All but one of the twenty-three canvases were painted in 1983. They have a pronounced richness, the oil paint expressing

through smouldering pinks and salmon reds the raw, fleshy surfaces of the figures, "their skin flayed and scalded as if by exposure to ferocious extremes." A swirling brush alludes to unstable weather, scorched or churned-up earth and uprooted vegetation. Exactly what the subjects are doing, who they are, is unclear, for like those of Francis Bacon, these figures "are not decided at the outset; rather they relate to the imaginative tradition in which forms are drawn out from the raw material itself." Nicholas Alfrey, writing for the Totah exhibition catalogue, thus steps into Lewis's critical framework and uses Motherwell's distinction between psychic and plastic automatism. These bulky, fleshy figures are therefore products primarily of plastic process, since they are drawn from the working of paint itself rather than from preconceived subjects. Their occupation is as hazy as an unresolved dream. The works contain landscape settings of an unsettling kind which "seem to evoke a primitive epoch: the figures have the appearance of fugitives or survivors." Scattered debris "suggest the aftermath of some catastrophe."

After the experience of half a career the act of painting had by now become second nature to Cockrill and he automatically conjured up shapes or imagery laden with psychic energy. Once established with the Bernard Jacobson Gallery after the mid-1980s, Cockrill's landscapes overflowed with a new found confidence, sensuality, and a full imaginative grandeur. They were underpinned by the procedures of automatism for the artist began each picture at arm's length, allowing the movement of paint and the tactile associations and sensuality of the working process to throw up imagery in a random and unexpected way. Not only the emotions elicited by the artist's social awareness of, and identification with, the Toxteth riots, but also "the years of submission to a precisely-rendered record of surface reality" led to a new phase of painting where the imperative was spontaneity, vigour, risk, rampant sensual indulgence and self-expression. In the mid-1980s Cockrill wrote explaining the violence and turbulence in the Venus and Mars series. "Conflict, human destructiveness, extreme states of mind and confrontations between male and female are archetypal and enduring conditions of human behaviour that I find regrettable, and for which I hope to discover appropriate imagery."[10] The Venus and Mars pictures ultimately stand out as striking figurative compositions, in which colour, paint and mark convey great energy and passion within grandiose proportions. Allusion to old masters like Goya, Titian and Rubens represent the artist who "develops his position in competition with the examples he admired" and also proves that the artist had adapted gesturalism and post-cubist problems of form and space to "more clearly conceived imagery and to traditional methods of paint application."[11] Mythological figures taken from Ovid also addressed eternal human issues; for it was written that "Cockrill's sympathy very evidently lies with women, the exploited, the victim."[12]

177

During the later 1980s and early 1990s Cockrill's art has abandoned the figure and reference to both mythological and oil master themes. Instead he has developed landscape as a metaphor for psychic flux, dream images and metamorphic symbolism. Landscape has always been a prominent theme in his work, and with the Jacobson works Cockrill pushes the convention of landscape painting to the furthest horizons of imaginative possibility. The elements of nature are rearranged or disrupted to pull the ground from under the feet of normal perception. Cockrill, the studio-based painter, stretches painting to its fullest plastic and psychic possibilities. A series of paintings displayed at Jacobson's in 1990 under the title *Song of the Earth* shows the artist's sensual identification not only with landscape but with nature in its total aspect, and in particular with the dynamics of growth and decay that lie within nature. The artist also alludes to the forces of good and evil. Disruptions of conventional perspective, unusual juxtapositions of at best hazily defined organic forms, and spatial and formal ambiguities are characteristics that have antecedents in Cockrill's earlier paintings. These landscapes possess the kind of absurdity, metamorphosis and personification of landscape forms that are found in the work of contemporary artists like Ken Kiff, Thérèse Oulton, or Christopher Le Brun. The pathos and awkwardness in these shifting landscapes results "not from incompetence or lack of taste, but from psychic necessity, from risks, questions, doubts."[13] The same writer also explained that in "his aggressive mythologies and introverted landscapes, Cockrill seems to have banished grace, but he is no 'Bad Artist', generating ugliness or kitsch to meet the conceptual requirements of trendy art world theory." However much Cockrill's work — from the hyper-realism and pop of the 1960s right through to the psychic expressionism of the 1990s — runs parallel to contemporary issues of style and theme, it is the work of a self-willed artist. The sharp changes of direction but also constant underlying issues common throughout all phases, highlight the individual and integral nature of his project, as it evolves through differing circumstances.

NOTES

1. Letter to the author, 26.3.91.
2. Artist's notes.
3. Artist's statement for catalogue of exhibition at Bootle Art Gallery, October 1978.
4. Marco Livingstone, catalogue for exhibition at Galérie Udo Bugdalin, Dusseldorf, 1986.
5. ditto.
6. 'The Jungle Song' from *The Hissing of Summer Lawns*, 1975.
7. Bluecoat exhibition catalogue, July 1980.
8. *Artscribe*, 1982, p.63, Adrian Lewis.
9. ditto, p.64.
10. Artist's statement, Dusseldorf, 1986.
11. Hans Albert Peters, Director, Kunstsmuseum, Dusseldorf, 1985.
12. ditto.
13. *Modern Painters*, Spring 1990, David Cohen.

In their own right: Stuart and John

Stuart Sutcliffe gained a wide reputation on Hope Street for being the hottest young painter in Liverpool. Even as a student, despite his small physical size and quiet, introspective manner, he became a cult leader in thought, a trend-setter in dress, and a painter of such obvious flair that he often bettered the contemporary work of his own tutors. Arthur Ballard was particularly fond of him, and sometimes even visited Stuart's flat. Here informal 'crits' would be given on work in progress. Ballard also drank socially with Stuart's father Charles, a marine engineer who was himself an amateur painter and pianist. He encouraged Stuart's artistic inclinations.

Stuart kept student notebooks, full of information gleaned from his tutors. The course was demanding and gave a far fuller grounding in the traditions and basics of fine art than is the case today. Stuart took his studies tremendously seriously; he was eager to learn all the classical conventions and historical traditions of the art of painting before embarking on his own dialogue with contemporary avant garde painting styles. Stuart's development into abstraction, which reached full pitch in the late group of darkly coloured Hamburg paintings, has authority precisely because of the full-blooded way that he confronted, and came to understand, the academic traditions of his chosen craft. Stuart's notes are as conscientiously full as John Lennon's are empty. John's was a largely primitive sensibility, operating on the level of gut feeling, raw instinct and emotional confrontation; Stuart was the cool, detached theoretician for the emerging Merseyside beatnik generation. His intellectualism was cerebral and philosophical. It appealed to John because it complemented, and gave guidance to his own muddled emotions. Out of the dynamics of this student relationship sprang the energy, ideas and inspiration for the embryonic Beatle culture, which would take a leading role in the international youth movement of the 1960s. Stuart, the failed guitarist, was a central component in this process, for it was he who disciplined John's anarchic tendencies and gave structure, form and style to the visual and conceptual, as opposed to the musical, aspects of the emerging Beatles.

Henceforth in this chapter Sutcliffe and Lennon, who became close friends after meeting one another as students through Bill Harry in the Cracke public house, will be referred to by their first names. This is to reflect their familiarity in the popular imagination as symbols of burgeoning youth culture. The purpose of this chapter is to unravel the myth and

180

legend that have attached to them, and to look at both as primarily creative artists in the purest sense of the word. 'Stuart' is also the name of the company, founded by the artist's sister Pauline, dedicated to promoting his art in a culture that is all too quick to forget he was a painter and too prone to remember him simply as 'the fifth Beatle'.

Stuart's student notes include information about paint chemistry, art history and philosophy concerning the nature of consciousness. He wrote about the way his own consciousness was modified through the act of painting. Perhaps the long, lonely nights spent frantically painting in his Hamburg loft reflected a special quality of self-awareness. In this sense he displayed the classic existential habits of the contemporary abstract painter who treated painting as an arena for psychic action and for the drama of self-expression. "When I paint this picture," he wrote, "I am not, as some people seem to think outside of myself, but aware of myself so acutely that at times this awareness can reach the point of hallucination. This acute consciousness is an essential element of hallucination."[1] Stuart was a romantic with lofty notions and hopes of the link between painting and experience. It made him an expressionist, though he disliked sterile, art-for-art's-sake formalism that detached itself from the human quest for higher understanding. Stuart wrote that "Pollock's own painting failed to become anything more than decoration." He went further in attacking the empty-headed fashion value that quickly attached itself to Pollock's sensational and epochal style of action painting. Jackson Pollock's work was, Stuart wrote, "nothing more than an erroneous burp. His work — unlike that of Max Ernst, Klee and Kandinsky who thirty years earlier had done much the same thing but had controlled their form and paint intelligently — was acknowledged in an age when any gimmick goes." Stuart's reference to "an erroneous burp" is not the sound of a reactionary; on the contrary, he was committed to a raw physical engagement with the medium and action of painting, as the conclusive Hamburg work would show. But he was impatient of false gods, easy sensationalism and cheap fashion. Yet Pollock featured a great deal in his notes, as did Cézanne, who interested him for the way that "objects in his pictures have ceased to be things: they share a character and value of objects of painting." He had been reading John Rewald's book on Cézanne at the time.

In other notes Stuart informs us of the wide-ranging value of lectures given at the college by George Mayer-Marton. The Hungarian émigré introduced concepts like stereoplastic colour (leading to a use of colour that conformed to spatial position within the picture's assumed three-dimensional reality). He also drew attention to linear-perspective, *trompe l'oeil* effects, and the widest use of colour that only paint pigments provided. These ideas are apparent in Mayer-Marton's own semi-abstractions of still life and landscape subjects at this time. A pronounced linear structure, and an

independent patchwork of colour that operated independently of object description, were the products of the ideas he imparted to the students. Stuart's Liverpool work, from his early, Bratby-inspired realist paintings through to the informal abstract paintings in light pastel colours — influenced possibly by Ballard, Horsfield, de Stael and Poliakoff — never seemed directly to draw on Mayer-Marton's style. But the much travelled Mayer-Marton's wide knowledge of the whole tradition of Western art, as well as his technical expertise with differing painting and priming media, greatly interested Stuart.

Stuart attended art history lectures given by Dr Warburg and also by Nicholas Horsfield. He studiously noted the whole history of Western art and took an equal interest in the practicalities of the craft. In March 1957 — Stuart's second term at the college — he was reading romantic literature, including James Joyce's *Portrait of the Artist*, Somerset Maugham's *Moon and Sixpence*, Chekhov and Dostoevesky. Stuart liked Graham Sutherland's portrait of Somerset Maugham which he saw at the Tate the following year. About this time he found his most appropriate philosopher in Sartre, since existentialism was the philosophy behind the heightened sense of gestural mark-making and automatism that motivated abstract painting at this time.

Stuart was a deep thinker and his notes reflecting on human life anticipated by nearly a decade the influence that Maharishi's teachings would have on the Beatles. In notes for a proposed philosophical essay,[2] Stuart used the metaphor of a door as the threshold linking the inner world of feeling with the outside objective world. "I find in the silence of isolation the element in which all great things fashion themselves." The all important quality of silence was where "one plunges one's eyes into one's heart and into one's self; one feels the charm of ethereal beauty which is not like the mundane beauty of physical experiences." Stuart goes on to express a desire for transcendence when he writes that "we owe it to ourselves to endeavour to cross the threshold of self-knowledge." Stuart's late Hamburg paintings — dark, enigmatic and brooding abstracts distilled of colour and containing a faint and private hieroglyphic language of squiggles and circles — are steps into the fathomless void that so fascinated him. He seems to have found little light at the end of his own psychic tunnel in these terminal canvases. Perhaps their blackness and greyness predict the coming of death, for in them he seems to follow Dylan Thomas's dictum, "Do not go gently into that dark night." Stuart's late Hamburg work remarkably parallels that of the German-born, but Paris-based painter Wols (1913–1951). Like Sutcliffe, Wols died young and he threw everything he had — physically and psychologically — into his larger scaled late work. In the spontaneous use of paint they released subconscious tensions and etched the surfaces with biomorphic scribblings of an unsettling kind.

Stuart Sutcliffe Drapery study: sketch after Lippi. *Pencil drawing on paper. Courtesy: Pauline Sutcliffe.*

Stuart Sutcliffe Hamburg painting, untitled, *1962. Oil on paper. Courtesy: Pauline Sutcliffe.*

In addition to his philosophical ideas, Stuart also wrote down his feelings concerning contemporary figures whom he did not know but whose work he had seen during visits to the Tate Gallery in 1958. He enjoyed the ambiance of the Tate, which he found "completely satisfactory as regards 'looking' at paintings." In his taste for modern European masters, Stuart clearly preferred artists whose work had substance and tangible structure. Perhaps for the same reasons that he disliked the diffuse and unstructured outpourings of Pollock, Stuart concluded that pictures by Claude Monet "seem terribly weak and have no excitement for me." However he liked Rouault, while Vlaminck "is terribly exciting, the reddish trees are strong and solid." Stuart also liked "the most beautiful harmonies" of Kokoschka's London views, proving that he greatly appreciated colour so long as it had an intelligible structure and reason behind it. Stuart did not, however, seem to appreciate the structure within Cézanne's work, for he discussed it in terms of the sensual qualities of the painted objects which were "too sophisticated but not in an alluring way." We may therefore conclude from these observations that Sutcliffe's taste was for a coherent art, structured by strong form and colour, but one that breathed with authentic, that is to say personal, life.

Stuart's notes about visits to the Tate are refreshing on several counts. They reflect the alert and original mind of a young painter who responded in a direct, personal way to the objects on the walls. The notes show the student conscientiously working overtime, for it would not have been part of the course to jot down all his artistic experiences outside college life. In them he reached his own coherent conclusions about his likes and dislikes. He was under no illusion about the difficulties facing young artists, for he wrote that "we young artists are like young sailors, unless we encounter rough seas and are buffeted by the winds we'll not become real sailors. There is no mercy for us, everyone has to go through a period of worry and struggle if he wants to go into deep water." In confronting the modern masters at the Tate Stuart was not only addressing the best, but was also encountering rough seas and winds in his quest to match the highest standards set down by the greatest of modern artists. One can imagine the enthusiasm and insight that he brought back with him to Liverpool. It therefore seems a pity that in 1991 a picture by Stuart (the big, Poliakoff-inspired John Moores painting), while making a respectable, if unspectacular, £7,700 in a depressed market at Sotheby's, should be sold as part of a collection of rock 'n roll memorabilia rather than in a mainstream modern British painting auction.

In the field of modern British art Stuart's immediate influence came from his tutor Arthur Ballard. Like Ballard and other Liverpool artists of the time, Stuart chose to follow the tactile, sensual and painterly qualities

of modern French abstract painting. Through Ballard, Peter Lanyon seems to have been an influence. One of Stuart's late Hamburg works — a blue and black monotype with collage which was reproduced on the cover of his 1990 exhibition at the Bluecoat Gallery — clearly shows that he was working in a vein parallel to Lanyon's contemporary work. The use of evocative glimpses of naturalistic imagery within an abstract composition built up with collage elements, was common to both. Lanyon came to Liverpool a number of times in the early 1960s, when he drank with Ballard. He came to judge the 1963 John Moores exhibition — a year after Stuart's untimely death and a year before his own — and he also produced a large mural in ceramic tiles for the University's engineering building. There is no proof, however, that Stuart ever met Lanyon.

In other notes Stuart referred to the "pale sickly nude youths" of Keith Vaughan, the empty patterns of Victor Pasmore, and the easy tricks of John Piper. He found more substance in Reg Butler's raw, metal sculpture, which had links with the kind of work that Stuart's later, liberating, Hamburg tutor, Paolozzi, was producing. The young Liverpool artist's late drawings and lithographs have a jagged, linear structure characteristic of abstract metal sculpture in general at this time. In a different vein, Jack Smith and John Bratby — who along with Van Gogh were obvious influences on Stuart's earliest figurative work — were favoured because through their work "we are shocked back into reality."

The works Stuart produced in his early Liverpool period that most show the influence of Bratby and Smith are the portraits or genre pieces, such as those depicting students (including John Lennon) drinking in the Cracke. Stuart's superb self-portrait with spectacles and polo-neck sweater was inspired by Van Gogh but is as much in the style of Bratby. His portrait of Bill Harry, fellow student and founder of the influential magazine *Merseybeat*, is an interesting study of another contemporary who contributed in no small measure to the expansion of Merseyside youth culture in the early 1960s. The portrait was painted in the sparsely furnished flat Stuart shared with Rod Murray in Percy Street prior to their move to Gambier Terrace.

Harry remembered the location as a "very bleak room with hardly anything in it."[3] The portrait came about because Stuart wanted a blue denim jacket that Harry had been able to afford as a result of a holiday job in a Birkenhead spillers mill. Stuart agreed to paint Harry in exchange for the jacket. In his short career Stuart did not develop a truly personal style until the late Hamburg works, but in the few years leading up to this mature idiom, he was noted for the facility with which he could paint in a wide variety of adopted styles. Not only in terms of dress and lifestyle, but also in his painting, Stuart was always the sophisticated pasticheur, but

186

it was done so well that he subconsciously developed existing ideas for his own ends. He asked Harry in what style he would most like to be painted. In Van Gogh's came the answer. Before tackling the painting on hardboard Stuart rapidly executed many preparatory studies of Harry's head on pieces of pink foolscap paper. In these he revealed his abstracting tendency by breaking down the head into broad spheres. The large, sculptural ovals anticipate the significance that Paolozzi would have. A half hour was spent reeling off two dozen sketches, frantically moving from one to the other in the process of absorbing himself completely in the subject before him. The portrait itself took a mere three hours.

Bill Harry planned to write a book on Liverpool that would be illustrated by Stuart and would include Lewis Carroll-influenced verse by John Lennon. Harry and Stuart wanted to work against the Americanising effects that rock 'n roll bootleg culture and the New American Painting were having on Liverpool. Years later Patrick Heron, the St Ives 'middle generation' painter, had words to say about the damaging effects of imported American "cultural imperialism".[4] Far from taking a reactionary stance, the prospective authors felt that the legacy of the city's maritime past would be rich material for a book and it would not need to include imported cultural influences. It was a pity that the project failed to materialise, because among them they had many disparate elements that would have gelled into a cogent whole. As we have seen, the introverted Stuart was interested in cosmic consciousness almost a decade before flower power and the growth of new age mysticism. He was 'into' Kierkegaard and mystical philosophy. In those days John was far more extrovert, though in time he, too, came to be interested in the inner orientation and wrote songs that voiced a generation's dissatisfaction with materialism and active pursuit of self-realisation. Instead of producing their book, the art student group were in the spotlight of the national Sunday paper *The People*. According to Mike Evans the flat in Gambier Terrace where Stuart and John were then living was "featured in an exposé as an example of the 'Beatnik horror' sweeping the country."[5]

After leaving Liverpool College of Art, where he had been refused entry onto the teacher training course on the grounds that he was too talented a painter to sit back in a comfortable but potentially stultifying teaching career, Stuart went to Hamburg as a playing member of John Lennon's band called The Silver Beatles. In Hamburg he enrolled at the State High School, the official art school of the city, where Eduardo Paolozzi took him under his wing. John Willett wrote that "He was playing with the Beatles every night and must have found it a strain to attend the school by day. In his first report Paolozzi called him 'very gifted and very intelligent', but already his work was being interrupted by periods of absence and illness, sometimes as long as two or three weeks. A great many of these pictures

must have been done outside the school."[6] This was in fact a practice that had gone on during Stuart's years at art college in Liverpool. He was way ahead of his student peer group, and even without the recurring headaches and sickness, he would have preferred painting alone, "in his own space". He was engaged to Astrid Kirchherr, the young German photographer, who with Jurgen Vollmer was responsible for taking all the now famous black and white snaps of the leather-clad Beatles in Hamburg. The attic room Stuart worked in at the Kirchherr's house was arranged with the black and silver colour schemes that were used in his Hamburg paintings. Paolozzi later confessed to being unsettled by the unique intensity he felt in Stuart and his Liverpool contemporaries. "I always felt there was a desperate thing about Stuart in his life . . . I was afraid of it."

Bill Harry grew up the hard way on Merseyside. His mother had to rescue him from the wild side — the way to the rough St Vincent's School near the docks had to be negotiated through a particularly intimidating street gang, and young Harry often came off badly in encounters with it. He was sent to Skerry's College on Rodney Street. His earliest inclination towards illustration and design found expression in his mother's shop in Parliament Street, where customers formed a constant, if impromptu, cargo of portrait subjects for the boy huddled away in a corner with pencil and paper. During his time at Skerry's, Harry developed an interest in art, and an unmistakable talent enabled him to win a scholarship to the junior art school in Gambier Terrace, an annex of the main College of Art. When Harry started in 1954 he did not fit easily into the art college ambiance, which he found middle-class and academic. He resumed earlier habits and took to the streets with pencil and gouache colours. In unfashionable back alleys he drew an assortment of characters including down-and-outs. He also did some creative writing (science fiction, horror stories, diaries and skits on Liverpool people) and founded two short-lived student magazines, *Premier* and *Jazz*, that were preludes to the influential and popular *Merseybeat* magazine. At the time words were as important to Harry, Stuart, John and their circle as drawing and music. Colin Wilson's *The Outsider* was influential, and the group held free association poetry sessions, word séances and the like in their flats.

Bill Harry was a member of the Students' Union Committee, in which capacity he released funds for a public address system. John would invite George Harrison and Paul McCartney into the college and during lunch breaks they would practise music in the life drawing rooms. The group would also play at college dances. Harry's contributions to art college life did not go unappreciated and Arthur Ballard, ever supportive of local working-class students, helped him over some student accommodation difficulties. Harry obtained his diploma' for design, and he continued on a two year scholarship specialising in packaging. He designed a poster for the

1959 Liverpool Academy exhibition. His biggest contribution came with *Merseybeat*, the magazine that covered the burgeoning music scene. He started the magazine with a small loan from a civil servant friend, Jim Anderson. The first issue, which went to 5,000 copies, sold out. John Lennon wrote a piece on the Beatles in that historic first issue. Harry did all the foot-slogging marketing himself, persuading twenty-eight newsagents to take it, as well as music stores, including NEMS in Whitechapel, where the manager was Brian Epstein. Epstein took more copies of subsequent issues and through the magazine became more interested in John's band. In the June 1962 issue the entire front cover was given over to the Beatles in Hamburg, using photographs by Astrid and Jurgen. Brian Epstein wrote record reviews for the magazine, beginning with classical music though soon moving on to Elvis Presley and rock music in general. A column entitled 'Beatcomber', was John Lennon in literary disguise, writing nonsense, stream-of-consciousness verse of the kind that was later published in his famous James Joyce-inspired books, *In his Own Write* and *Spaniard in the Works*. Eventually Harry sent Epstein to see the Beatles perform at the Cavern, beginning a story that hardly needs repeating here.

Merseybeat ran to no fewer than a hundred and twenty issues until 1965. Ray McFall, owner of the Cavern Club, financed the magazine until Brian Epstein bought Harry out. Beginning as a fortnightly, the magazine eventually sold 75,000 copies on a weekly basis, and also went into colour. The magazine was the first ever to feature the Rolling Stones. Once Epstein took control he wanted to universalise it and decided to change its title to something a little less local. It became known as *Musical Echo*. Harry was unhappy with Epstein's efforts to change things, which he felt were guided by a mistaken need to interfere with a legend that he did not actually create. *Merseybeat* was another example of the creative, entrepreneurial zeal that was going on at the fringe of Liverpool's artistic, musical and literary life during those extraordinary times. Even for characters who were not themselves artists there was an opportunity to make a lasting contribution. Entrepreneurs like Alan Williams, owner of the Jacaranda Club, found themselves on centre stage. Unfortunately, Williams never made much money from his efforts, and his role in running the club as well as becoming the first manager of the Beatles (taking them to Hamburg) has never received full credit. Williams took on the club in Slater Street with his Chinese wife and it became a convenient rendezvous for art school staff and students and also for people who worked around the Seel Street area. It had a coffee bar used by Arthur Dooley (who exhibited his earliest metal sculptures there), Don McKinlay and Jimmy Cliff. West Indian steel bands performed, as did the Beatles. Williams also promoted an arts ball every year at St George's Hall. Another club, the Blue Angel, opened at this time, though it was a more formal night club that degenerated eventually

into a place where dance mixed with fisticuffs. Yan Kel Feather, the painter who later moved to Cornwall, ran a short-lived club not far from the Adelphi Hotel. The most important influence in the social life of the arts scene at this time, however, was the businessman and cinema proprietor Leslie Blond, who opened Hope Hall, later known as the Everyman.

Leslie Blond, the son of Lithuanian Jews who immigrated to Limerick in the 1880s, came to Manchester in 1916, aged 11. His father died early, and Leslie was brought up by two sisters who opened a greengrocer's shop in Dublin. Blond later lived in the Cheetham Hill district of Manchester and entered grammar school on a scholarship, though he left early in order to pursue an opening in the film industry. Leslie began with the Universal European Motion Picture Company based in Birmingham. The 1930s were successful years — he was offered a more senior position with the company in Liverpool, and was married in 1938. The newlyweds built an art deco home in the Gateacre district of Liverpool, and Dorothy Blond opened a fashion shop in Bold Street. In 1944, with their business acumen they had acquired enough capital to allow Leslie to buy the first of his cinemas. In the following year he was able to leave his job and concentrate his energies first on the Lyceum in Garston, then on three other cinemas he bought at Bangor, Kirkham and Orrell. In the early 1950s he built the Phoenix Cinema in Wallasey. He introduced avant garde French, Russian and Japanese films to the cinemagoer's diet, and his commercial success led to his providing twenty-one scholarships to the university and art college. In 1982 he created the Leslie Blond Trust, run by a panel of professors to allocate scholarships. In 1959 he acquired his most famous premises, Hope Hall, where continental films were not as popular as they had been in Wallasey. In their place he began holding exhibitions of local artists whom he befriended and whose work he avidly collected. Ballard, McKinlay, Martin Bell and Austin Davies were shown along with David Bomberg. The upstairs was let to a university theatre group. In 1963 the basement became a poetry club, where recitals and happenings were frequently held. Blond also built houses in Maghull, and a cinema which was opened by Harold Wilson. He sold all his cinema interests in the mid-1970s and retired. His sons, Max and Jonathan Blond, have gone on to make names for themselves in the field of contemporary British art as painter and art dealer respectively.

In complete contrast to Stuart Sutcliffe's studiousness and painting flair was John Lennon's laziness and student rebelliousness. Yet he had been accepted for the art college precisely because he possessed 'something special', a charisma and a talent for illustrating which gave visual form to a sharp and satirical wit. He never developed as a fully-fledged painter, though he reeled off hundreds of humorous cartoons and illustrations which impressed his tutor Arthur Ballard and no doubt saved him from the shame

Austin Davies Portrait of Leslie Blond. *Coll: Max Blond.*

of expulsion from the course. Mike Evans determined that in spite of John's abrasive, Teddy Boy stance, "what certainly rubbed off was the liberating influence of the artistic environment." Evans went on to describe how "Ballard's opinion of Lennon's ability was modified when he came across John's cartoons for the first time . . . which convinced him that Lennon's talent was as a purveyor of surreal humour rather than in 'serious art'."[7]

John Lennon's mature work and major contribution of course came through the music and lyrics he wrote. His songs are often melodically beautiful, though he is not now considered to have been as much of a musical craftsman as Paul McCartney. On the evening following his murder, George Martin, musical producer throughout the eight years when the Beatles were an active ensemble, spoke of him as being not a great musician, but a great man — one of the great men, in fact, of the twentieth century. Given his natural leadership qualities — he became a voice for a whole generation in the throes of social upheaval and cultural revolution — it is hard to argue with such a statement. His efforts towards peace and love outgrew mere late 1960s flower power rhetoric and became a personal banner he took into the less optimistic, if more realistic, 1970s, and with which he continually fought injustice, hardship and cruelty in the world. The Amsterdam and Montreal bed-ins of 1969, the association with a wide array of causes, and above all the message songs like 'Give Peace a Chance', 'Woman is the Nigger of the World', 'War is Over', 'Power to the People' and 'All You Need is Love', made Martin's assessment of John's achievements seem worthy.

If John was not to be considered a great musician in a technical or formal sense (though he undoubtedly possessed a great understanding of the roots of rock n' roll music) then his music possessed an artistic structure, intelligence and conceptual vigour that was not attained by the more conventional narrative and descriptive songs of his songwriting partner Paul McCartney. John's lyrics are often noticeably visual in quality, referring to colours as indicators of mood and emotion. Rather than tell a story he often attempts to create an evocative aura. The word imagery frequently has a spare, almost abstract, quality and is presented in a peculiarly artistic way. Furthermore, his songs are often complete pictures in their own right, or they are ready-made collages taken from other sources. His 'Mr Kite' contribution to the classic 1967 'Sergeant Pepper' album was composed in the florid language of an antique circus poster found by chance.

John was nothing if not inventive. His sharp humour — riddled with a sense of the ridiculous as well as a cutting satire born of anger — later found its perfect outlet in Dada and surrealist antics. The anti-academic element in his sensibility dated back to his years as a student on Hope Street, when he frequently satirized the preciousness of life drawing sessions or the ponderousness of art history lectures. But by the mid-1960s his

mischievous humour, once aimed at his art tutors and later at pretentious television or newspaper interviewers, sought a more structured outlet, that is to say, a more meaningful absorption into his work. Yoko Ono, the Japanese American conceptual artist whom he met at the avant garde Indica Gallery late in 1966, was the catalyst. Her conceptual art was laced with black humour, irreverent, anti-formalist iconoclasm of a kind that greatly appealed to John's neo-Dada instincts. Thereafter her influence became even stronger. The Amsterdam and Montreal bed-ins, planting of acorns in Coventry Cathedral, the return of the M.B.E., and the bag events that he and Yoko held in the late 1960s belonged to the world of 'happenings' and 'performance art' that at the time was part of the baggage of conceptual art as a whole.

John Lennon was an artist before he was an entertainer, musician or anything else. The formative role that his years at Liverpool College of Art may have played is undefined and difficult to prove. But what is apparent is that he gained at the very least a useful introduction to the creative energy and formal discipline of the plastic arts from his time on Hope Street. This gave his music professional rigour, integral inventiveness and formalised elegance and coherence. As we have seen he met Stuart Sutcliffe at the college. There too, he developed his talent for humorous illustration, a genre that remained with him as a background activity, through the notorious erotic lithographs of the late 1960s to the private doodlings of his reclusive years in the Dakota apartment above New York's Central Park. His ability as a witty illustrator had been encouraged by his first wife Cynthia Powell, who studied illustration under Jardine on Hope Street. His interest in art was considerable, even if he is most popularly associated with his anti-academic postures. Alan Wood took John to a party in New York in the mid-1970s — in the middle of his eighteen-month 'lost weekend' separation from Yoko Ono — and remembered John as being dumbstruck when he met Willem de Kooning. At art school John undoubtedly learnt the basics of modern art — collage, abstraction, sublimation of humour in the use of Duchampian modes of expression, elevation of the ready-made or found object as a valid, plastic entity in the art context and so on. These devices were used time and again once he had matured and shed the figurative conventions of the popular song along with his Beatle suit and hairstyle.

John Lennon had entered the art college in 1957, when it was still possible to be admitted solely on the basis of an obvious creative bent or a folio of drawings. John had failed all his 'O' levels. But by the early 1960s entry standards had tightened up considerably and it became necessary for the candidate to have 'O' levels or other qualifications. This factor scuppered Mike McCartney's plans to become an art student. Born in Liverpool in 1944, Mike was the younger brother of Paul. The single 'O' level he possessed was not enough to gain entry into Liverpool College of

Stuart Sutcliffe in Hamburg with Astrid Kircherr and
Klaus Voorman.

John Lennon drawing. Courtesy: Christie's.

Art in 1962. Stanley Reed, art master at the Liverpool Institute for Boys, where Mike McCartney studied, was sympathetic. He gave Mike first prize at the school for a self-portrait and also gave him a reference for the art college. Failure to gain admission left him "devastated" and together with losing his mother in 1956, when aged only 12, formed the second of the pair of events that most affected him. He was accepted at the Laird Art School in Birkenhead but owing to difficulties in obtaining a grant was unable to take up his place. In 1963, the year the Beatles broke through, Mike and Paul McCartney's father was earning only £10 a week, and Mike had to look for a job. With encouragement from his paternal aunt Gin, described by Mike as "boss of the McCartney mafia",[8] he went into hairdressing. He also went to evening classes and started drawing. He looked at fashion imagery and he developed a cartoon phase.

During these years Mike lived with his family in Allerton. He knew many of the artists and students who came around to see "our lad" — brother Paul. In particular, he liked Stuart Sutcliffe and Sam Walsh. He received a letter from Stuart in Hamburg, in which the 'fifth Beatle' wrote about the murals of West Indian faces that he was reputed to have painted on the walls of the Jacaranda Club. Mike made his own contribution to the Liverpool scene of the 1960s — helping to fill the vacuum that had been left after the Merseybeat revolution had died down. His best-known phase came as a member of the Scaffold group, whose song 'Lily the Pink' was a big hit in the national charts. Consisting of poet Roger McGough, John Gorman and himself, the group sprang out of the witty culture of the Liverpool scene. John Gorman himself was responsible for the Merseyside Arts Festival of 1963, an event that saw the emergence of the 'Liverpool One Fat Lady All Electric Show'. Adrian Henri, John Gorman, Roger McGough, Celia Mortimer and Jennie Beattie were all involved in an open-ended project in which poetry was read, comedy sketches were produced, and satirical events and other inter-related media activities were put on. Mike was introduced to the circle by Mike Weinblatt, duly became a part of it, and performed at the Cavern. They were not as well received on Matthew Street (where the audience was used to a musical diet) as at the Everyman Theatre. The later formation of the Scaffold set the jokey, skittish performances of the 'Fat Lady' to music, and the result was instant national recognition, enjoying a deflected spotlight from the huge success of the Beatles.

As Mike Evans has suggested what first drew Stuart Sutcliffe and John Lennon together was the fact that they were both romantics. Their form of revolt, the kind of style they adopted, though responding to a uniquely modern situation, was essentially of a timeless quality. For all their contemporary relevance as sons of the 1960s, Stuart's and John's romanticism was of a kind rooted in times stretching back as much as two centuries. Stuart

195

showed many of the qualities of nineteenth century decadence, in his dress, lifestyle and art. The thrust of his, and more particularly John's, project was to topple the barriers of conventional middle class morality. The permissive sixties were the perfect scenario. Stuart came from the more restricted background, though his mother Martha was supportive and encouraging. But John's problem tended to be the opposite: a lack of parental guidance through his teenage years. Yet within the cocoon of progressive 1960s 'youth culture' came the notion of spiritual progress, the feeling conveyed in the Sergeant Pepper song that "it's getting better all the time". As students Stuart, John and their circle conducted automatic poetry sessions and word séances that seemed to wed the search for artistic expression with the self-exploration of group psychotherapy. The air of exclusiveness that emanated from their sessions appealed to John, who was always highly tuned to snobbery both in himself and in others. Furthermore emotive references were made, in his later work, to the experiences of Janovian primal scream therapy. He used the echo chamber of the recording studio as an existential arena in which to enhance the psychodrama that gives his mature work such intensity.

During the height of the 1960s counter-culture John identified strongly with the drug-influenced, 'underground' extremities of the youth movement, which became almost an élite. The subtly-evolving hippy dress and manners were also expertly exploited by John and conformed again to a traditional cult of dandyism that stretched back to the days of Baudelaire, Proust, Whistler, and Symbolism and Decadence in general. Indeed, John's poetic efforts in *Spaniard in the Works* and *In his Own Write* resonate with qualities that were as integral to nineteenth-century Symbolism as they were to twentieth-century Surrealism. For reasons old and new Stuart and John merit looking at afresh as artists in their own right.

NOTES

1. I am grateful to Pauline Sutcliffe for allowing me access to Stuart's student notes.
2. *The Function of a Door.*
3. Conversation between Bill Harry and the author, London, June 1991.
4. Patrick Heron's three-day article comparing the achievements of St Ives artists with those of their New York contemporaries was published in the *Guardian*, October 1974.
5. Mike Evans, *The Art of the Beatles*, p.12, Anthony Blond, 1984.
6. John Willett, introduction for Stuart Sutcliffe Memorial Exhibition Catalogue, Walker Art Gallery, May 1964.
7. Mike Evans, *The Art of the Beatles*, p.11, Anthony Blond, 1984.
8. Conversation with the author, Lower Heswall, Wirall, March 1991.

Squaring full circles: recent art

If ever there was a painter who has remained youthful in spirit and adapted his art to changing times it is Adrian Henri. His work — which in addition to painting encompasses poetry, performance art, happenings, writing and art criticism — has always retained an open-ended response to culture in its broadest guises. His openness to such wide source material and his honest reference to, and acknowledgement of other 'systems' or 'traditions' — old or new — has been a function of an extremely well-informed, brilliant mind. He has continually avoided the pitfalls of precious formalism and of both academic and avant garde convention. For these reasons he has often fallen foul of the British cultural establishment, which has not been able safely to pigeonhole his diverse art into an easy category. Henri has wilfully challenged the position of the London art scene as an arbiter of British taste by remaining a steadfastly Liverpool-based artist. As Edward Lucie-Smith, one of his main critical apologists, has written, he became "an underdog who has never for a moment seen himself in that position, to the vast irritation of many of his opponents."[1] Self-evident in Henri's position as an artist is a democratic, indeed popular outlook, a fact that carries with it the implication that he wishes to communicate through accessible art forms to a wide range of people — be they cognoscenti or laymen — with as instant an appeal as possible.

In an earlier section relating to Henri's close contemporary Sam Walsh, the distinction was made between the 'schizoid' and 'manic-depressive' types that Anthony Storr detected within the creative personality of the artist. The former category was symptomatic of the reclusive, highly individual artist dealing primarily with his own self-contained cosmos. The latter category, more likely to include artists like Walsh and Henri, requires the outlet of an approving audience which can help fill the existential void, and neutralise the feeling of cultural and psychological isolation. Adrian Henri is an artist who has always needed an audience; indeed, on occasion he has even needed that ultimate indicator of democratisation, audience participation. The poetry readings and performances that Henri has delivered down the years fulfill the need to bring his art to an immediate, living audience and to enjoy the feedback. He even performed at the 1969 Isle of Wight rock festival (filling a gaping hole left by the absence of all the Beatles) with his skittish Liverpool Scene band. In the same year the band toured Britain with Led Zeppelin.

197

Implicit in Henri's desire for direct and immediate communication is his interest in art, poetry and music that communicates to raw gut feeling before it filters through to more rarefied levels of understanding. Henri has quoted jazz and cinema as the two new arts that best achieve this. The Beatles of course also possessed this magic, but Henri's extremely well informed literary and artistic frame of reference enables him to realise that this quality belonged also to French symbolist poetry, where the sound of the lyrical verse mesmerised long before the meaning and structure were grasped by the intellect. The increasing preoccupation with poetry during the 1960s and 1970s fulfilled his desire for instant 'live' communication, but also possessed the further advantage of generating ideas for his painting. As a result a cross-fertilisation of theme took place between the two art forms — thus his poetic imagery often became more concrete and visual while his painting used themes first presented in verse. The effect of this, as far as his painting was concerned, was to prevent any tendency to run out of meaningful ideas and allow his pictorial themes to retain the freshness and unexpected variety of a painter who had successfully avoided formal and academic limitations. One other significant 'therapeutic' value that poetry had for his painting was that it made him think in more purely visual terms when it came to picture-making. His seminal *Entry of Christ into Liverpool* (1962) — arguably his most important painting — was constructed purely from imagination, relying on his visual memories of the Liverpool friends, colleagues, contemporaries (together with more distant heroes) that he used for the large picture. Henri sometimes uses painted handwriting to make more explicit use of the theme that interests him. This writing is like an extension of the artist's signature, and therefore does not operate in quite the same way as Robert Motherwell's association between painted gesture and abstract shape in his *Je t'Aime* series. As well as hinting at the inter-changeability between visual art and the written word this device also suggests the inherent abstract and visual quality of letters as crypto-symbols. His painting of Ferdinand Cheval's house that gained entry to the 1989 John Moores exhibition, is a case in point. Cheval was a postman who, before the age of rigid planning controls, single-handedly built a fantastic palace that had originally come to him in a dream.

Adrian Henri's high regard for Magritte was based on the purity of his visual poetry. In Magritte's paintings the comic poetry, the jarring juxtaposition of objects and the disrupted perspectives are described in very literal, almost photographically visual terms. The highly figurative Magritte is quoted by Henri as an artist who proves that visual purity need not mean abstraction. Similarly, Magritte can use the semblance of collage, the cut-out or *object trouvé* by faithfully representing it through the painting process rather than by the physical process of cutting out and sticking down. George Jardine, whose work Henri admires and has collected, also followed

198

Magritte's habits in these respects. The significance of Magritte's elevation of banal objects to a heightened sense of visual drama has translated itself into Adrian Henri's series of salad, meat and cake paintings that were produced in the 1960s. One good example of this is the Walker Art Gallery's *Salad Painting* (1965). Such a picture made a further point by associating the hygiene of food processing with the equally clinical presentation of the painted image. Henri achieved this effect by elevating and isolating the food against what the critic Paul Overy referred to as the "virginally white canvas". Overy continued by stating that the "food is tangible and yet not to be touched, edible, yet 'for display purposes only'. Henri borrows his presentation from the display techniques of the shop window."[2]

Henri's reference to the presentation techniques of the shop window display 'artist' typifies the wide spread assimilation, common to all so-called pop artists at this time, of advertising and media culture generally during this period. Henri had first been alerted to the new role assigned to ambitious and forward-looking fine artists — a role that Henri later assessed made them "highly conscious trained craftsmen who design objects for mass consumption" — by the artists of the 'Independent Group' during the 1950s. A formative influence on his own development as an artist was one member of the Group, the prominent artist Richard Hamilton, who 'taught' Adrian Henri at Kings College Newcastle, where the young Birkenhead-born artist studied between 1951 and 1955. The late 1950s saw Henri's first serious efforts as an artist out on his own. Henri then mixed the untidy paint handling of the gestural expressionists with collaged material chosen for its emblematic reflection of consumer culture. Omo packets recur in Henri's work of the time.

One enduring formal quality suggested in the series of food compositions was to surface many times; it is the characteristic ability to conjure out of a minimal background a memorable image of which the cogency is as much a product of its formal enhancement and isolation against the empty background as it is of the image's popular appeal. A case in point is the series of *Kop* paintings from 1977. That year saw the fruits of Bill Shankley's endeavour to rebuild Liverpool Football Club, and marked the start of a decade of unparallelled domination of League football. Not since Arsenal in the 1930s had a club become so dominant in the domestic game. The carnival atmosphere of match day at Anfield is conjured out of the dark background with a pulsating series of red pointilliste dots and markings, representing scarfs, berets, banners and flags. Without a single face or figure being identified, Henri creates an impression of the whole and identifies the electric excitement and emotion felt on the terraces for the City of Liverpool that the football club proudly represents. A different mood is presented in his series of debris paintings from 1975. Against a similar,

dark-brown background, the artist this time paints rubbish scattered around a raised demolition site.

In pictures like the hedgerow and garden series of the late 1970s (openly influenced by Maurice Cockrill), or the Sunset Heights series of the mid-1980s, the artist allows the greens, reds and lilacs of lush vegetation to predominate. In spite of employing either photographically real or theatre decor styles (he was once a scenic artist at the Liverpool Playhouse), Henri's garden pictures also signify his love of French Impressionism and Pointillisme in their most decorative guise. The skies are uniformly blue. In recent years Henri has made visits to friends in Hollywood, where he has concentrated, not on swimming pools like Hockney, but rather on the cacti, palm trees and deep-green foliage of the luxurious gardens of Beverly Hills. He sometimes chooses to leave a bottom corner untouched with anything other than a run of paint from above. The device suggests again that the painting is not quite finished — posing the perennial sixty-four thousand dollar question about when a picture is complete. It also reminds the observer of the inherently mimetic, indeed cosmetic, quality of the picture as a window on reality. By emphasising process, Henri avoids identifying the picture too closely with reality. This process seems akin to Magritte's disruption of safe perspective, his desire to break up the window-on-reality by jolting us out of passive audience participation in the pictorial conspiracy.

Henri's frequent employment of a simple, even minimal, format is part of his way of externalising themes or ideas that are actually deeply rooted in his complex autobiographical and intellectual background. He wishes to strip away any élitism. By identifying his work with current, newsworthy or pertinent concerns, he is able to invest it with desired accessibility. One way of doing this, as we have already seen, is with the use of media devices. Another is in the straightforward choice of theme as a popular, immediately identifiable emblem. On occasion he uses mass sentiment and popular taste as a theme. It was not for sentimental reasons, however, that he painted a picture of the sea of floral wreaths that swamped the Anfield pitch after the Hillsborough football disaster. In marked contrast to Warhol's car crash or Hamilton's Charles Manson imagery, Henri's picture brings a smile to the face of tragedy, and at the same time personalises pop art. Similarly we saw how Sam Walsh exercises his essentially romantic interest in faces by focussing, not on the uniform or deadpan aspects of reproduced facial imagery, but rather on the character given to the face by age. Without ever trying to be controversial, Henri never shirks from what he sees as his responsibility to pick up on the events, issues or images that most affect his community. This is reflected in his support for lesser-known Merseyside artists. Abraham Newman, the solicitor who was involved with Henri at the time of the Liverpool Academy's break-up, is one example. Due to family

pressure Newman never made use of his training at Liverpool Art School (1927–32) and the Royal College (1932–35), but nonetheless continued to paint haunting, obsessively detailed pictures of streets with bald, somnambulistic figures going about their unidentified daily business. Another example is David White, a young artist with a Bridewell studio who paints in an impastoed, figurative way and frames the results with giant strips of driftwood.

Adrian Henri, the cultural 'magpie', undoubtedly looks on his activities as an artist as contributing to a 'total work', a gestalt that by its very totality best expresses the character and nature of the artist. The images that form the currency of his pictorial 'business' are not didactic, rhetorical or moralising, but are essentially metaphors for the externalising of personal emotion into the aesthetics of the general. The modern myth of improvisation does not apply to him, for even in the 'Happenings', influenced by Alan Kaprow, there is a script. The thematic immediacy of his chosen image does not require a repertoire of formal techniques that are improvisational or gestural. He does not fill the gap between art and life in this way.

Edward Lucie-Smith has gone some way towards explaining Henri's popularism when writing that "Modernism, in its earliest manifestations just before the First World War, was élitist. It was often caught up in a cult of the superman, which it had inherited from Nietzsche. The Liverpool bohemians of the early 1960s, and Adrian Henri in particular, transformed modernist élitism in a curious way. By adopting, half ironically, the idea of stardom from the movies, and also from the near-at-hand world of rock music, they transformed the dominant, stand-offish superman of Nietzschean mythology into the far more accessible notion of the popular superstar."[3] Henri's war on élitism is waged well from Liverpool's ambiguous cultural position. As Lucie-Smith says, Henri is, as a Liverpool artist, "a figure who is both provincial and international, but not metropolitan."[4] Indeed, the artist has always argued that Liverpool's position as a port, its special relationship with Wales, Ireland, and New York and the Americans, has given it a peculiar kind of independence and with it a refusal to kowtow to the supposedly superior taste of London.

In any final analysis Henri would emerge as a happy artist, a man with an optimistic vision rather than someone wanting to close down possibilities. The ultimately academic straightjacket of modernist formalism, evolved from Fry's preference for form over content and ending up with Greenberg's critique of artistic 'progress', is particular anathema to Henri. At the same time Henri has willingly participated in modernism's experimental and innovative practices. In common with Walsh, Cockrill, Ballard and more recently Horsfield, Henri draws from the past and pastiches art history to give an old theme current appeal. His *Entry of Christ into Liverpool* is a good example. It is based on James Ensor's masterpiece that maligned

201

the Brussels bourgeoisie of the late nineteenth century by casting them in the role of anti-Christs, but Henri introduces into his own version clearer composition, spatial coherence and greater thematic optimism. Henri's picture "is about pleasure not pain, delight rather than dismay." Perhaps this has something to do with the broader scope for spiritual joy present in the late twentieth century than in Ensor's day, in spite of, or perhaps because of, the liberating effects of technology.

Something happened to culture after the 1970s. It became harder to look at the supposed progress of modern art — the tradition of the new — in terms of logical movements and sequential innovations. If ever there was a time for eccentric, individual contributions in a pluralistic climate that encouraged hybrid style it was surely now. The enduring myth of the 1980s was not the enterprise culture (too dependent on the fluctuating fortunes of economic life) but rather the notion of choice. This cherished eighties ethos put the consumer first, and since the days of the proto-pop artists of the late 1950s, it has been respectable for the artist to be cast in the role of a consumer (as well as being a producer of imagery for mass audiences). An artist like Adrian Henri consciously exploited this, and put his role as consumer before any pretence of originality. He openly enjoyed the inspiration gained from the work of others and used pastiche or multi-cross-reference in the unassuming context of his own art.

One of the clearest instances of art breaking out of modernist orthodoxy is provided when figurative painting copies, or uses themes suggested by, Old Master pictures. For those disillusioned with the modernistic cul de sac, rummaging through the paintings of past masters offered new possibilities. Pastiche is often a sign of artistic confidence and freedom from stultifying dogma. Skilfully used it can blend the familiarity of the old with the shock of the new in an ironic synthesis. Picasso used it devilishly, and Arthur Ballard's *Punch and his Judy*, though stylistically copying Manet, repeats Picasso's recurring autobiographical theme of Beauty and the Beast. Liverpool artists are witty, and have been quick to make their own contribution to a post-modern spirit by parodying the past in terms of the present. We have seen various degrees of open reference to past art in the work of Cockrill, Walsh and Sutcliffe as well as Henri and Ballard. But one of the most surprising forays into pastiche is provided in the recent work of Nicholas Horsfield, and it could be a symptom of an ennui with the uneventful, if exquisitely handled, post-Cézanne landscape painting that he had hitherto practised.

Lying in the infinitely flexible area between abstraction and representation, Horsfield's landscape paintings have always breathed with the life of both tradition and modernity. He chose as his central theme not Cézanne's mountains of the South of France but the flat coastal plains of Normandy near his friend John Willett's house. Traditionally, Horsfield's work has run

202

Adrian Henri Dream Palace, *1989. Acrylic on canvas. Coll: Walker Gallery, Liverpool.*

Nicholas Horsfield Fleeing maiden, from Tintoretto's St. George, *1990. Chalk.*

parallel to, rather than directly drawn on, the art of his 'heroes'. Sickert's earthiness, realism and above all direct absorption of drawing into the painting process are reflected in the work of Horsfield. Dieppe and the modest attic rooms provide another, if incidental, link between the two. Horsfield's occasional flamboyant colour might also suggest the influence of Bomberg, though surprisingly Bomberg was never on his list of influences. But de Stael certainly was, and this influence took Horsfield the closest to all-out abstraction. This took the form, in Horsfield's landscapes, of thick wedges of palette-knifed colour, summarising details like horizons, river reflections, farmhouses and fields. A latent compositional order used what Mondrian saw as the essential verticals and horizontals of nature.

The sensuality of Horsfield's use of paint goes hand-in-hand with an ethos of sobriety and seriousness. He was never an outwardly ambitious careerist or a trite exhibitionist, preferring to conduct his own profession from a sane, provincial sanctuary. He was never a Sunday painter, but Horsfield's output was often restricted to the art college holidays, and his long association with France encouraged his natural inclination to follow Bonnard's relaxed attitude. Asked in 1991 why he thought his Liverpool contemporaries had been for so long neglected, he answered that London critics were traditionally loath to make regular journeys north to see the principal exhibitions on the Merseyside calendar. The quietism of Horsfield's career is therefore part-circumstantial, part-choice. He disliked what he saw as the loud, harmful and subversive currents of much sixties art, when the whole history of painting seemed for a moment to be sidelined under a banner proclaiming that 'painting is dead', and replaced with an outlook that fostered ephemeral and hedonistic imagery and cheap reproductive processes.

Horsfield's series of 'copies' began with studies based on the early Cézanne pictures that he saw at the 1988 Royal Academy exhibition. One, depicting the artist's Uncle Dominique dressed as a lawyer, inspired a number of oils and related monoprints. Cézanne's lavish handling of pigment in his colouristically restricted early portraits (blues, blacks and flesh tints predominate) proved a suitable example for Horsfield to follow. He also copied the portrait of Marie, Cézanne's sister. The Cézanne phase was followed by a Titian phase, inspired by the *Portrait of a Lady*. Several pastel and watercolour studies were produced based on this painting. Géricault's *Raft of the Medusa* followed, a picture that he had admired since his student days. A copy probably made by William Etty was owned by a relative, and during the 1960s Horsfield inherited the picture. He later described the experience of transcribing something that so fascinated him as being "rather therapeutic".[5] The Géricault inspired a number of aquatints and small pictures, some focussing down on a fragment of the grand composition. The *Raft* is one of the great images of Romantic art, but it is likely that the

principal fascination for Horsfield lay with the work's formal and visual qualities — the compositional complexity elicited by the varied postures of figures who are stranded on a raft at sea likely provided as much drama for the artist as did the emotional range from hope through panic to despair. An ink study for the grand Louvre composition belongs to the Rouen museum and Horsfield became familiar with it on trips made to Rouen from John Willett's house in nearby Thil.

The postural interest of the *Raft* is echoed in the splendid *contrapposto* gesture of the foreground figure in Tintoretto's *St George and the Dragon* in the National Gallery. Horsfield has adapted this image from colour postcard reproductions. Once again he has chosen to home in on a section of the composition, yielding a series of pastels, drawings and small oils. The *contrapposto* of Tintoretto's figure caught Horsfield's attention as a result of an interest in gyrating posture inspired by an exhibition of Degas bronzes at the Whitworth Gallery in Manchester in the mid-1980s. He made drawings of the rotating dancers in the gallery and subsequently tumbled upon the compelling image of a woman coming towards the viewer as though issuing from the fabric of the picture itself.

The recent Horsfields, both by virtue of their rich colour and adaptation of grand art historical sources, could not seem further away from the continuing vein of 'bedsit realism' practised by the gifted Dick Young. Yet the two artists share a similar range of sympathies, and acknowledge their provincial situation as if it were a positive advantage for their art. They support one another's reputation and have exhibited together for many years though their joint exhibition at the Ayeling Porteous Gallery in Chester during 1988 was their first dual show. Alex Kidson commented at the time that "where Horsfield moves on to a new campaign, beginning the process of another investment and capture, Young may overhaul his weapons, but he maintains the same relentless siege. For neither is there any end to the war."[6] The metaphor of a siege may be interpreted as their embattled positions, as neglected and undervalued artists, in relation to the art establishment in London. But Young has breached the walls several times and has meritoriously exhibited work at Burlington House and at the Hayward Gallery. Furthermore, Auerbach and Kossoff have admired Young's painting since first seeing it at Riverside Studios in the exhibition that Mike Knowles organised in 1982.

Dick Young, the north country 'bedsit' artist par excellence, speaks quietly and slowly to those with the patience to look at art without thinking only of the price. If he makes a pastiche then it is only of his own past work. Since the early 1930s Young regularly attended life drawing classes, and his nude and recurring self portrait drawings are academically strong statements with an intuitive understanding of the role that untouched paper can play alongside hatched and shaded areas in the formal construction of

205

Richard Young, 1991. John Moores painting (Self portraits).

the image. He can draw with the full repertoire and fluency of classical draughtsmanship, an ability that on occasion gives him the confidence to compose looser drawings with a single, heavily inlaid line. Such statements seem a little naive, for Young circumscribes the figures, furniture and domestic bric-a-brac with a line of wobbly, literal quality. But as the evidence of his academic drawings shows, Young is anything but a naive artist, for he possesses a considerable formal arsenal as well as the natural artist's ability to edit out unnecessary detail. He often conjures a rich and compelling image from an unpromising, banal subject, achieved by filling in an unremarkable composition with a thick application of paint and a drastically restricted palette.

An end product of his perennial practice of drawing using the theme of self portrait was his successful entry for the 1991 John Moores exhibition, selected by (among others) Maurice Cockrill. Young's painting, in characteristically drab ochres, greys and dirty whites, is based on a large number of small self portrait drawings — dating from the 1930s right through to today — that were pinned to the wall of his small studio. This is Young as pasticheur of his own work, a painted anthology of his own self portrait drawings over many years. Here is a hermetic theme of great subtlety, matched in the execution by a parallel sophistication in the use of tonal handling. The composition has an unassuming, fortuitous air about it as if the artist has picked up on a ready-made situation. He paints a picture about his own past work with the objectivity that time and irony give him. Janine Pinion, the enterprising director of the Acorn Gallery — that in recent years has done so much to show gifted local artists — detected this when she wrote that Young's "still lifes lack arrangement — no need to tidy up to make a pretty picture."[7] Indeed, Young seldom takes the soft option and his colour never sinks to the level of easy, eye-catching decorativeness. As Pinion again perceived, Young is never "imposed upon by the fickle imaginings of middle-class romanticism." Once referring to himself as "an armchair painter" the artist may pass himself off as naive and neo-amateur, but the rest of us know better, for his artistic intelligence and technical ability are anything but naive.

Dick Young, for so long a quiet, undemonstrative presence on the post-war Liverpool art scene, elevates the banality of his surroundings to formal, even monumental, significance. The artist's years as an electrician and an interior decorator had the effect of preventing any tendency towards preciousness or timidity in his handling of the materials of the craft of painting. In common with an artist like William Scott, Young can reproduce in terms of paint on canvas, the drawing process of preparatory work done with pencil on paper. Young also shares with Scott an interest in texture. Janine Pinion first met Young in the late 1970s, and found that "his shabby appearance belied the richness of his character,"[8] a comment

that can also be applied to his superficially drab pictures which operate on the level of irony, *trompe l'oeil*, paraphrase and so on. As Pinion wrote, it is "the element of illusion that draws you into each picture." In modern art much is made of the painting as object, referring to nothing other than itself as an abstract concoction of paint, colour, surface form and the like. Yet representational painting can refer to, and stand as a surrogate for, the object that forms the subject of the painting itself. On one of the dark, windowless walls, a characteristic Dick Young picture of a window and backyard can be an equivalent for the missing window. As recently as the early 1980s Young was encouraged by the painter Mike Knowles, Head of Fine Art at the Liverpool Polytechnic, to enrol at the art college for a full degree course. Young was left alone in a supportive environment to continue painting and Knowles found him a small flat near the college.

Knowles was born in Warrington in 1941. Continuing the tradition of former students of the art college to become tutors on Hope Street, he joined the staff in the late 1960s. He had been a student between 1959 and 1963 under first Ballard, then Charles Burton, Peter Crabtree and Heinz Koppel, a Jewish artist from Germany who once had assisted in Kokoschka's studio before escaping to England during the war. Koppel had spent time in South Wales where he knew Josef Herman, and he was introduced to Liverpool by Charles Burton, who later retired to South Wales. Koppel went on to teach at Liverpool for ten years between the mid-sixties and seventies. He lived in the hills above Aberystwyth, where he kept a market garden. In 1980, while working on his smallholding, he suffered a fatal heart attack. With his Central European touch and feel for colour, Koppel had a small following and he certainly influenced Knowles, whose later work luxuriated in thick expressionistic handling and lush naturalistic colour. His paint-clogged life painting of Liverpool Art College's perennial model Sue Lee — a rival of June Furlong's — exudes the physical energy and impasto of artist émigrés like Auerbach and Kossoff.

Knowles's student work partook of the generally dark, even black, industrial landscape and brooding figure styles of the late 1950s. An interest in early de Stael fitted in with the current fascination for the painterly exuberance and blocked composition of the French artist's work. Knowles's wife Veronica Johnson was at that time a girlfriend and fellow student of Stuart Sutcliffe's in Liverpool, and as we have seen Stuart was also immersed in the de Stael cult. At the end of Mike Knowles's first year, the summer of 1960, he and Veronica went to Paris where they saw de Stael's work. Knowles's lofty ambition as a painter has been, since that time, to invest the painting of still life or landscape subjects with the primal emotions that these themes aroused in the mind of the artist. He

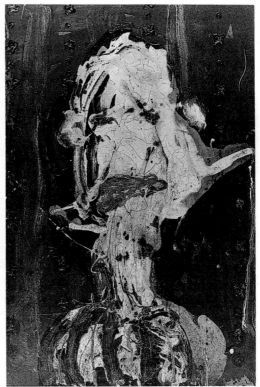

Michael Knowles Portrait of Sue Lee *(the model at Liverpool College of Art). Oil.*

Rodney Dickson Portrait head (Gulf War series).

Andrea Lansley Self portrait. *Courtesy: Walker Gallery, Liverpool.*

is interested also in the plastic contrivance whereby paint becomes the image, rather than tamely describing it as is the case with more narrative or illustrative approaches. He manages in some of his Anglesey landscapes to convey the impression that he had painted the image in one fell swoop. By so doing he emulates that exquisite sense of liquid continuity and spontaneity that we find in, say, Cadell's or Peploe's panels, in Kossoff's portraits or even in Nicholas Horsfield's small works. Knowles formed a close friendship with Horsfield, the two even on occasion painting in one another's company outdoors.

When in 1966 Knowles left the Slade, having completed two years' study, he obtained a teaching post at Manchester, taking over Adrian Henri's position in foundation studies. His impact as a teacher must have been rapid because the following year he was appointed a full-time tutor at Liverpool, where he taught alongside some of those who, just seven or eight years previously, had taught him. John Virtue and Peter Prendergast, two of Knowles's Slade contemporaries, followed him into teaching at Liverpool Art College. Indeed, in 1969 Knowles bought a cottage next to Prendergast in Bethesda, North Wales. The cottage, which he kept until 1978, provided wonderful views of Snowdonia and resulted in a series of elemental pictures of sky and sea as seen from mountain heights. By the 1980s Knowles had consolidated his position as an influential teacher. He became Head of Fine Art when, in 1983, the college temporarily lost its degree status. Knowles got the course back on its feet. Such responsibilities led him to say that at this time he had "been like a Sunday painter." He moved to Anglesey but kept on a Bridewell studio. Many of his paintings in recent years have consequently been based on Anglesey landscape subjects, a fact that led Kyffin Williams, the best-known Anglesey painter, to encourage the Welsh authorities to buy Knowles's work for official collections. Knowles has also done his own promoting of colleagues' work, and in 1981 and 1982 was asked by Jenny Stein to organise two exhibitions, 'The Nature Parallel', at the Riverside Studios in Hammersmith. Among those he selected were Liverpool colleagues like Horsfield, Brenda McDermott, Peter Prendergast, Dick Young and Veronica Johnson, together with Accrington's Robin Bownass, and Burnley's David Wilde. It was on this occasion that Young's painting won favourable comment from Auerbach and Kossoff.

Landscape has also inspired, and consequently been the chief metaphor in, the work of the gifted Irish painter Clement McAleer, who came to Liverpool in the late 1970s after completing a postgraduate course under Peter da Francia at the Royal College. At the time of writing McAleer is installed in a Bluecoat studio and is able, by virtue of the accessibility of his work to a buoyant Irish and Merseyside market for inexpensive contemporary art, to make a living solely off his work. McAleer's studies began

in 1972 at art school in Canterbury, where a lively and contemporary-minded staff included Tom Watt and Stass Paraskoss, two painters who encouraged a cult-like regard for paint and colour in a climate then dominated by austere minimal and conceptual art. At the Royal College visiting tutors like Ruskin Spear and Colin Hayes encouraged McAleer in the pursuit of the real in landscape, though he later reflected on the teaching on Exhibition Road as being "a bit erratic and hit and miss",[9] and he gained more from fellow students than the staff. McAleer never really found his artistic feet until after student days; moving to Liverpool because his sister lived there proved to be his lucky break.

As early as 1978 he gained entry into the John Moores exhibition, exhibiting a large triptych depicting three rooms in a derelict building. The following year, encouraged by the Moores success, and also bolstered by support from Brian Biggs and Maurice Cockrill, McAleer took on a Bluecoat studio. In April of that year he had a commercially successful one man show at the Bluecoat Gallery. Many Liverpool collectors bought his work but it was by tapping into the following gained in his native Ireland that he was able to survive the lean years when he was struggling to get off the ground as an artist. An Arts Council show was put on in Belfast, and from that time on he made several trips home a year, using the visits to make drawings that would later lead to paintings produced back in Liverpool. Twice during the 1980s McAleer repaid his Irish debts by focussing on two Irish literary themes. In 1982 he produced six paintings as part of a 'Ulysses project' for the James Joyce centenary. In 1989 he produced another set based on the poet John Clare.

McAleer's accomplished landscape painting generally reveals an involvement with panoramic, aerial perspectives. These allow the artist scope to focus on the grand geomorphological design: the artist expresses landscape as an obliquely tilted plain, scoured with the rhythmic markings of its own history. Roads, hedges, rivers, fields, hill profiles and so on are keenly picked up by the eye of the artist and are subsequently translated into the pictorial arena in terms of enhanced linear perspective, surging rhythm and exaggerated movement. Sheila McGregor commented that the "network of roads and paths which wind their way towards a distant horizon represent . . . an 'interior journey' . . . their progress aided or impeded by the nature of the weather and terrain, they become a pictorial metaphor for the uncertainty of human experience."[10] Yet McAleer's are not predominantly linear paintings, for his application of oil or acrylic paint, pastel or watercolour adds, by way of animated brushwork, to his feeling for the flux of nature. Despite his relaxed handling, McAleer has never formalised his work to the logical conclusion of linear abstraction. Bryan Wynter's later abstract canvases distilled landscape texture and river patterns into a hard-edged, pictorial geometry. But Peter Lanyon has inspired McAleer,

211

particularly for a total vision of landscape in a constant state of elemental flux. McAleer's composition is more conventional, using a fixed reference point. In common with the Cornish artists McAleer has embraced the region where the sea meets the land, and paints the turquoises, blues and sandy ochres of a coastal panorama with uninhibited panache. He introduced acrylics after experimenting with the medium on paper. They enabled him to work faster, due to their fast-drying properties. His recent use of both oil and acrylic in the same work represents his aim to express the interaction of air, water and earth. McAleer never breaks the umbilical cord that ties even the most abstracted of his works to the subject of land-scape. Even the least representational of his works — resembling the Americans Diebenkorn and Sam Francis — maintain a horizon line. He sees the horizon between sea and sky as a mysterious illusion and articulates the feeling with the simplest technique imaginable, that of smudging the junction point of sea and sky with his hands. McAleer's total association with his subject won his painting *Coastline* the response from one critic that ''Emotionally this is one of the clearest and most eloquent pictures in the show.''[11]

Landscape forms the background in most of George Jardine's recent pictures. Like McAleer he often takes an elevated view of a landscape, not in order to formalise it but rather to provide a metaphor for the feeling of unbounded wonder that it is the artist's intention to evoke. Quite apart from the fact that Jardine's choice of Welsh or Lakeland landscapes gives him a ready-made romantic setting, he is in many ways an artist of the grand Romantic tradition. Set against these landscapes, as we have seen, are strange, hybrid creatures, exotic birds or unusual plant forms culled, not from the primaeval swamp of his own imagination, but from scientific fact. By introducing exotic elements from distant places or times long past, Jardine's vision points to a natural order, not restricted by mundane mechanical laws, but rather one that has fully actualised itself from a state of potentiality. He boosts ordinary views of nature into a supernatural orbit. His linear stylisation, tight drawing and keen eye for detail may suggest a scientific and obsessive sensibility, but in fact they are mere tools that enable him to illustrate an all-encompassing vision of nature. Stylistically, Jardine's work reveals revivalist instincts that hint at the Renaissance masters through to Burne-Jones and Art Nouveau.

Symbolism of a more political kind enters the work of Liverpool-born Mark Skinner, suggesting that to be a teenager in Liverpool during the early 1970s engendered angry feelings concerning urban decline and social neglect. Skinner was helped during foundation studies in Liverpool by Maurice Cockrill, who freed him from a tight and detailed style. He went on to study at Birmingham during the late 1970s spending much time in the sculpture department making wooden reliefs. After a spell in London in

the early 1980s Skinner returned to his native Liverpool in 1983 and obtained a Bluecoat studio. He was selected by the Bluecoat's Brian Biggs for an exhibition of new Liverpool artists who included John Bagnall, Josephine McCormick and Mark Power. The exhibition's reviewer found Skinner struggling for originality. He wrote that the "inspiration offered by [Graham] Crowley seems to be too strong for any personalised adaption to be noticeable."[12]

Since the 1960s there has been evidence of strong formal links between abstract painting and sculpture. St Martin's sculptors, led by Caro, influenced the work of abstract painters and during the pluralistic climate of the 1980s, a new decorative gaiety was introduced into the work of committed abstract painters. Certain of these even produced quasi-sculptural objects in the form of wall-bound reliefs. The interlocking shapes and embellishment of painting practised by younger British artists during the 1970s characterised much in the output of both abstract and figurative painters, with many moving freely between illusion and concrete form. The magazine *Artscribe* promoted the new school which included artists like Noel Foster, Stephen Farthing, Graham Crowley, Jennifer Durrant and Hugh O'Donnel, all of whom to some extent rubbed off on Skinner. Another more immediate influence was provided by the artist's experiences of fairground machinery in Southport. Skinner made gouache studies of men working on the machinery, which he used to produce oils that abstracted the functional forms into brightly coloured, hard-edged shapes. De Chirico, early and late Guston, Sheeler and Stuart Davis were useful sources for Skinner. In the mid-1980s he made reliefs with geometrical forms which evoked the missile silo, pointed hood, fairground roundabout and the arrow shapes that were chosen for their iconic menace. Skinner next moved into the overtly political arena, using accurately depicted symbols such as tyres, ropes, or noose-like belts hung around pulleys. His 1990 *Necklace* is a reference to execution in South African townships.

A similar commitment to social and political issues entered the work of two Merseyside-born painters who left the area and pursued their careers in the South. Ray Walker (1945–84) studied at Liverpool Art College between 1961 and 1965, where his work revealed typical surrealist tendencies. He also fulfilled a tradition for Liverpool artists to go on to the Royal College. There he painted with the heightened sense of narrative content that was part of the Royal College ethos. He lived in extreme poverty in London, sharing a number of squats, a situation which reflected his early working-class Liverpool background and contrasted markedly with the comfortable, middle-class student ambiance of Exhibition Road. Walker brought into his work a unique blend of social realism with political symbolism and mythical fantasy. He used as subjects for his work the drop-outs, street characters and ageing hippies so typical of Notting Hill in the

213

late 1960s. Edward Lucie-Smith, discovering his work at the degree show in 1969, wrote about Walker's "mixture of realism and fantasy, its grotesque eroticism." Walker's art was truly democratic — few concessions were made to formal preciousness, prettiness, or middle-class romanticism. His socially committed and public art drew its inspiration from the Mexican muralists Siqueros, Orozco and Rivera. It ultimately depended on the mural to speak directly to the man in the street. His work, which is invariably so full of people, exudes emotionalism of the kind we find in William Roberts and Jacob Kramer. Anguish, defiance, anger in the face of repression are everywhere. Also in common with Roberts, and even with the Vorticists, Walker introduced a linear stylisation into his schematic drawing of figures, betraying a frequent identification of the human figure with machines.

An exact contemporary with Rod Walker at the Liverpool College of Art, William Bolger, also went to the Royal College where he studied until 1968. Bolger had two solo shows at the Bluecoat, one in 1969 — the year Rod Walker graduated from the Royal College — and the other in 1970. 'A future primitive' may sum up Bolger for he wishes to create a modern context for the self-expressive forms of primitive art. His contribution to the 1973 'Communication' exhibition at the Walker was a mural-sized work. It depicted primitive and mechanistic hybrids in a hard-edged and occasionally humorous style, a cross between Scottie Wilson, Paolozzi and South Sea carving. Bolger later went to live in St Ives, where at the time of writing he continues to work, under-appreciated as seems to be the lot of so many Liverpool artists.

Birkenhead-born Graham Dean also left Merseyside and after studying under Hoodless at the Laird in the late 1960s pursued his activities as a painter in the more promising pastures of the South. Also in common with Walker, Dean pursued the figurative 'ideal' in his work, though their respective approaches diverged greatly. Process is important in Dean's large watercolours, so much so that in addition to using the medium of watercolour to its expressive limits, while still tied to subject matter, the artist also exploits the texture of paper which he crinkles, creases or stitches together in collaged units. The freshness of his broad handling of watercolour, manipulating as it does staining, accidental 'bleeding' and fluid 'runs', goes hand-in-hand with a use of paper suggesting age or neglect. Dean is well aware of the dilemma faced by the modern artist, the problems presented by too much freedom. Perhaps it is for this reason that he has retained the discipline of traditional figuration, for as he has remarked "total freedom is often more limiting than a degree of constriction, self imposed or otherwise."[13] At the same time he has confronted head-on the glut of visual information that is a product of the age of pop and the media. Cuttings collected for their visual poetry, resonance or symbolic suggestion,

are pieced together as prototypes for the watercolour fragments that constitute the eventual image. Dean's figures frequently have a monumental presence, not just on account of the scale of the sheet, but because of the way the overall image is itself a product of a fragmented surface made up from a series of contrasting units of colour, shape and texture.

Frank Green, born in Liverpool in 1943, was a student contemporary of Ray Walker's at the art college. Although never using symbolism, Green, like Walker, retained a strong interest in the life of the streets. But in contrast to Walker, Green stayed in Liverpool and adopted a straight-forward, topographic style in which to portray the streets of Anfield. Green was taught by Charles Burton and Peter Crabtree in the early 1960s, but he disliked John Edkins's teaching that pressured the students in the direction of non-figurative experiments with pure shapes and formal arrangements. Green's answer was to stray onto the college rooftops and paint the excellent panoramic views on offer there. In the mid-1960s he visited Italy on a scholarship and by the end of that decade was a bus conductor, an experience that at least gave him daily insight into the demolition of Everton, and the replacement of picturesque, if grubby, terraces with ugly, impersonal and indeed architecturally unsound high-rise blocks. Using pastels, Green decided to record the changing face of this region, a project that had motivated Tankard and Rod Warbrick in Liverpool, Lowry and Riley in Manchester, and Carpanini in Wales. Also, Henri Cartier Bresson and Chambré Hardman had each used the camera to portray the street life of old Liverpool before the era of demolition. In the 1970s, Green, the working-class street painter possessed of exceptional representational skills, was encouraged by Walker director Timothy Stevens, who unsuccessfully tried to get a philistine Council to take an interest in the artist's portraits of the changing face of Liverpool. But a solo show at the Bluecoat in 1976 was a best-seller. In the 1980s Green opened a shop in Liverpool selling prints of his work, and he moved to North Wales, where he speaks fluent Welsh with a detectable Scouse accent.

In common with all the other students on Hope Street, Green would have practised drawing on another fixture of the Liverpool scene, the Life model June Furlong. The model always felt the need, however, to extend her activities beyond the life room, becoming a freelance exhibition organiser and putting on shows throughout the region. Her service to Liverpool art has been considerable and it is all too easy for highbrow or establishment-minded commentators to forget the grassroots activities of a unique Liverpudlian enthusiast. 'Discovered' by Don McKinlay, Furlong first began modelling in Arthur Ballard's life drawing sessions. She left her native Liverpool and spent six years in London during the 1950s. She modelled in the leading colleges and knew many, if not most, of the leading artists — Auerbach, Weight, Freud, Uglow became particular friends. Even

215

Clement McAleer Coastline, *exhibited John Moores, 1985. Oil, 96" × 64".*

Below: June Furlong, as seen by Barbara Davies and Stanley Reed.

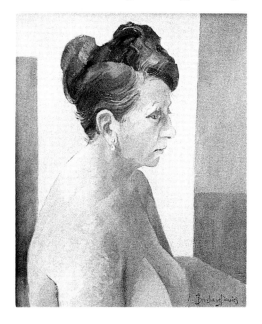

Augustus John requested that Furlong pose for him. An exhibition put on at the Cambrian Academy in 1979 included the numerous studies of June produced by the many Merseyside painters who down the years have made constant use of her as a model. She became particularly friendly with George Jardine, travelling with him to Majorca every year (some of Jardine's more exotic landscape backgrounds are based on sketches made on the island). Among the local artists she has promoted most frequently in her group exhibitions are, in addition to Jardine himself, George Drought, Ron Scarland, Ulrich West, Frank Green and Paul Cousins. The life drawing by Liverpool's most accomplished portrait painter, Stanley Reed, and the much more recent head and shoulders portrait by Chester-based but Liverpool-trained Barbara Davies, provide two likenesses of this talkative and gregarious woman.

Barbara Davies studied on Hope Street during the early 1950s, and she practises in the conventional figurative style then imparted by Wiffen, Tankard, Gill and Jardine. Yet her love of North Wales's rugged landscape, which she regularly explores on foot, "cancels out any kind of timidity in my work."[14] There is indeed nothing timid in her portrayal of June Furlong, which within its own conventional style, completely expresses both the physiognomy and personality of the sitter. Another of Furlong's artists, Ulrich West, studied on Hope Street in the early 1960s, where he was taught in the graphic design department by Jardine and Roy Sharpe. A linear obsession is a feature of his often tiny compositions. Collieries fascinate him as obsolete structures that have a poignant presence in the post-industrial landscape. An interest in texture and the colours of weathering enters the work. George Drought also works with fine linear control over detail. He is a realist, depicting local villages close to his St Helens home base with a finely tuned use of ink and wash. The ink line, while having strong fidelity to the subject, sometimes shows an inherent horizontal versus vertical tension, though the inlaid washes give vivid topographical credence. Paul Cousins, a product of Liverpool Art College during the early 1970s, makes paramount use of oil pastel. He followed his tutor, Sam Walsh, into a use of photographic perspectives to compose and structure his pictures of gardens and parks. A rich colouration recalls the overgrown vistas of Adrian Berg, an artist with whom Cousins — with typical northern independence — once assured me he was wholly unfamiliar. A series of compositions based on local Widnes cooling towers silhouetted against fabulously coloured dawn skies (experienced while driving to his school teaching job), led the artist into making his most powerful and sublime statements, ones not without relevance in our present environment-conscious era. Two other recent Liverpool artists who are making an impact with unorthodox styles befitting a pluralistic, post modern climate are Rodney Dickson and Arturo di Stefano.

217

A healthy development in recent years has been the growing number of women artists, who breathe fresh air into the lungs of a sedentary and traditionally male-orientated urban culture. Their closeness to nature brings new meaning to the familiar categories of figurative, abstract and symbolic, for they often make an instinctive and unselfconscious use of all three within the same work. A woman's special emotional identification with the human body, its sensations and rhythms, allow her to paint figuratively while breaking new artistic ground. It is for this reason that so many women artists are prominent in the current era of figurative revival. Andrea Lansley's two bear-like, embracing figures, painted in plum reds and deep blues, is a good example, and prompted Adrian Henri to remark in 1991 that ''Andrea Lansley, a current John Moores prizewinner, paints huge, sexually explicit 'self portraits' attempting to externalise internal bodily feelings.''[15]

The second half of the twentieth century, when British art blossomed and made a significant contribution to modern art, saw great changes in the social and economic organisation of Britain. And Liverpool, the great port of the British Empire's heyday, slid inexorably into economic decline, with all the social ills that this process entailed. But adversity only served to highlight the inherent Liverpudlian spirit, humour and individualism. Creativity expressed itself through an art scene which, as we have seen, flourished around the art school. A healthy mix of traditional and avant garde, local and 'foreign', and more recently male and female artists distinguished Hope Street. The informed intellectualism of European émigré artist George Mayer-Marton, who imparted craft-based skills using Max Doerner's *The Materials of the Artist*, complemented the more romantic, robust and experience-based approach of Arthur Ballard.

The Liverpool College of Art was a legacy of the educational zeal and reformist purpose that the great shipping wealth made possible and necessary during the nineteenth century. The shock that at first attended Dada and abstract assaults on safe, academic, suburban taste has now long gone, and the empirical openness of post-war painters like Peter Lanyon now seems to provide us with examples of antique modernism, ageing prototypes. The works have a timeless quality also, but their relative value is based on their importance as originating factors in the chain of artistic evolution. As we have seen Liverpool artists since the war have seldom originated significant innovations (other than the Anglicisation of rock n' roll by the Beatles), yet have made solid and valid contributions, in their own regional dialect, to international issues and styles. The city has always boasted a well-grounded, substantial art scene, with a more middle-class hinterland on the Wirral, and during the 1980s has attracted younger artists drawn by relatively cheap studio and, living conditions, by the new Tate Gallery and of course by the existing artistic infrastructure — those

galleries, institutions and traditions that are a legacy of the philanthropic and art-loving nineteenth century. The danger now is technology, the dehumanising process that led to designer art, yuppie fashion and the demolition of the picturesque. High-minded, big-money investors know where the quality lies, however, and it is hopefully only a matter of time before Liverpool artists like Ballard, Cockrill, Horsfield, Jardine, Mayer-Marton, McAleer, Sutcliffe, Walsh and Young become collectable in the wider arena of the London auctions.

NOTES

1. Edward Lucie-Smith, *The Art of Adrian Henri 1955–85*, p.8, South Hill Park Arts Centre, 1986.
2. Paul Overy, *Studio International*, November 1968.
3. Edward Lucie-Smith, *The Art of Adrian Henri*, p.9.
4. ditto, p.8.
5. Nicholas Horsfield in conversation with the author, Crosby, September 1991.
6. Alex Kidson, catalogue introduction, Ayeling/Porteous Gallery, Chester, October 1988.
7. Janine Pinion, *Artpool* no.2, p.9, Winter 1987.
8. ditto.
9. Clement McAleer in conversation with the author, Liverpool, September 1991.
10. Sheila McGregor, catalogue introduction, Clement McAleer touring exhibition organised by Atkinson Museum, Southport, 1987.
11. Stuart Morgan, *Artscribe* no.52, p.56.
12. Len Green, *Artscribe* no.42, p.63, 1983.
13. Graham Dean, artist's statement for 'Foolish Fires' at Austin/Desmond, October 1991.
14. Letter to author, September 1991.
15. Adrian Henri, 'In my Liverpool Home', *The Green Book*, p.64, November 1991.

Index

Bold entries indicate black & white picture pages.